Design Secrets:
Advertising

50 Real-Life Projects Uncovered

Lisa Hickey

ROCKPORT

First published in the United States of America by
Rockport Publishers, Inc.
33 Commercial Street
Gloucester, Massachusetts 01930-5089
Telephone: (978) 282-9590
Fax: (978) 283-2742
www.rockpub.com

Library of Congress Cataloging-in-Publication data available

ISBN 1-56496-663-1

10 9 8 7 6 5 4 3 2 1

Production and layout: Susan Raymond
Cover: Madison Design and Advertising

Printed in China

To Caitlin, John, Allan, and Shannon, who, when asked,
"Should I do this? Should I open an agency, write a book, go for it?"
would always vote unanimously: "Yes."

And to Kelly Driscoll, who made it all happen, as if by magic,
just the way a great producer should.

contents

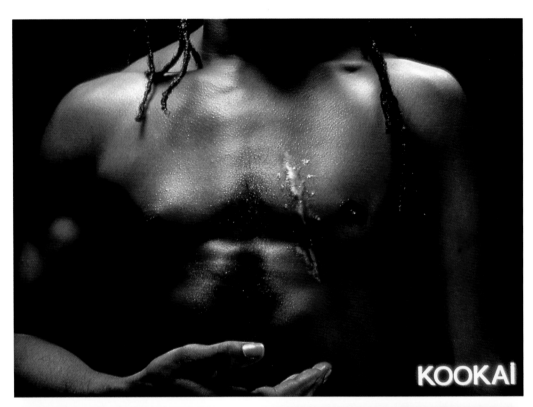

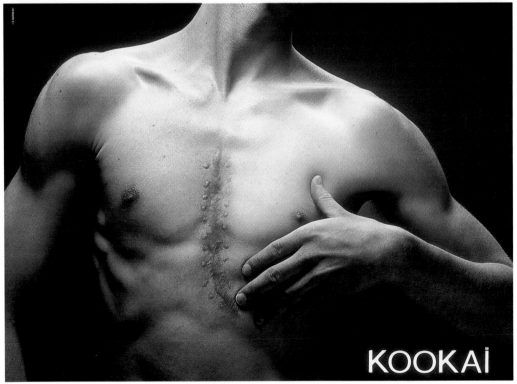

For more of the season's hottest looks, go to giro.com/Borsa

passion

Introduction

You're clicking through the television channels and a commercial catches your eye. Thirty seconds later, it's gone. You're driving down the highway and have seven seconds to read a billboard. You sit in an airport and flip through a magazine. The advertisements hold your attention for how long? Four or five seconds?

Think of the enormous job that any advertisement has to do in a miniscule amount of time. Get your attention. Make you interested. Tell you a story. Sell you on the idea of something. And ultimately move you to action. How can that possibly be accomplished in such a short amount of time?

The campaigns in this book were weeks, months, even years in the making. It took endless strategy sessions, creative brainstorming all-nighters, long, drawn-out client meetings with passionate speeches, and untold production hours to see them through. But because of that, as you look through this book, we're sure you'll have flashes of recognition. "Oh yes," you'll think. "I remember *that* ad. That was great."

The best brands have a story to tell, and they tell it well. Here's a glimpse of how it's done.

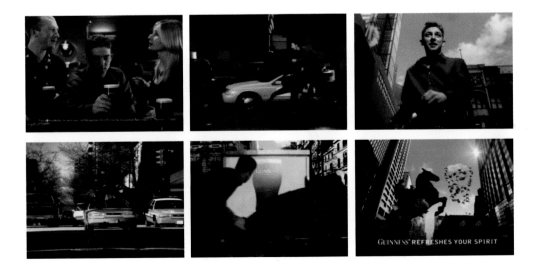

Absolut is the campaign that **most often gets discussed** in meetings between agencies and other clients. Any client who's doing a **print campaign**, whether it's for shoes, software, or sofas, will invariably pose the same question, **"Can't we do a campaign like Absolut?"** they'll ask.

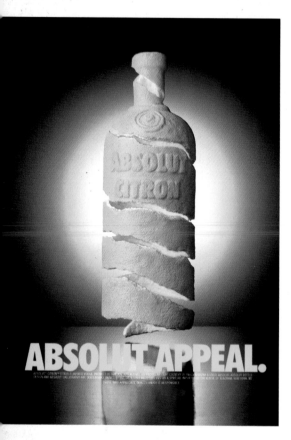

Inspired by Swedish medicine bottles, theirs was the first liquor bottle that didn't have a paper label. It was also designed with a short neck and round shoulders, unlike most liquor bottles that have long necks and square shoulders. Absolut continues to break all the rules of advertising, even the agency's self-imposed rules.

There is just one reply: "only if you're very, very patient." The campaign has been running nonstop for twenty years and is about 1000 ads deep. During that time, the campaign has evolved and grown, but it has never walked away from its core components. A viewer seeing an Absolut ad anywhere in the world has an immediate spark of recognition followed by a "What have they done this time?" sense of surprise. As Richard Lewis, who's currently account director in charge of the brand worldwide, attests, "Absolut advertising is celebrated not just for its longevity, but also for its ingenuity.

"Readers enjoy a relationship with this advertising that they have with few other advertising campaigns, especially in the print media," states Richard. "They are challenged, entertained, tickled, inspired, and maybe even befuddled as they try to figure out what's happening inside an Absolut ad."

First, a little vodka history. Four hundred years ago, Sweden had a bustling industry of vodka distillers. Pure Swedish water and rich Swedish wheat were combined in a rather imprecise science. The small Swedish distillers simply did not have the knowledge or equipment needed to remove the impurities that are a natural result of the distillation process. In 1879, a Swedish inventor changed everything with his creation of a new distillation method called rectification, still in use today. It removed nearly all the impurities produced during the vodka-making process. He called his product *Absolut rent bränvin*, Swedish for "Absolute pure vodka." For this, he earned the nickname King of Vodka.

The distilling company and brand owner, Vin & Sprit, knew it needed to import to America to stay viable. The first hurdle was finding an importer. After many dead ends with larger companies, they struck a deal with Carillon Importers. Designing the bottle presented its own set of challenges, but by now the plucky group knew not to take "no" for an answer. Inspired by Swedish medicine bottles, theirs was the first liquor bottle that didn't have a paper label. It was also designed with a short neck and round shoulders, unlike most liquor bottles that have long necks and square shoulders. Preliminary research about the bottle was yet another test of fortitude—it came back very unfavorable. Luckily Al Singer, head of Carillon, said "Who needs research?" and kept the momentum going. That same philosophy spilled over into an antiresearch approach to the advertising—in fifteen years the Absolut client never once tested the ads to see if they were good.

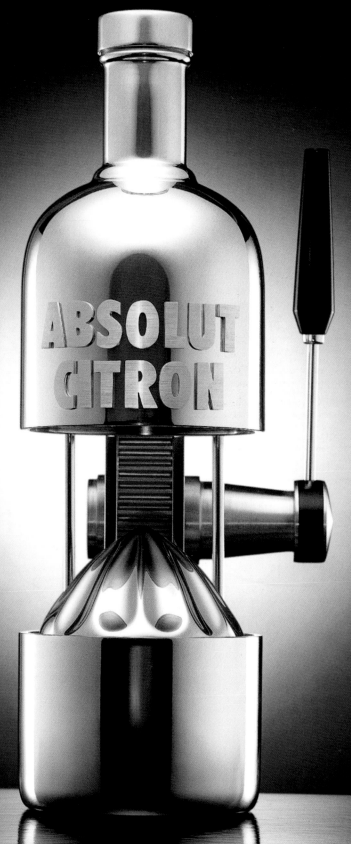

ABSOLUT SQUEEZE.

The first ad in the campaign was created by ad agency TBWA when they were pitching the account. They presented two campaigns, the first being a more traditional lifestyle approach that gave a nod to the vodka's Swedish heritage. The headline "There's nothing the Swedes enjoy more when it's cold" appeared over the image of a typical Scandinavian ice bather, with the requisite product shot tucked away in the corner. The second campaign presented in the pitch was nearly identical to the ads that still run today. The very first one created was an Absolut bottle, with a halo over its head, and the headline "Absolut perfection" in the same large, sans-serif typeface.

As the campaign evolved over the years, it took several different directions while remaining true to its core. The first direction was what Richard calls product ads simply because they still feature Absolut Vodka inside the actual glass bottle. Not only does Absolut continue to run these ads in the magazine schedule, but they also produce new variations that look like the "old" ads. "Absolut Homage," with its array of martini glasses bowing to the bottle, is an example.

The campaign continued in this very strict format for several years. There were many self-imposed restraints: always a photograph of the bottle with its signature glow (an element added by photographer Steve Bronstein, who still shoots many of the ads today). Always a two-word headline. Always a bit of wit to the visual.

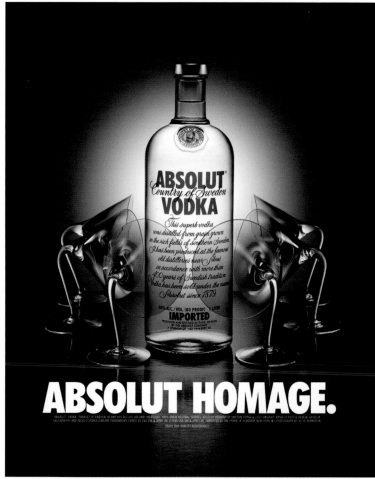

At first, there were a lot of restrictions that have slowly been knocked down over the years. The ad above entitled "Homage" remains true to the campaign's beginnings. At the start, they always photographed the bottle with its signature glow (an element added by photographer Steve Bronstein, who still shoots many of the ads today).

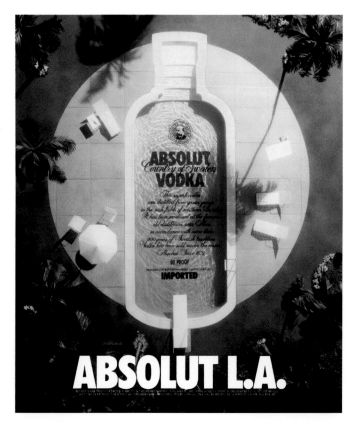

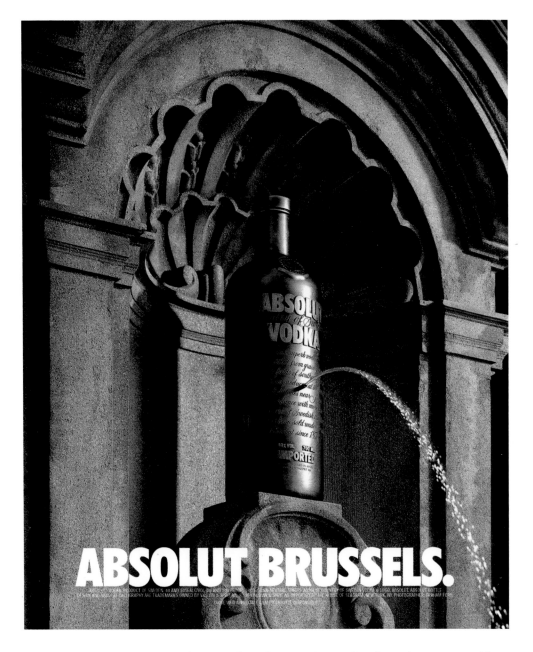

ABSOLUT BRUSSELS.

⊘ "Absolut sales are heating up in California," was the exclamation that rang out in art director Tom McManus's ears. He had a picture of a swimming pool (far bottom left) that he wanted to incorporate into one of his ads. The campaign took a new turn and began using cities and objects in place of the bottle.

A few years later, however, it was the client who came up with an idea that not only "removed many of the campaign's self-imposed restraints but also served to reinforce and magnify the brand's fashionable identity." Michel Roux, president of Carillon, Absolut's U.S. importer until 1994, had met Andy Warhol when he commissioned him to do a painting of another Carillon product. Richard describes what happened next. "Over dinner one night, Warhol tells Michel that he's enthralled by the artfulness of the Absolut bottle. He tells him that while he doesn't drink alcohol, he sometimes uses Absolut as a perfume.... Warhol proposes painting his own interpretation of the Absolut bottle, and Michel agrees, not even considering its use in advertising—merely thinking, 'Let's just see what happens.'"

Although Roux was as surprised as everyone else to see the "black" Absolut bottle, he loved it and thought it would make a great ad. It took some convincing to get the ad agency to agree. They thought the current campaign was humming along just fine, but Michel was a true visionary. "No major advertiser before him had thought to use art as a marketing strategy," notes Richard. The other brilliant stroke of Michel's was the way he continued the chain: He asked Andy to introduce him to other up-and-coming artists. Andy introduced him to Keith Haring. Keith introduced him to Kenny Scharf. And after working with half a dozen established, high-profile artists, it grew to include lesser-known, unestablished artists who were looking to Absolut to help them launch their careers.

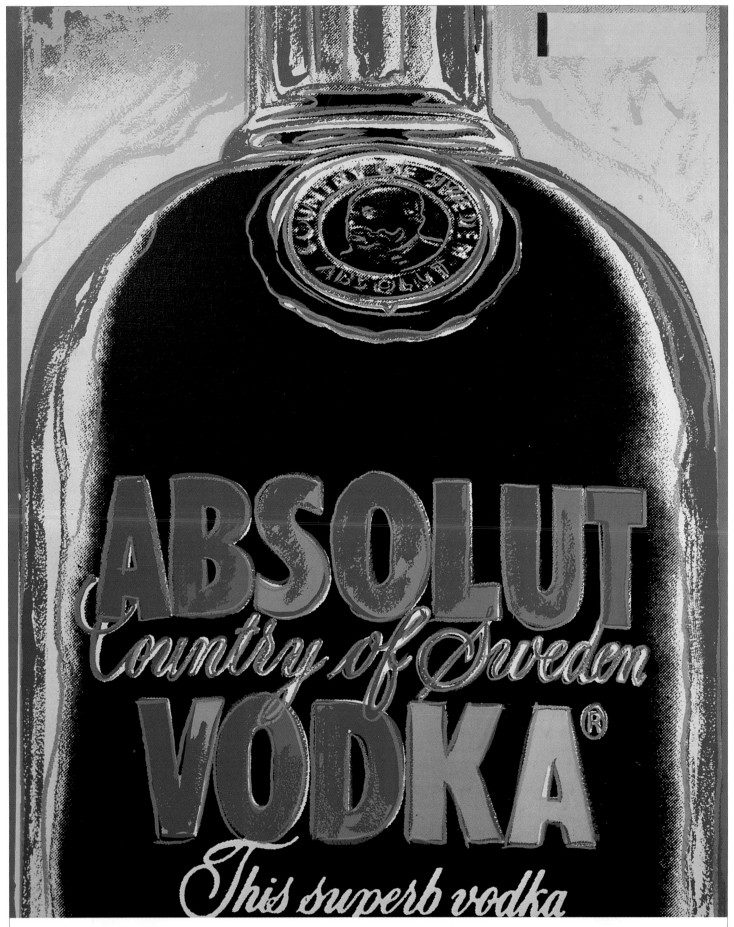

ABSOLUT WARHOL.

ABSOLUT® VODKA. PRODUCT OF SWEDEN. 40 AND 50% ALC/VOL (80 AND 100 PROOF). 100% GRAIN NEUTRAL SPIRITS. ABSOLUT COUNTRY OF SWEDEN VODKA & LOGO, ABSOLUT, ABSOLUT BOTTLE DESIGN AND ABSOLUT CALLIGRAPHY ARE TRADEMARKS OWNED BY V&S VIN & SPRIT AB. ©1994 V&S VIN & SPRIT AB. IMPORTED BY THE HOUSE OF SEAGRAM, NEW YORK, NY.

The campaign broadened yet again with the idea for the series known as "Absolut Cities." This evolution of the campaign simply grew out of an opportunity. One day in early 1987, Page Murray, an account executive with an imaginative streak, strolled into the office of art director Tom McManus and copywriter Dave Warren with an assignment. "Absolut sales are heating up in California," he reported, "so we need to do some kind of ad for Los Angeles."

Tom, like most art directors, was a collector of interesting images, and had just recently seen a photo of a swimming pool that he became enamored with. For a couple of weeks, he had been trying to figure out which of his current campaigns he could use the image for. He did a hasty sketch of his idea that transformed the swimming pool into the outline of the bottle and showed it to his creative directors. They were underwhelmed. Arnie Arlow was troubled by the lack of an actual bottle. Peter Lubalin had an even bigger issue. "This doesn't work. L.A. is just a place. It doesn't say anything positive about the product or the person drinking it." What was so discomforting to the creative directors in retrospect was that it was clear the rules were changing, and no one could tell exactly where the campaign was going. Luckily, the client did not obsess over the rules. The ad got produced and started a new phase in the campaign's development.

As the campaign evolved, it continued to grow as wide as it was deep, encompassing other genres such as flavors, holiday spectaculars, fashion, film, and literature. The client, Michel, cannot be given enough credit for making it all happen. As Richard says, he was "one in a million. He lived the brand, day and night, leading us to do the same. If one week we showed him a crazy idea that he thought was all wrong, when we returned the following week with something equally outrageous, he'd never begin the meeting with, 'I hope you haven't brought me another ad with insects in it,' or whatever. He'd forgive and forget." What's equally as remarkable is that, as other marketers tend to keep their brands' personalities fresh by changing campaigns, Absolut has managed to keep their advertising fresh while keeping the same campaign. A toast to you, Absolut, for showing us it can be done.

SOURCE: LEWIS, RICHARD W. *ABSOLUT BOOK: THE ABSOLUT VODKA ADVERTISING STORY* (BOSTON: CHARLES TUTTLE CO., 1996)

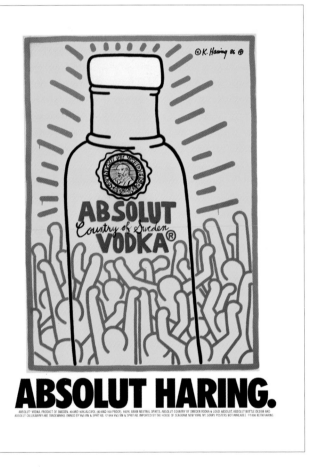

ABSOLUT HARING.

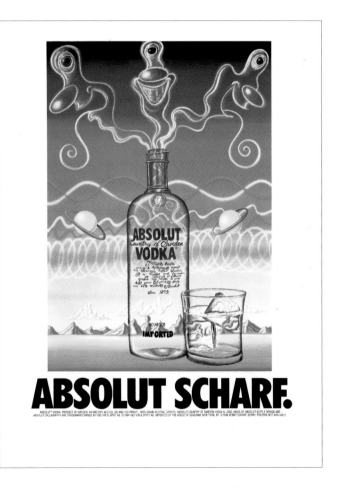

ABSOLUT SCHARF.

"Over dinner one night, Warhol tells Michel [Roux, president of Carillon, the company that imported Absolut in the beginning] that he's enthralled by the artfulness of the Absolut bottle. He tells him that while he doesn't drink alcohol, he sometimes uses Absolut as a perfume…. Warhol proposes painting his own interpretation of the Absolut bottle and Michel agrees, not even considering its use in advertising, but merely thinking, 'Let's just see what happens.'"

MasterCard

It's hard for someone to **say** the word **"priceless"** out loud without the thought of **"MasterCard"** coming **immediately to mind.** It's a campaign that has struck a nerve with people all around the **world.** Almost overnight it was able to change and **update MasterCard's image.**

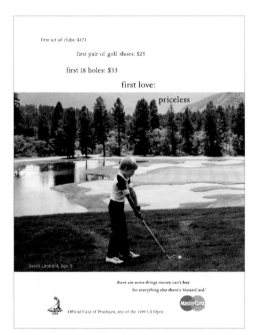

first set of clubs: $175

first pair of golf shoes: $25

first 18 holes: $33

first love:

priceless

Justin Leonard, Age 8

there are some things money can't buy
for everything else there's MasterCard.

Official Card of Pinehurst, site of the 1999 US Open.

The old image of MasterCard was not worth rejoicing about. In fact, "MasterCard had an image that was bland, boring, and frumpy," explains Joyce King Thomas, creative director at McCann Advertising, when talking about the "Priceless" campaign's origins. "That's what came back from research. Whereas American Express was a real brand with personality and Visa was a badge that had prestige, MasterCard was seen as the 'front porch card.'"

The research was done during a pitch for the MasterCard account that was going on between McCann and four or five other agencies. After talking to consumers, the agency realized that it could take what might seem to be a poor-image problem and turn that into an advantage. They found that there was what seemed to be a movement toward "anti-badge." For example, people were wearing Swiss army watches while once upon a time they might have been wearing Rolex. Products that are simple, functional, and smart were getting more prestigious.

Three print executions that can still carry the same message as the thirty-second commercials. One shows a boy on the green, listing the prices of the items that got him there in the first place, but the end result, his first love being golf, is priceless. A glistening ocean with a sailboat on the horizon calls out the cost of owning and operating this vessel—but that doesn't come close to the feeling of freedom—priceless. Lastly, two young siblings with pouting lips around lollipops are satiated for the time being because of the attention to detail given by their parents. Each one has to get the same treat as the other so no favoritism is shown. This moment of truce is—for their parents—priceless.

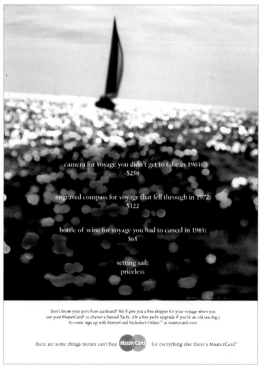

camera for voyage you didn't get to take in 1964:
$250

engraved compass for voyage that fell through in 1972:
$122

bottle of wine for voyage you had to cancel in 1985:
$65

setting sail:
priceless

Don't know your port from starboard? We'll give you a free skipper for your voyage when you use your MasterCard to charter a Sunsail Yacht. (Or a free yacht upgrade if you're an old sea dog.) So come sign up with MasterCard Exclusives Online™ at mastercard.com

there are some things money can't buy. MasterCard for everything else there's MasterCard.™

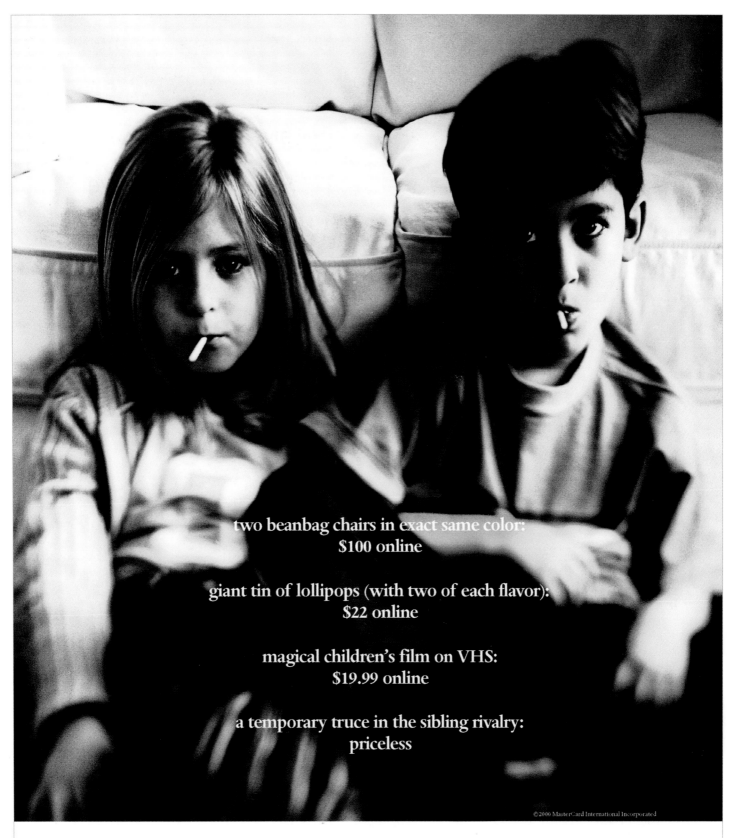

two beanbag chairs in exact same color:
$100 online

giant tin of lollipops (with two of each flavor):
$22 online

magical children's film on VHS:
$19.99 online

a temporary truce in the sibling rivalry:
priceless

©2000 MasterCard International Incorporated

And here's some more peace of mind for you. With MasterCard® you don't pay for any unauthorized purchases. Not on the Web. Not anywhere*. For more information, go to mastercard.com

there are some things money can't buy. for everything else there's MasterCard.™

*Does not apply to commerical cards or PIN-based transactions not processed by MasterCard. Other conditions apply. For more information, go to mastercard.com

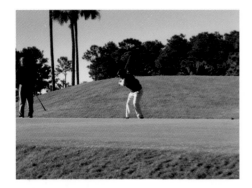 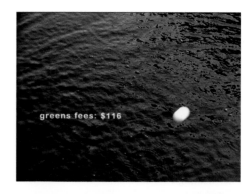

 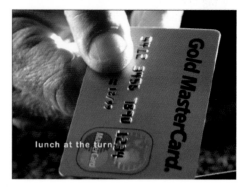

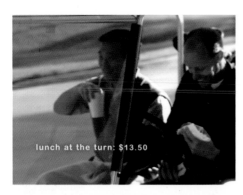 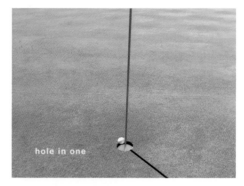

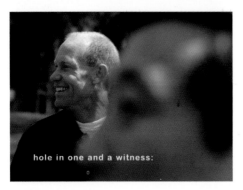

⟨⟩ Almost overnight this campaign was able to change and update MasterCard's image. In this particular commercial, two men are playing golf at a nice country club. It lists the costs of what it takes to play golf for a day: greens fees, $116; tees, $36; lunch at the turn, $13.50; hitting a hole in one...and having a witness, priceless. The man stands there victorious with his lucky ball in hand.

Research also showed that credit cards in general had a negative image—people think the cards lure an unsuspecting public into purchases they don't want. But if you asked those same people if *they* used their credit cards poorly, the answer was usually "no." Most people think that they themselves use credit cards wisely and pay them off quickly. This led to a decision by the agency to target what they called "good revolvers"—people who were purchasing things that had real meaning with their credit card.

After hearing the research, a copywriter named John Kranin wrote the tag line, "There are some things money can't buy. For everything else, there's MasterCard."

Joyce, who was running the pitch, looked at that line and thought, "Yes, that's a great line for them, and it really supports the research." The line seemed to imply that there was a higher order of things, that credit card purchases need not be about needless spending.

So Joyce and her creative partner, Jeonen Bours, spent about a week and a half talking about how to make that tag line work in a campaign.

They were still working on it one Sunday morning before the pitch. The team had just started talking about different scenarios, and they had one that involved a father and son at a baseball game. As they were talking, they started a list of things that you can buy at a baseball game. Suddenly it hit them that the antithesis to things money can't buy is simply the things that you can.

According to Joyce, "We wrote the script for the TV spot—which ended up airing pretty much exactly as we wrote it that Sunday afternoon—and then we stood up and said, 'Okay, we're done.' We wrote six more scripts and then left to go to a movie."

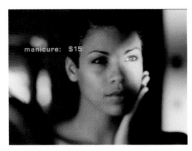

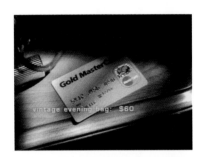
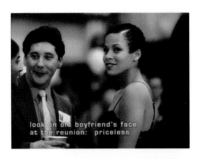
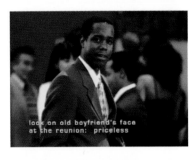

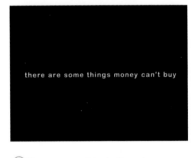

These commercials don't need to count on the music track to hold the commercial together—the concept is what holds this campaign above so many out there. In this particular sweet spot of revenge, a woman is getting ready for her high school reunion. Her skirt cost $85, her manicure $15, her new vintage handbag $60—but the look on her old boyfriend's face when he sees her for the first time in 10-15 years...priceless.

 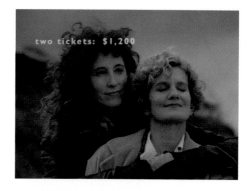 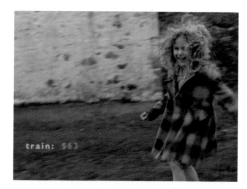

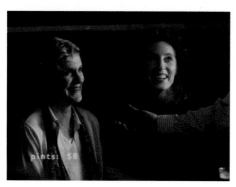

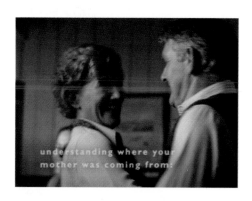 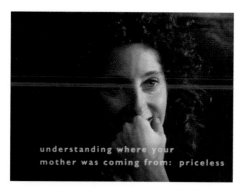 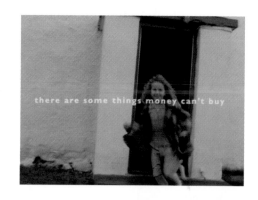

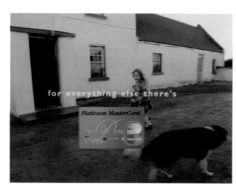

On the day the ideas were presented to the client, the agency could tell they had nailed the account. This commercial deals with the connection between a mother and daughter. The daughter takes her mother back to her homeland of Ireland. Plane tickets cost $1,200; train to her village, $63; pints of beer at the local pub, $8; finally understanding where your mother was coming from...priceless.

The day of the presentation dawned and, as Joyce explains it, "When we presented the campaign in the pitch, we had the scripts all done up in these blue velvet presentation books that were just lovely. And we could see from the client's face that we had gotten it, and that this was the advertising that would run. And even though it took four months before the campaign got on the air, even though it had to go through extensive focus group testing, we knew we had something."

Now there is a large group of people at the agency who work on the campaign. Having different people work on it gives different perspectives to the campaign.

A lot of good has come out of the campaign. Banks respect the cards more, partners respect it more, and market share has been increasing. The campaign has run in more than sixty countries.

The core concept remains the same, but there are sometimes surprisingly simple changes that make it relevant all over the world. In Australia, for example, instead of a father and son at a baseball game, they are at a cricket match.

Joyce thinks they have at least a few more years that the campaign could run. She's not sure why you would cancel a campaign when it has such momentum. And they're doing a lot of things to keep it fresh.

For example, the use of cartoon characters was a new spin on it. "Happy" ran during the Super Bowl, when there were lots of dot-coms, babe humor, and beer humor. The spot showed cartoon characters who need things, but at the end a dancing Fred Flintstone decides that "being happy with who you are" is priceless. "People really loved that spot," notes Joyce.

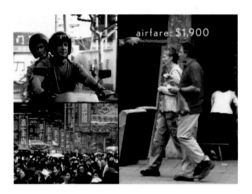
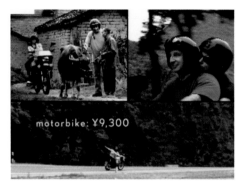
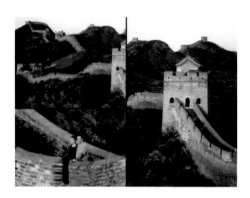

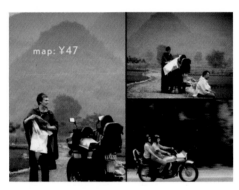
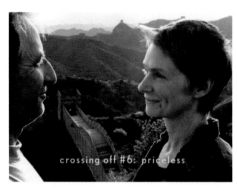
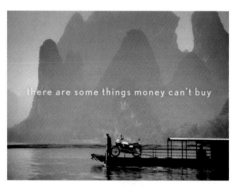

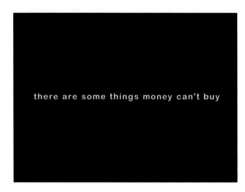
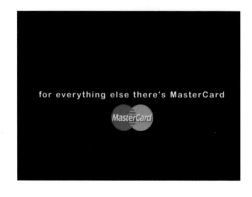

The ads in this campaign always end with the signature tag line, "There are some things you can't buy. For everything else, there's MasterCard." In this spot, what appears to be a retired couple travels to all the places they've always wanted to visit: airfare to China $1,900; motorbike rental 9,300 yen; map to the Great Wall of China, 47 yen; crossing #6 off your list of places to see...priceless.

Budweiser How do you coin a **catch phrase** that becomes a part of the popular culture? The saying **"Whassup"** has joined the **ranks** of popular phrases like **"Where's the beef?"** to take on a life of its own beyond advertising.

The story of how "Whassup" became so popular started years before it was ever in an advertisement. It began in 1986 with Charles Stone III, at a time when he was simply a young college student with a group of friends who started greeting each other with the phrase on the phone. It was one of many rituals and greetings among the friends, lasting around six months. It might have lived and then died forever at the end of that time, but Charles jotted it down in his sketchbook, knowing he'd use it for something in the future.

The future was a while in the making. It wasn't until 1996 that Charles wrote the script for a short film he titled *All in the Family*. Since he was by then a very successful music video director, he would fit in the making of the film between other gigs. It took another three years before the two-and-a-half-minute short film was shot and edited.

Enter into the picture Vinny Warren, a copywriter at advertising agency DDB in Chicago working on the Budweiser account. It was, in Vinny's mind, a huge opportunity. To him, the entire beer category was lagging in its advertising effort, especially compared to what beer advertising was in Europe. In the U.S., says Vinny, "Beer advertising still tended to be about happy, smiling people drinking the product." Plus, Vinny himself was a Bud drinker, and his inherent love of the product made him enthusiastic about communicating its merits.

Vinny firmly believes that Budweiser's brand is well and truly built, and is at its heart an American beer. To not take advantage of that would be foolish. But at the same time, he didn't want to do a commercial that resembled other beer ads. He felt that beer should be incidental to people's lives, not be their whole life. It's a common mistake that advertisers make, says Vinny, to try to make their product seem as if it will miraculously change someone's life, make them more popular, more glamorous, happier.

◁ According to copywriter Vinny Warren, to catch on, a saying needs to meet just two criteria: It has to be something people want to say, and it has to have some obvious application in their lives. Following up the success of this formula in the original spot, "Girlfriend" was shot as the first spin-off.

So Vinny set out on a quest—to find things in the popular culture that could be associated with Budweiser, that shared its values, that would be interesting and involving to the consumer.

As Vinny puts it, he looked at everything as a potential Bud ad. At a party, at a movie, meeting a friend, he'd ask himself if that moment would be appropriate. "At breakfast, I'd look at a muffin and ask, 'Is that a potential Bud ad?'" He was only half-joking.

One day he was talking with a good friend, TV producer Carol King. They happened to be talking about the role of African-American culture in fashion. And during the course of the conversation she suggested he check out a short film she had seen called *True*, which was Charles Stone's *All in the Family*. So check it out he did, albeit a little reluctantly. "I thought it would be a long and boring twenty minutes or so," explains Vinny. "Instead it was a very cool and funny two-and-a-half minutes."

So when Vinny asked "Is there a Bud ad in this film?" he found he had to believe there was.

After seeing the film, Vinny and Carol discovered themselves doing exactly what Charles had done fifteen years previously—greeting people they knew with a long, drawn-out "Whassup!" As Vinny tells it, "I think we were the first white people in America to do that." The fact that they couldn't help using it as a greeting started Vinny thinking that it could catch on.

Vinny had only one fear: "If it didn't take off, we would have looked kind of stupid. We banked everything on the contagiousness of the saying."

But it was a well-calculated risk. According to Vinny, in order to catch on, a saying needs to meet just two criteria: It has to be something people want to say, and it has to have some obvious application in people's lives. And it wasn't the first time Budweiser would have a saying adopted by the general public. In the 1990s, "I love you, man" caught on for Bud Light.

Next step: tracking down Charles and asking him to let them use the film for a Budweiser commercial. Timing helped: While *True* had been extremely successful in the independent film awards, its PR value was starting to fade. But Charles was understandably reluctant to take his film commercial. Not only was it an extremely personal project, but also as he puts it, "I was really afraid they would take the idea and flatten it to make it more accessible to

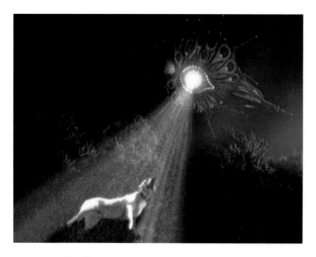

the masses." In a conference call with the creative team, they assured him of their intention to maintain the integrity of the original film. But what finally swayed Charles was the advice of a lawyer, who said either you do it and put your best foot forward and get things worked out, or you run the risk of someone taking the idea and changing it just enough to be legal and doing a bad job on it. Charles agreed to the idea.

The production of the spots began, and Charles admits it was "pretty cool." Vinny would write the spots, then send them to Charles, who would rewrite the dialogue while keeping the essence of what Vinny wanted to accomplish.

The concept of what can happen when you "sell out" became abundantly clear in the process of casting for the spots. Originally Budweiser wanted to create a multiracial cast. Charles's first reaction was "Oh, that figures." But he realized it wouldn't be fair not to at least try it and see if it worked. They auditioned more than 300 people. On the last day, Charles brought in the original cast plus some friends from Philly. Everyone fell in love with them. Vinny adds that in the end, he thought it was "very brave of the brewery to keep the same cast. It wasn't really their exact demographic."

Once the commercials were shot, the plan was to save it to air right before the Super Bowl. But the client saw it and loved it so much that they wanted to put it on the air immediately. Even August Busch IV himself did an informal focus group in a bar and found that everyone loved it.

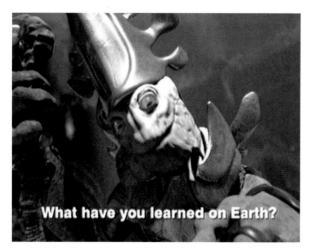

What have you learned on Earth?

In this commercial that ran during the Super Bowl, a dog is seemingly abducted by aliens. As it turns out, the dog is really an alien in disguise. When asked what he has learned on Earth, the alien sticks out his tongue and gives a resounding "Whassup."

They auditioned more than 300 people for the "Whassup" spot. On the last day, filmmaker Charles Ston III brought in the original cast plus some friends from Philly. Everyone fell in love with them. Vinny adds that in the end, he thought it was "very brave of the brewery to keep the same cast. It wasn't really their exact demographic."

From the moment it aired, Vinny watched it catch on in an almost dreamlike fashion. "Oh my god," he kept thinking, "this is working out."

The public caught the "Whassup" craze and the press did as well. Staid *Newsweek* did an article on it. ESPN guys were shouting it all over radio. But the one medium that no one had counted on as a facilitator was the Internet. One day at work, someone ran up to Vinny yelling, "You gotta check this out." The first parody had appeared. In all there were about seventy parodies, all spread via the Internet. In one of the most popular ones, you could learn to say "Whassup" in thirty-six different languages. People were putting "Whassup" parodies on their own sites just to drive more traffic to them. There was even a site that taught people how to do "Whassup" parodies because people were starting to do ones of questionable quality.

The Internet also helped propel the campaign internationally. The campaign became a worldwide hit even before it officially aired anywhere outside the United States. It became a huge hit in France even though France generally doesn't like beer advertising. In Germany, where they don't even allow Bud advertising, it was also a hit. In England at V2—the Virgin-sponsored music festival held in Staffordshire and Chelmsford—where it first broke, 60,000 fans started cheering the moment it appeared on the screen. Eventually it aired in England, Ireland, Spain, Greece, Argentina, and Japan, and was a success in all of them.

Vinny feels as if the real hero in all of this was the client. "There could have been a million reasons to kill the campaign and yet the client didn't mention one of them," says Vinny. "For example, we found out early on that the campaign didn't test well with people older than forty. When the clients at Budweiser found that out, they didn't even flinch."

As for where it will go from here, Vinny is hoping to keep doing more. "We have to keep being media savvy so we don't run out of steam. It's tempting to look at the campaign and think it was lucky. But in fact the only lucky thing was that I saw the short film just when I did. The rest of it was a lot of conscious decision making, hard work, and the collective approvals of a very brave brewery."

The one medium that no one had counted on as a facilitator of the "Whassup" craze was the Internet. The first parody quickly appeared online, to be followed by about seventy more. So Vinny and the team jumped on the bandwagon and parodied their own spot with "What Are You Doing?" which replaced the original cast with a bunch of yuppies in tennis whites.

Altoids If there's **one thing** to be said about **Altoids** advertising, it's that it **revolves** around a **curiously** strong campaign.

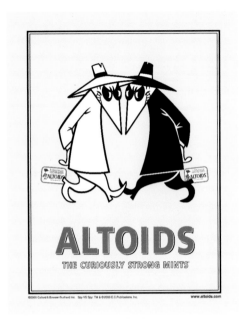

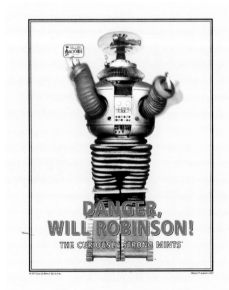
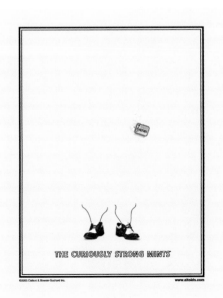

Now in its seventh year, Altoids has risen through the ranks of mints to be the number one peppermint around, not to mention as common a household moniker as Kleenex, Xerox, Windsurfer, you name it. There's no question what's up for grabs when someone offers you an Altoids.

Stefan Postaer of Leo Burnett, Chicago, has been the creative director—or principal architect and primary gatekeeper, as he refers to himself—on the account since the campaign's inception, and he parallels the advertising success with that of Absolut vodka. "They are the only two print campaigns that have done so much for one brand. Both are obscure, foreign brands envied by Americans, with interesting packaging and a print ad campaign executed with an extremely consistent, bold, graphic look and feel." There the comparison ends, as one certainly wouldn't throw Altoids in with a mixer.

Though eager to embrace the creative opportunity of such an intriguing product, Stefan recognized the value of the tag line the original copywriter penned some 150 years ago that was, as it is now, "curiously strong." Although coming dangerously close to taking a stab at a new line, he admits that "The words were written beautifully and there was no need to rewrite them. The smartest thing I did as a copywriter was knowing what not to write." And so "curiously strong" became the cornerstone of the campaign from beginning to end, determining strategy and copy platform and defining the brand by ads that measured up to two simple and succinct criteria: being both curious and strong.

Among other elements, the campaign's real appeal comes from the nostalgic childhood notes of Americana: old valentines, toy battleships, robots, dolls—things that people can relate to from their youth and still fall into the "cool" category.

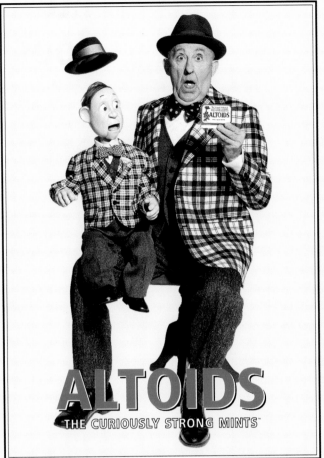

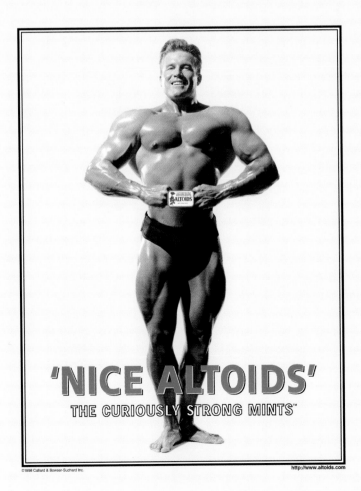

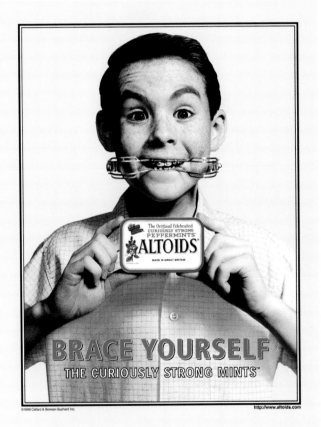

"We uttered the words 'curiously strong' and opened a Pandora's box. Strong men and robots came flying out. We knew we were on to something huge," muses creative director Stefan Postaer.

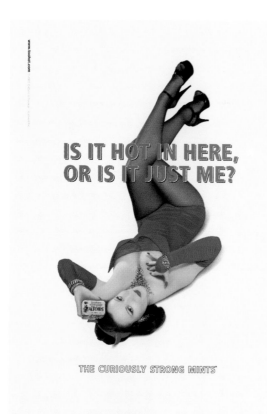

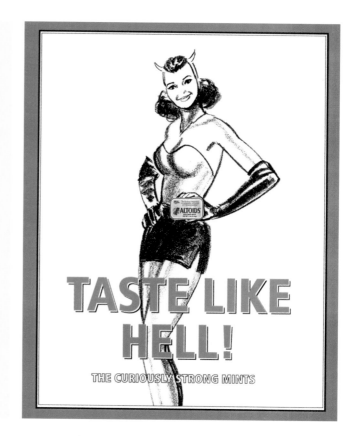

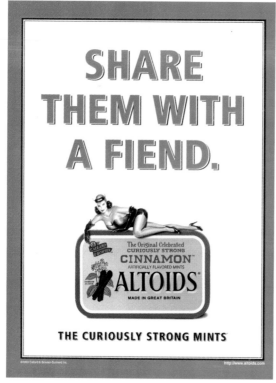

Stefan recalls the incredible popularity of the ads. Even as recently as last year, Sindy—the femme fatale of cinnamon Altoids—was one of the trendiest Halloween costumes to be found.

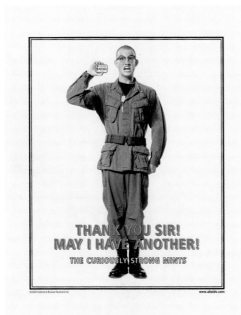

THANK YOU SIR!
MAY I HAVE ANOTHER!
THE CURIOUSLY STRONG MINTS

Art director Mark Faulkner instinctively chose the unusual color scheme that fostered the hip retro vibe of the campaign. But, he claims, "It's not just the '50s look. It's the '30s gym locker, the '50s steel nuts and bolts, the '70s comic book. It's the century of progress, not tied to any one year or decade."

Stefan remembers how "When we started on the account, Tic Tac and Dynamints were what people carried around in their pockets; Altoids wasn't even on the radar." Well at least that's what they thought until they started researching and found one little blip on the screen: Seattle. "Here was a culture that gave us Kurt Cobain and Starbucks, the stuff of popular culture. We realized we had to be just as hip, cool, and aware as our customer."

Using intuition and observation, Stefan and art director Mark Faulkner skipped the demographics, market research, and focus groups and went to it like Don Quixote at a windmill. "We uttered the words 'curiously strong' and opened a Pandora's box—strong men and robots came flying out. We knew we were onto something huge," Stefan muses. With few people at the agency interested in the project and even fewer to answer to, Stefan and Mark took the opportunity to run with it. "The monsters and characters were coming to us so fast, we were able to sell wonderful things that might otherwise have died under the weight of paranoia and criticism."

Mark instinctively chose the unusual color scheme—a look Stefan says was "totally him"—which fostered the hip retro vibe of the campaign. But, Mark claims, "It's not just the '50s look. It's the '30s gym locker, the '50s steel nuts and bolts, the '70s comic book. It's the century of progress, not tied to any one year or decade." Among other elements, the campaign's real appeal comes from the nostalgic childhood notes of Americana: old valentines, toy battleships, robots, dolls—things that people can

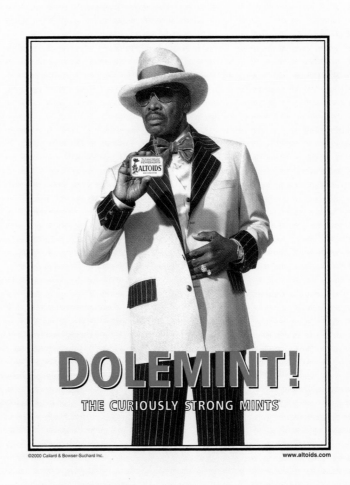

DOLEMINT!
THE CURIOUSLY STRONG MINTS

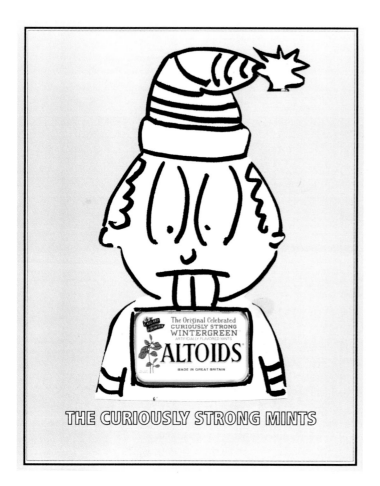

THE CURIOUSLY STRONG MINTS

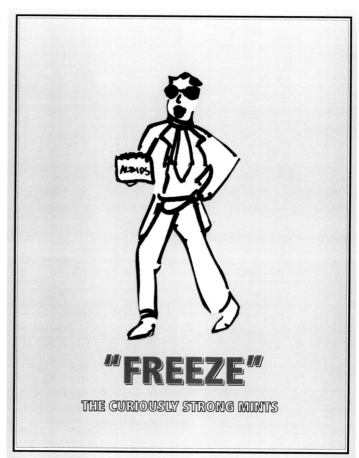

"FREEZE"

THE CURIOUSLY STRONG MINTS

relate to from their youth and still fall into the "cool" category. After all, not every CD can claim that "Quentin Tarrantino was all over it" or that people were trying to pimp faded stars into the campaign.

So how did response measure up? Phenomenally: with twenty, thirty, forty percent gains in sales. Even Stefan was compelled to admit that "The results were bigger than my own massive ego." Not surprising, considering that shortly after the first print ran he went to the local package store for some cigarettes and found that the owner had framed the outdoor posters and hung them in the store. Soon afterwards, Sindy—the femme fatale of cinnamon Altoids—was one of the most trendy Halloween costumes to be found. He recalls the incredible popularity of the ads from the very start: "I remember the account person ran into my office way back when. 'Jesus Christ,' he said. 'The client just called and said people are stealing the ads. What do I tell him?' I replied, 'Tell him to thank his lucky stars.'"

When presenting ads to the client, the comps could be as simple and iconic as the ads themselves. "The characters were coming to us so fast, we were able to sell wonderful things that might otherwise have died under the weight of paranoia and criticism," notes Stefan.

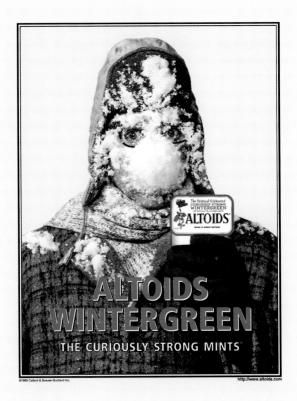

Contemplating the huge success of the campaign, Stefan recognizes that Altoids is by large an English-speakers phenomenon, mostly due to the fact that the words "curiously strong" don't translate to the same meaning in other languages. "I'm of the opinion that there is no such thing as a global advertising campaign. To try and market one product in different cities and cultures is just about impossible."

At the end of the day, the team is still wonderfully satisfied—especially since their initial mission statement acknowledged the following: "We owe it to the customer to do it in a cool way. And you owe it to yourself to do something interesting, to do ads that stimulate the culture rather than degrade it. Terrible ads work but they make the world a crappier place. I can sleep at night thinking at least I totally didn't muck up the world."

Gotta wonder if there's a little tin under Stefan's pillow.

American Legacy "Truth" How do you take an **addictive** behavior as **difficult** to change as **smoking**, and convince people to **stop?** How do you create a **brand** around the **simple and powerful** word: **"truth"?**

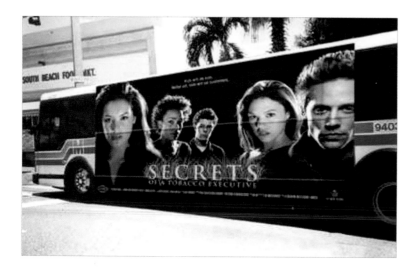

⊘ Top: One of the most compelling efforts by Crispin Porter & Bogusky was a trailer for a movie. It aired in movie theaters as a preview because the agency discovered that to reach teens in the summer via any other medium is nearly impossible. The campaign also included movie posters that hung in the lobbies and were slapped on the sides of buses for more visibility.

⊘ Bottom: Crispin Porter & Bogusky of Miami had the Florida Department of Health as their client and they had been working on the "Truth" campaign down there. When the two agencies were put together on the national antismoking account, Truth became the slogan for all of the work.

Picture this: You are walking down a sidewalk in downtown New York. Suddenly a couple of vans pull up next to you. Dozens of young people pour out, obviously on a mission. Some are carrying video cameras. Some are carrying...you do a double-take, but no, you're not mistaken. Some are carrying body bags.

Two great creative agencies, with two great creative directors, given the same exact problem, came to an extremely similar, big-picture answer about how to get people to stop smoking. The answer was to create a brand that was cooler than the brands the cigarette companies had created.

You're on the street corner because you have just been shopping. You check around wildly to make sure nobody's out to hurt anyone. Then you ask one of the people hauling the body bags the only question you can possibly ask, "What are you doing?"

America was founded on tobacco. It's how the country was financed. For years and years politicians were too afraid to attack it. No one, really, had done anything about it. The tobacco companies were simply too powerful. Even though it was proven time and again that tobacco companies continued to market and sell cigarettes they knew were harmful, no one tried to stop them. No one had created a big tactical effort to go out and simply tell people the truth in a compelling way. So finally, Arnold Worldwide of

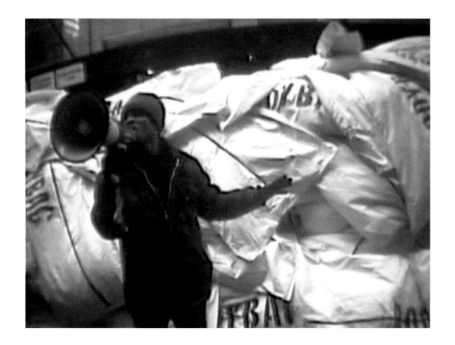

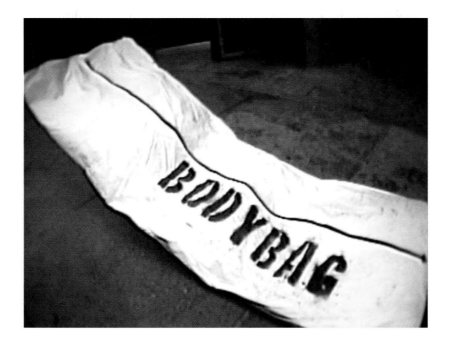

Ten employees of Philip Morris applied for mental health counseling after they saw the 1,200 body bags piled up outside their offices. It was the first time they were shown so dramatically just how many people die every day from smoking cigarettes.

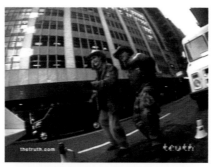
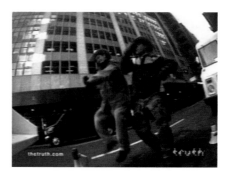
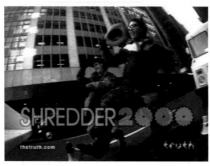

Both "Body Bags" and "Shredder 2000" were shot on location in one day. No rehearsal, by the seat of their pants is how they pulled this off. They needed several video cameras to get everything on tape. They even had two kids infiltrate the building with hidden cameras.

Boston and Crispin Porter & Bogusky of Miami reached the same conclusion: If the tobacco company is all about lies, the antitobacco brand needs to be all about the truth.

As surreal as it seems to you on that city street, the explanation appears valid enough. These people are placing the body bags in front of the headquarters of Philip Morris. They want to make a visual statement about the fact that smoking kills 1,200 people every day. They need to drive home the fact that 1,200 people dead every single day is a lot of people. These people are making a commercial.

Just telling people that cigarettes are bad seems to have an adverse effect on actual behavior, especially when it comes to teens. It gives them a concrete way to rebel, and thus gives them a reason to smoke more. No wonder the tobacco companies agreed to millions of dollars' worth of settlements for advertising efforts directed at smokers. They probably figured that the ad agencies would simply tell teens not to smoke, which in turn, the tobacco companies might have surmised, would get them to smoke more.

You ask your second simple question of the day. The question is, "Can I help?"

The Truth brand started because two different agencies surmised that kids would start to get pissed off when they realized that they were targets of cigarette companies. The agencies realized that kids are smart enough to draw the conclusion that tobacco companies are manipulating them in the very way they hate to be manipulated. The "Truth" campaign gave them a way to rebel that doesn't involve lighting up a cigarette. It was not just anti-smoking, it was antitobacco industry.

You put down your shopping bags and start stapling signs on telephone poles. The signs say simply, "Every day, 1,200 people die from tobacco. Truth." You stop for a moment to turn around and stare as the body bags pile up.

Research showed that Truth as a brand had an 85 percent awareness level in just one and a half years.

Later, much later, you find out that ten people working in the offices at Philip Morris that day had to apply for mental health counseling. You are glad to have been a part of the "Truth" campaign. With one simple act, it is apparent you have helped to do some good in the world.

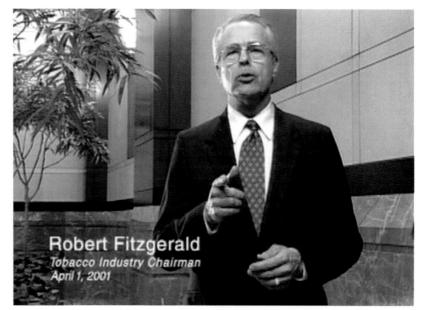

> This commercial featured a "representative" of big tobacco who comes on screen and admits that there *are* toxic poisons in cigarettes and anounces at *all* cigarettes are being pulled off the shelves until there is a solution to all the deaths related to smoking. The kicker? The words April Fools appear on screen at the end of the spot. This commercial was designed to run, not surprisingly, on April first.

Robert Fitzgerald
Tobacco Industry Chairman
April 1, 2001

Down in Florida, a similar type of uprising was happening. The agency down there, Crispin Porter & Bogusky, was also creating a powerful brand, a brand that was also called Truth. Originally they had called their brand Rage. But research showed that kids of this generation just don't have rage. What they have, instead, is a genuine feeling of surprise when told the truth about how tobacco companies operate.

The campaign done in Florida was tactically different but had similar effects to the one being created 1,500 miles away in Boston. It changed people's perceptions almost overnight. One of the most compelling spots appears to be a trailer for a movie. It aired in movie theaters because the agency discovered that to reach teens in the summer via any other medium is nearly impossible. So once they knew the best way to reach teens in the summer was to get to them in movie theaters, the idea of making a commercial that actually appeared to be a movie trailer seemed natural. The campaign also included movie posters that hung in the lobbies, with credits such as "featuring Greedy Executives, a huge Death Toll, and Original Score by The Whistleblowers."

Two agencies. Two campaigns. One brand. Phenomenal results. It's interesting to note the mission Arnold Worldwide had at the outset, when they were first pitching the account. They created a video that ended with the words, "Years from now, when our grandchildren look at us and say, 'In the war against tobacco, what did you do?' we want to look them in the eye and say, 'I was in advertising.'"

Škoda There was a **joke** making the rounds about the **car** brand **Škoda**. "How do you **double the value** of a Škoda? Fill it up with **gas**."

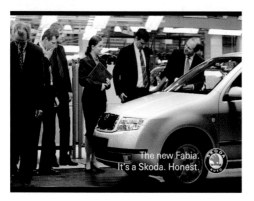

⊘ The factory is in the Czech Republic (Mladá Boleslav), where they make the Fabia, and in fact where they make virtually all Škodas.

The jokes were cruel and ever present. "Why does a Škoda have a heated rear window? To keep your hands warm when pushing it." How can you possibly overcome such a negative perception with mere advertising?

Chris Hirst, the account director, paints a decidedly unrosy picture of the marketing landscape surrounding the car. "Škoda has a very high level of awareness in the U.K. Unfortunately, it has about as bad a reputation as any brand can have. I have done this case study for a lot of different people, and nobody in either the U.K. or the U.S. can think of a brand with such a bad reputation.

"It was so bad" Chris continues, "that some of the Škoda dealers we talked to told us stories of kids crying in the showrooms, begging their parents not to buy a Škoda!"

However, the good news was that they had been bought by Volkswagen in the early '90s, and VW had completely revolutionized the product. So even though their reputation remained at rock bottom, the product was at least as good—if not better than—the comparably priced competition such as Peugeot, Renault, Rover, and GM. What they had failed to do, despite significant ad spending, was improve their reputation; nobody cared how good the products were if it was a complete humiliation to have one in your driveway.

So the brief was decidedly simple: Relaunch the Škoda brand. And do this by using the launch of their new supermini, the Fabia.

There was a bit of research done, but not much. As Chris explains it, "In a way we didn't need to—we knew exactly what people thought about Škoda: They hated it! This told us that the only way they were going to change this was by our taking some pretty radical action."

The agency came up with a simple but brave solution. They came right out and acknowledged the negative perceptions. The advertising campaign actually exploited the dramatic potential of "great car meets disbelieving public." So, television executions showed situations in which a visiting dignitary, motor show official, and parking attendant all fail to realize the car in question is a Škoda. Magazine and outdoor ads featured lines such as "It's a Škoda, honest!" and "No, really."

The television spots needed to be produced flawlessly to get people to buy into them. "We did spend a lot of time casting, as the scripts are very subtle," explains Chris. "To work they needed to be just right and that demanded people who look believable and could really act."

In "Motor Show," they actually changed the casting on the shoot day. The spot depicts an official at a car show watching some men lowering a Škoda car onto a podium. He is aghast: "What do you think you are doing?...They're going to be dead chuffed when they see their car on the Škoda stand, aren't they?" The reaction shots of the men lowering the car speak volumes. The spot was initially scripted as one actor playing the official and one actor lowering the car. Both the actors were English and were flown out for the shoot, which was held in Prague. What happened next was serendipity. "The set was being built by these fantastic-looking Czech guys, and the creative team thought, 'Let's try it with them instead,' so that's what we did. So all of the guys lowering the car are the Czech set builders. Not one of them spoke a word of English, and they look confused because they genuinely are—they didn't have a clue what was going on or what the guy was saying to them. In fact, at times they didn't even know they were being filmed!"

In keeping with the subtle approach, the director was looking for very natural performances. Overt comedy, it was felt, would take away from the believability. The spots feel unhurried and include difficult silences and pauses. The feeling of total bafflement that comes with discovering such a nice car is indeed a Škoda is complete.

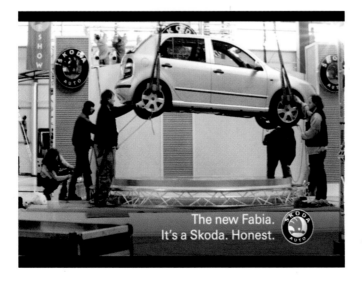

The new Fabia.
It's a Skoda. Honest.

The campaign took around nine months to produce, from creative brief to on-air television spots.

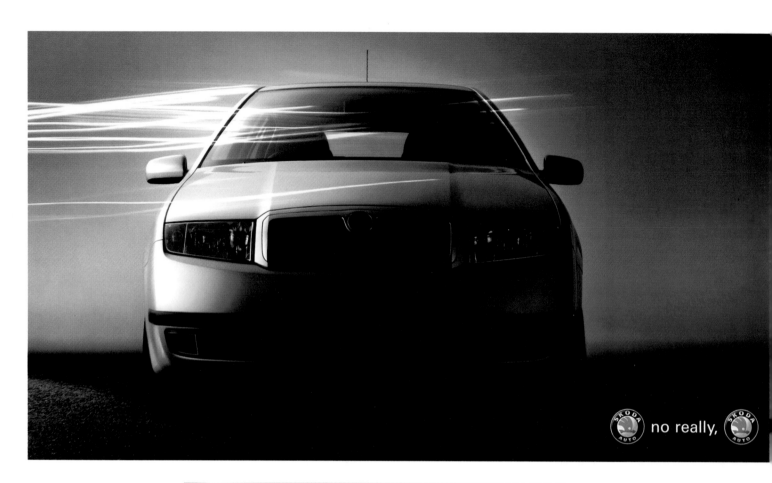

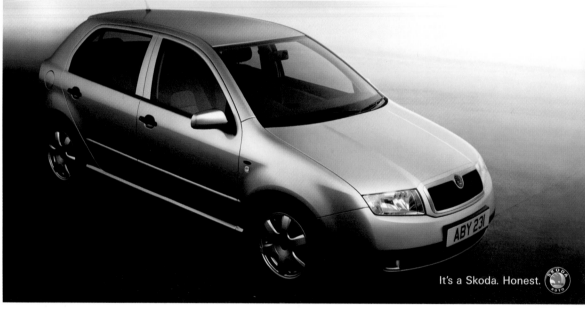

It's a Skoda. Honest.

The complete copy on the print ad reads, "We didn't use special camera lenses to make it look good. We used a billion pounds worth of research and development, and we used a man called Dirk Van Braeckel, one of the world's finest car designers."

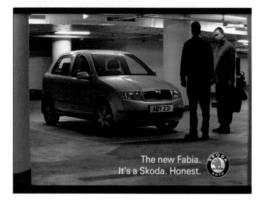

The new Fabia.
It's a Skoda. Honest.

In this spot, a parking garage attendant believes that a vandal has mischievously placed a Škoda decal on the hood of a man's new car.

SCRIPT
"Vandal"

We open on a normal-looking man, an office-worker type, walking into a car park, whistling.

He stops whistling when he sees, at the far end of the car park, a figure hunched over the bonnet of a car.

Our man frowns and walks quickly toward the scene.

The man hunched over the bonnet straightens up quickly. We notice that he is, in fact, the humble car park attendant.

MAN: Excuse me, what's going on?

The man is nearly at the car now. The car park attendant looks concerned and worried.

CAR PARK ATTENDANT: I'm so sorry. It's your new car, sir...

MAN: Oh no, what's happened?

CAR PARK ATTENDANT: I just noticed as I was doing my rounds.

The man looks at the car and back to the attendant.

CAR PARK ATTENDANT: I'm afraid some little vandal's stuck a Škoda badge on the front of it, sir.

We end on a wide shot of the car with the two men beside it.

CAR PARK ATTENDANT: I'm really sorry.

SUPER: THE NEW FABIA

SUPER: IT'S A ŠKODA, HONEST.

Adidas

Adidas People who take the **sport of running** very **seriously** really are different. But the **irony** is that most **running shoes** are the **same**. "One might be a little **better than another**, but in the end, what a **runner** finds **works** for them is often a matter of **personal taste** and running **style**."

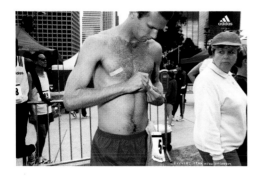

The art director swapped heads on the woman to the right with a head from a different shot. It was just a better, more subtle expression.

"In fact, once a runner finds a shoe he or she likes, they are likely to buy several pairs at once as insurance against the shoe company discontinuing a line," explain Sean Ehringer and Harry Cocciolo. "So how do we convince these diehard and not too adventurous runners that Adidas, the third-choice brand in the category, is worth a look?"

Adidas didn't have a category-changing technology. So the creative team decided to try to convince serious runners that Adidas understands them better than anyone else and hopefully, by doing so, get them to change their perception of Adidas from a second- to first-tier running product along with companies like Nike and Asics.

The creative teams came up with about five solutions. Some were about how runners are superior to the rest of us TV-watching, beer-drinking, fried-chicken-eating people. "Harry and I didn't find that funny, seeing as how we like all three of those things," says Sean. But two of the ideas seemed close. One was about how it felt to be a runner in a race, with visuals of dogs chasing after runners or saw blades nipping at runners' heels. They were full of metaphor and very striking graphically. The other was about how runners are just different animals with their own odd traditions and habits.

"The first idea died for reasons that frankly, I can't remember now," says Sean. "Whatever the reason, it was a good thing because it left us to focus on the 'runners—yeah, we're different' campaign, which we liked a lot."

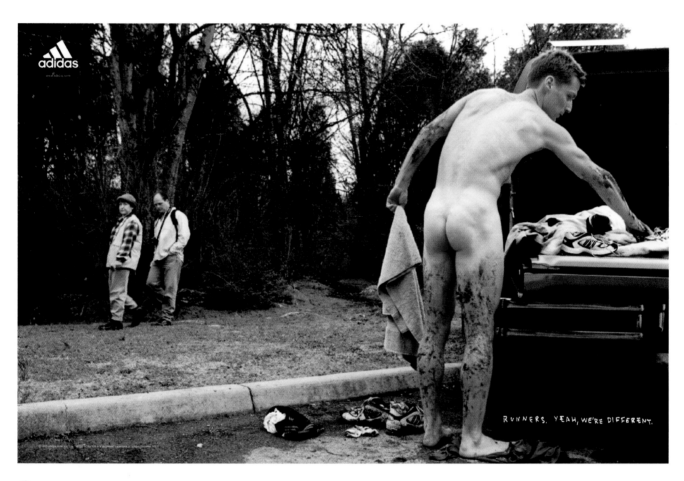

RUNNERS, YEAH, WE'RE DIFFERENT.

This campaign would only be as good as the runners' truths that were told.

© 2001 adidas-Solomon AG. Adidas and the adidas logo are registered trademarks of the adidas-Salomon Group.

This campaign would only be as good as the runners' truths that were told, so the first thing the team did was make sure that the things they would be talking about were really relevant and inside for the serious runner. They recognized that the ads might exclude a lot of average runners—and most of the nonrunners—but that was okay. In fact, that was part of the point, so to convince serious runners that Adidas understood them they had to do ads that could be done for only serious runners. Once about ten ads were done, they were tested against the scrutiny of serious runners.

Execution was very important for these ads to ring true. The creatives decided that since these runners' truths really happen, they should make the ads more documentary or journalistic. That meant they didn't have a lot of leeway in the angles and lenses. The shots had to look like a journalist just happened by and recognized a collision of two worlds, the runners' and the rest of ours. In the end, while the photos seem very natural, they were actually painstakingly crafted and styled. In fact, in the ad with a runner putting Band-Aids on, the art director swapped heads on one woman, the one to right, (see page 38), with a head from a different shot. It was just a better, more subtle expression. The response to the campaign was huge. Runners started talking about the ads on the Internet. Then they started sharing their own stories about being different, and finally runners adopted the expression "Yeah, we're different" to describe themselves on several runners' chat group sites. Adidas really set out to strike a chord with runners and get them to change their perception of Adidas. In the end, they did just that.

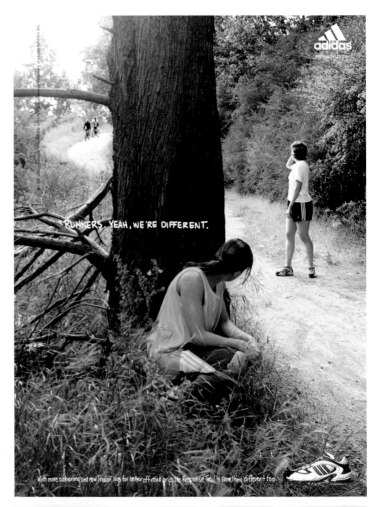

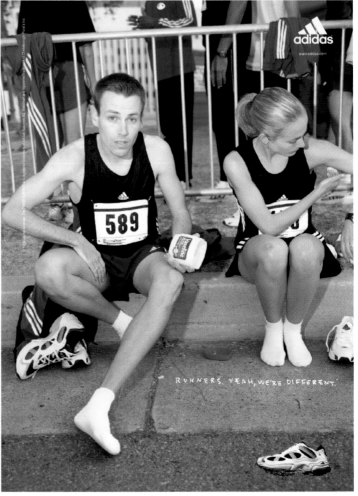

> Right and opposite: "Runners started talking about the ads on the Internet, and adopted the expression 'Yeah, we're different.'"

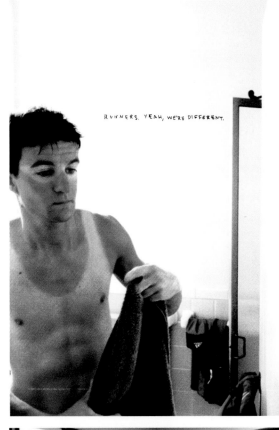

RUNNERS. YEAH, WE'RE DIFFERENT.

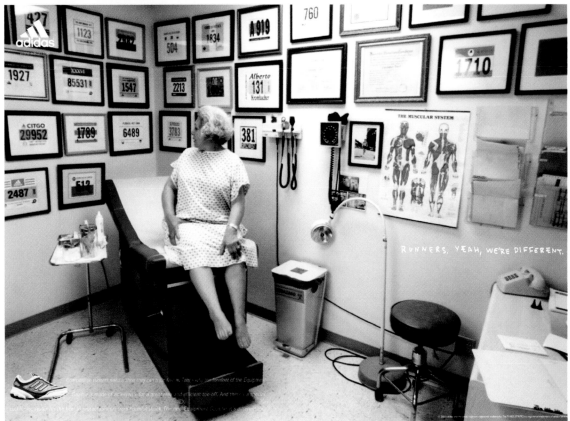

RUNNERS. YEAH, WE'RE DIFFERENT.

ABC Television

This is the **story of how ABC** (American Broadcast Company) became a **brand**. Until this **campaign**, there was a question as to whether a **television network** could even be **considered a brand**, or if it was **doomed** to be nothing more than a **logo**.

Do not disturb.

Unless you're that pizza guy.

abc

Alan Cohen, executive vice-president of marketing, advertising, and promotion at ABC, explains the situation at the time.

"Looking at the climate, I thought we really needed to do something dramatic to get on people's radar screens. Even though we were performing well with individual shows, we were not the number one network. We had been doing what everyone else was doing and it didn't make a dent. Just like the other networks, we had the smiling TV stars holding up the logo saying 'Brought to you by ABC.'"

So the charge went out. Three agencies would pitch the account, and ABC would create a campaign that would brand them in a way that no other network had before.

At the time Rich Siegel was creative director/copywriter at TBWA\Chiat\Day, Los Angeles. He recalls ABC approaching the agency and asking Lee Clow if he wanted to pitch the account. Lee, founder of the agency and creator of arguably some of the best advertising of all time, said, "Yeah, but not if it's going to be like typical network advertising." ABC executives assured him otherwise.

So Lee had a meeting with the creative department and said, "I know you've heard this from me before, but this time I really mean it. I really want you to really go for it."

The agency created five or six campaigns for the pitch. The campaign created by Rich and his partner, John Shirley, was clearly the most outrageous. The idea, boiled down to its simplest form, was to get the network to champion the idea of watching TV. The creative team took on what appears to be a universal truth—that people look down on watching TV. But actually, as Rich sees it, it's really one of society's dirty little secrets. People say they don't watch TV, or if they do admit to it, they qualify it by saying that they only watch "documentaries and PBS." But the reality is that almost everyone, at some time, likes to kick back and watch TV.

So they took what they knew would be a polarizing stance and said, "Let's celebrate TV for what it is! Let's just tell people that TV is really not a bad thing. ABC will be the champion of that." And after that, ideas sprang forth as though from a well.

◇ Once the campaign really got rolling,
the ads appeared everywhere—even
imprinted in the beach sand.

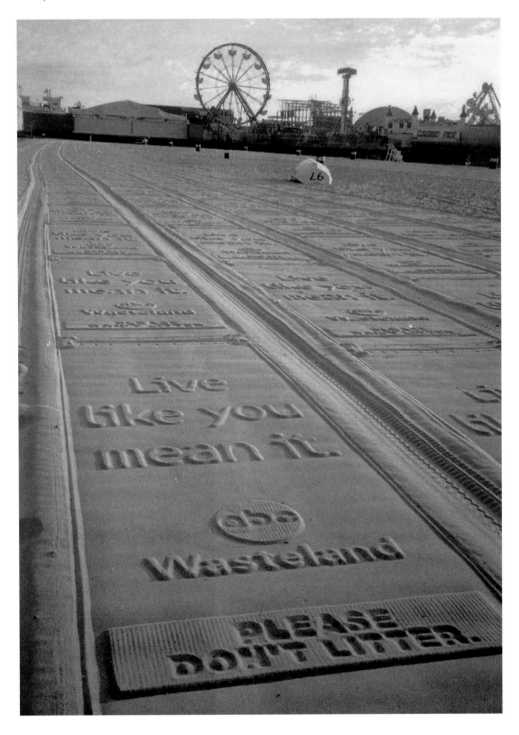

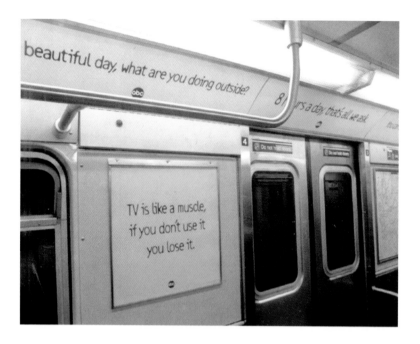

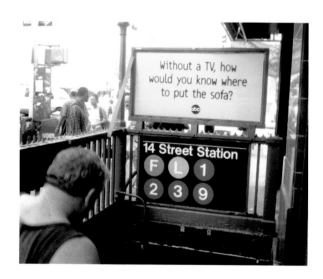

This page and opposite: Another form of marketing ABC and TBWA\Chiat\Day used is called guerilla marketing. A major outdoor media buy in cities such as Los Angeles and New York meant you couldn't turn a corner without seeing yellow.

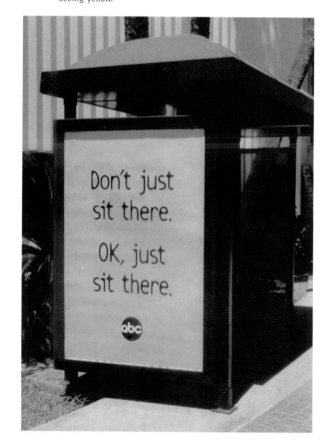

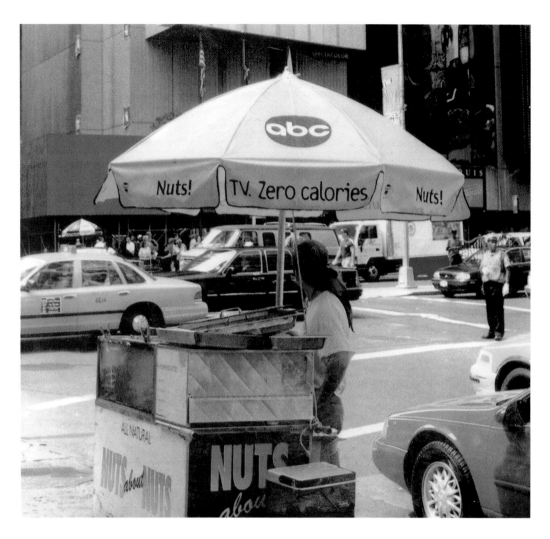

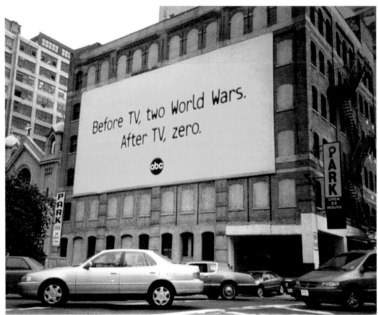

As soon as they got the idea, they wrote a couple of lines, and then Rich, the copywriter, jumped up and said to his art director partner, "Give me some templates!" So John scrambled to put some quick layouts together, and the art direction stemmed from the fact that, recalls John, "the first color on the menu of the computer screen was yellow, and there was the template."

The creatives then cranked out thirty or so lines. The one line that summed up the campaign—the creatives were quick to admit that it wasn't particularly profound or clever—was simply "TV is good."

Alan Cohen tells what happened at the pitch: "The day we walked into Chiat\Day, we knew they had nailed it with their idea of 'celebration of television.' Who else but ABC could really say that? Even though we weren't the number one network, we still reached more types of people than anyone else. No one else could say 'We love TV' the way we could." And when Alan saw what they had done with the logo, he said "this should be the way we use the logo, in the classic form that Paul Rand created it in."

Although the client was gung ho right from the start, the campaign still needed approvals by all the usual layers that are in place at a multimillion-dollar organization. The approval process needed to start with a small, select group, and then be sold all the way up to the highest-ranking officials. Luckily, says John, "people laughed all the way to the top."

So the pitch was won, and the agency and creative team got to produce the work. Soon after the campaign broke there was an op-ed in *The New York Times* wondering, "How dare anyone say TV is good," and that seemed to set off a PR firestorm. Not a day went by without the press calling. Rich couldn't even take a paternity leave because the press was hounding him so much.

There was the whole outdoor campaign, but there was also a TV branding campaign about a guy on the network who's the "TV enhancement guy." He tells people how to get a better TV viewing experience—how to adjust color, for example, or in one spot he comes right up to the camera to wipe the lens. There were also commercials that celebrated television icons like the Barcalounger and the TV tray. It all tied together because the real beauty of the campaign was that anything about celebrating TV would work.

In the end, there were some campaign ideas that didn't make it because they were too provocative. One unsold headline said, "The whales can save themselves." The creative team also had one idea to take out a full-page ad in *The New York Times Book Review*. The ad would have a small headline stating that "Reading is overrated," then 6,000 words of copy and another line that basically said, "Well, look, you just skipped over all that copy and helped us prove our point." It didn't make it.

Although the campaign ran in all sorts of media, the outdoor was the most visible—you couldn't walk down the streets of New York or Los Angeles without seeing a bright yellow board. And as part of a grassroots effort, ads appeared on everything from hot dog carts to wastebaskets; they were even imprinted in beach sand.

Even the more traditional station promos incorporated the look and the idea that this was another funny moment from the whole ABC organization. As John puts it, "I can't think of a time a company has been able to own a color like this." But color was only the initial thing that happened. Soon the brand identification grew to include, among other things, a four-note sound and black-and-white photography. Such a huge branding effort takes time. As Alan notes, "In order to seamlessly integrate everything we were doing, it took a couple of years to really gel."

As for results, Alan notes that the campaign registered most with the 18-24 age group that ABC was going after. NBC parodied the campaign, which gave ABC even more credibility. And Alan notes, "Our competitors were angry we were getting so much attention." But in fact, one of the most rewarding comments the agency and client got was when someone said, "Why can't the television shows be as funny as the advertising?"

The advertising blitz hit everything from coffee travel mugs to produce in local grocery stores.

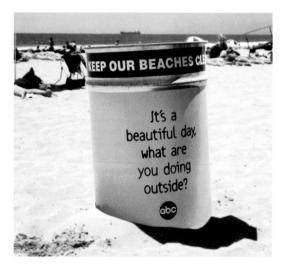

"These were out on trash cans all along Santa Monica Beach. A brilliant piece of media placement," according to John Shirley and Rich Seigel.

"The first color on the menu of the computer screen was yellow," said John Shirley, art director at TBWA\Chiat\Day, explaining how he started to develop a template for the look of the advertising.

Hello? It's free.

Marry rich.
Kill husband. Repeat.

Tonight, we're gonna sit like it's 1999.

Molson Canadian It's **safe to say** that most **beer commercials** are guilty of **showcasing** only **one thing**. **Beer**. And then there's **Molson Canadian**, whose ads serve as a **tongue-in-cheek** national tribute **instead**.

To pull off the "Rant" spot, Glen knew "casting would be a huge part of the success. Everyone loved this guy Jeff Douglas. He was the quintessential Canadian. Nice smile, proud but humble. Good-looking but not too good-looking." He was so perfect in fact, that after the spots aired, he became an icon known as "Joe Canada."

Glen Hunt, copywriter and creative director at Bensimon-Byrne D'arcy, had just moved back home to Toronto and had a chance to pitch the Molson account with a team of both Americans and Canadians. They went into it with about thirty-six spots, trying to revive the old tag line "I am Canadian" that had been dropped by Molson a while ago. "We thought that instead of walking away from the line, they should just have a new strategic way of looking at it."

Which is where Glen's experience as a Canadian living in America for the previous three years came into play. Reflecting on his life as an ex-pat, he admits, "I knew how Americans perceived us and some of the misconceptions they had about us. 'The Rant' spot was a manifest for all those misconceptions. I just sat down and started writing something that came from myself—it took about twenty minutes."

Paring the one minute and forty seconds of ranting down to a sixty-second spot was a greater effort, but one that also allowed Glen's initial concept to evolve. "The original idea was to just have the guy standing in front of the flag the whole time—to make it Canada's *Patton*. But we ended up with a video backdrop with visuals punctuating the copy."

The client loved the work, but as part of their company culture they needed to extensively test everything. Ten to fifteen spots were earmarked as favorites, and the client established a particular benchmark they had to pass in terms of purchase intent. So Glen and the team created animatics and started testing. "The Rant" was one of the hands-down winners, both in terms of purchase intent and consumer likeability.

But to pull it off, Glen knew, "Casting would be a huge part of the success. Out of forty other actors, everyone loved this guy Jeff Douglas that we'd used in the animatic. He was the quintessential Canadian. Nice smile, proud but humble. Good-looking but not too good-looking." He was so perfect, in fact, that after the spots aired, he became an icon known as "Joe Canada" because of a line in "The Rant" where he states, "I'm just an ordinary Joe." Yet the clients were still nervous that they hadn't done due diligence in the casting process and asked to see who else was out there. After an even more exhaustive search, "Joe" still came out on top, and the shoot was a go.

Crush, the image house, had been working right down to the wire to get the images they wanted behind the actor. Some worked wonderfully, others needed to be created on the spot.

SCRIPT
"Rant"

"Hey. I'm not a lumberjack, or a fur trader. And I don't live in an igloo, or eat blubber, or own a dogsled. And I don't know Jimmy, Sally, or Suzy from Canada, although I'm certain they're really, really nice. I have a prime minister, not a president. I speak English and French, NOT American; and I pronounce it 'ABOUT,' not 'A BOOT,' I can proudly sew my country's flag on my backpack. I believe in peace keeping, NOT policing. Diversity, NOT assimilation, AND THAT THE BEAVER IS A TRULY PROUD AND NOBLE ANIMAL. A TOQUE IS A HAT, A CHESTERFIELD IS A COUCH, AND IT IS PRONOUNCED 'ZED' NOT 'ZEE,' 'ZED'! CANADA IS THE SECOND LARGEST LANDMASS! THE FIRST NATION OF HOCKEY! AND THE BEST PART OF NORTH AMERICA! MY NAME IS JOE! AND I AM CANADIAN!

Thank you."

"Joe ran through the rant forty or fifty times and he nailed it every time." Glen recalls. "He had great energy. And we shot him at a lot of angles." The first day of production and they had the performance in the can; the following day was devoted to the background treatment, with Kevin Donovan directing. Glen recognizes, "He was incredibly collaborative, which is fantastic to find in a director."

When the time came to cut it all together, Glen was concerned. "Since we had shot it on green screen, it was all in bits and pieces and looked really flat. David, the editor, and I looked at it and said, 'Wow, this might be crap.'" Slowly but surely, however, the pieces came together, but not in time for the first client presentation. "I was afraid to show it unfinished," Glen admits. "I spent the first five to ten minutes of the meeting underselling it, telling the client how bad it looked." Despite the fears, the client saw the potential of the unfinished spot and approved it with very few changes.

Crush, the image house, had been working right down to the wire to get the images they wanted behind the actor. Some worked wonderfully, others needed to be created on the spot. Glen tells, "Where the script says 'peace-keeping, not policing' we tried a bunch of things, but none worked. Ten minutes before we had to show the spot to the client, David had the idea to show his fingers as a peace sign and as a gun. We did it right there on the camera stand in the edit studio, and I think it came out great."

Finally wrapped and ready, the "Rant" spot first aired during the Canadian equivalent of the Oscars, right after a song called "Blame Canada." "Canadians felt really good about the spot," Glen relays, "so we thought—what else can we do with this?" The idea of live cinema performances came up, where a backdrop was put up on movie screens and then Jeff, aka Joe, performed in front of the crowd. They were hugely successful.

With the smaller venue a hit, Glen and the team wanted to go bigger—ice hockey arena bigger. "We got Jeff to go out there, right on the ice," Glen recalls. "I was in a rink once when he came out and it must've been twenty thousand people who all started cheering so loud you could barely hear him. People were standing, applauding, and an incredible rush came over the entire place. It became gratifying to see how it became a part of the popular culture."

Part of pop culture indeed. Even without PR efforts, the spot started a trend on the Internet, inspiring people to write between seven and ten thousand rants—many surfacing as people's personal versions for their own foreign countries. And that was only the launch pad. "It got on radio shows all across the world," Glen beams. "TV interviews, *The Today Show*, *Good Morning America*. It seemed to capture a few people's attention along the way."

Following up this success came another spot destined for cult status. "No Doot Aboot It" was based on one of Glen's own experiences in New York, "working at an agency I'll keep nameless. One guy we'd nicknamed 'Spooky' was taking a riff at Canada. He was a tad younger than me, and like a brother I felt I could manhandle him a little." Pulling his shirt over his head and "jerseying" him into submission, Glen walked Spooky around from office to office—and later wrote the script for another memorable sixty-second spot.

A less significant spot than "The Rant" with a much smaller budget, Glen finagled a deal with a production house so they could shoot and test it. Casting it professionally, they went with an antagonist character with perfect hair and teeth—"a Yale or Princeton guy." The other actor in the spot had a much easier job; all he had to do was "smolder a bit."

Testing was a matter of gauging people's reaction to the spot as they watched and rated it on a one to five scale, from really disliking it (one) to really enjoying it (five). "You could see the curve as the spot went on. It'd start with people really disliking it, but then when our hero jerseys him it'd go up to five and people would start cheering." And with the client cheering about purchase intent and likeability levels, the team decided not to reshoot it and aired the original test spot instead.

Glen again drew on a personal experience for creative motivation when creating the "Here's to You" spot. He reminisces about being in Scotland and not having any "Canadian" songs to sing for the bartender upon request. Instead they sang rugby songs and one guy in his party stood up and recited some beautiful poetry. "So when I sat down to think about this spot," he tells, "I started writing all the things I love about Canada in a rhyming couplet."

Casting led them to a Scottish actor living in Canada who had an impressive Scottish brogue. Well, Glen admits, "That's not quite true. It was really a 'Scirish' accent." They shot him sitting in a pub, with cuts that illustrated the different things he was musing about—but in an offbeat way. They shot over four to five days at several different locations, finding different ways to capture unique images.

In retrospect, Glen relays how inspiration for "Here's to You" also stemmed in part from the fact that, as he puts it, "America is like a big brother to Canada. You feel like you're standing next to a giant and not being understood. In this spot we don't define ourselves by how the States think of us, but by who we are. One of the great things about Canada is that it's hard to define, and when you live here you can lose perspective on the great things about being Canadian. This spot is through the eyes of a new Canadian."

Obviously the eyes of the average commercial viewer liked what they saw. Once again, testing results and Internet response were off the charts.

So for producing creative we in advertising can stand by and be proud of—here's to *you*, Molson Canadian.

For the "Here's to You" spot, casting led the team to a Scottish actor living in Canada who had an impressive Scottish brogue. "One of the great things about Canada is that it's hard to define," Glen explains, "and when you live here you can lose perspective on the great things about being Canadian. This spot is through the eyes of a new Canadian."

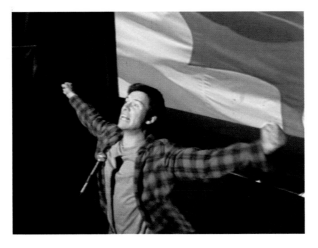

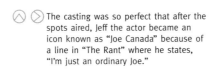

The casting was so perfect that after the spots aired, Jeff the actor became an icon known as "Joe Canada" because of a line in "The Rant" where he states, "I'm just an ordinary Joe."

GT Bicycles "If GT weren't making bikes, what would they be making?" That was the question posed to the executives of GT Bicycles during a brand-planning day. The answer stuck in copywriter Ari Merkin's mind. The answer was "fighter jets."

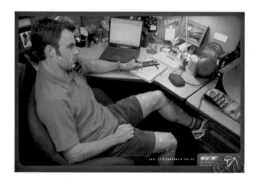

The strategy to be about speed prevailed into the second year of concepting and production, and the genius of the ads was in their astute simplicity; the "Shaving" ad was simply a guy in a cubicle with nicks and cuts covering his legs.

The people in this ad had to wear custom-made prosthetics on the bottom half of their faces. They then needed hours of makeup to make it real. "They had the stuff on all day. It was weird having lunch with them," says Alex Bernard. "They smiled all day long. And they could only talk with their teeth clenched. They would have to hold their fake teeth with one finger."

Opposite top: "'Sex' was the first ad in the GT series. The guy was a friend of the photographer who had two big nipple rings that we made him take off," says Markham Cronin, art director. "I'm most proud of the fact that we've made premature ejaculation something to be proud of," states Ari Merkin, copywriter.

Opposite bottom: "We had a real dentist, then brought in an actor as a dentist, but neither seemed to be working quite right. Then, as we were looking at the Polaroids, the photographer and I got these evil grins on our faces," says Alex Bernard, art director. "We asked the marketing manager of GT to step in, and he was perfect."

Ari goes on to explain the campaign's origins. "We didn't pitch the client, we were handed the assignment. The agency had lots of 'bike accessory' experience, but this was our first actual bike account." So what they really wanted to do was let people know GT was making some of the most kick-ass bikes in the industry. The bikes were really at the top of their game. They looked race-ready, looked great. There was a feeling that "the guy who makes the fastest bike wins," explains Ari. Alex Bogusky, creative director, adds, "GT was a very tight brief. We wanted to be about speed."

Ari elaborates, "It's not about making the bikes by hand. It's not about caring. It wasn't about making the frame by hand until you were bleeding. It was about machines and technology. GT had a machine that electronically built a bike right before your eyes. It all seemed very high tech, which was not a selling point people wanted. It seemed as if what people wanted was the story about two guys in a garage who carved out a bike by hand."

But the strategy to be about speed prevailed. The creative team did several campaigns with a number of different approaches. "When Ari first wrote the line 'Fast. It's corporate policy,'" says Markham Cronin, art director, "it was one of those 'Eureka!' moments. Ideas kept spilling out afterward." Alex remembers the

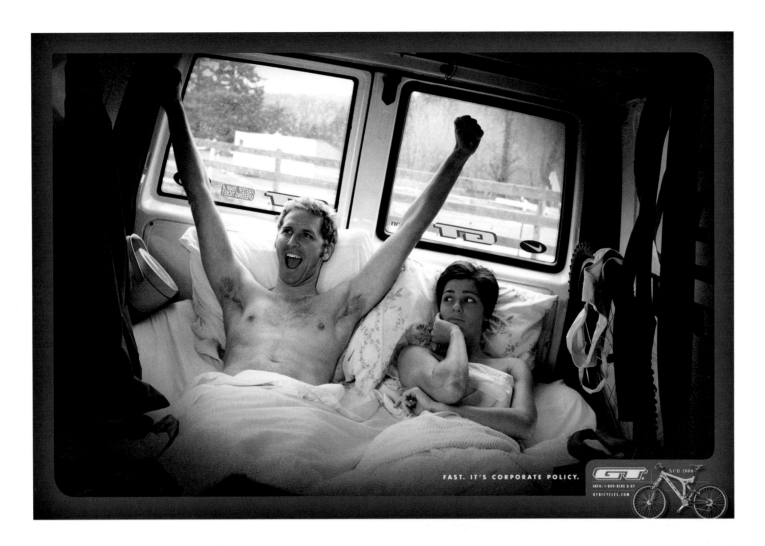

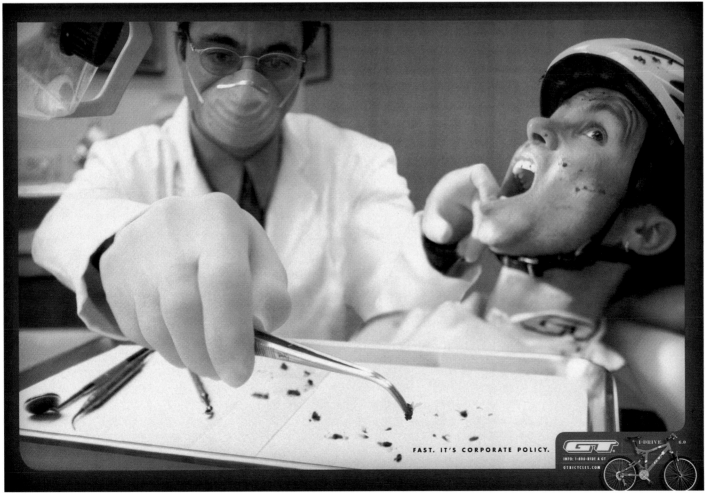

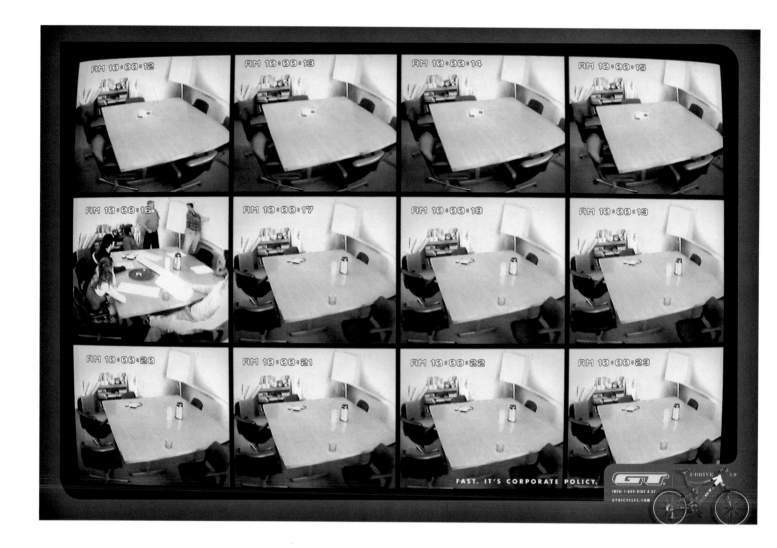

design taking a long time to get right. There was a lot of argument over whether that line should be the headline, a caption, or a tag line. The line started out as a headline, but the consensus was that it was more valuable as a tag line.

Alex notes that there was a lot of great work that probably was almost as good as this campaign, but this one won by a nose. It rose to the top because it rang true about what the brand was all about, and this campaign was not a hard sell. The client left the decision of what campaign to produce up to the agency. There was a slight argument as to whether to include the photo of the bike in the ad at all. The client was leaning toward taking it out, but the agency wanted the ads to appeal to everyone, not just people who knew about GT as a bike brand.

Alex says, "I think the feeling was it would be a very good campaign. But you worry because there was very little money to make it happen, and there are never any guarantees."

The relatively low budget meant that the creative team had to become very resourceful. Alex Bernard, who art-directed four of the ads, explains, "GT didn't have a lot of money and we made too many good ads. They only had money to do two, but we had four to six that we wanted to produce. But we always find a way." As

one example, most of the people in the ads were actual employees of GT. The marketing director became the casting director. That saved a lot of money on talent, which could then be put back into the photography.

The campaign didn't take long to garner some notice. In fact, the day the campaign broke, the CEO of GT, Andrew Harik, was at a bike convention. He came across a bunch of people looking at something, and he made his way in. It was the "Sex" ad. As he walked back across the floor, someone shouted his name. Andrew raised his hands above his head in imitation of the ad. The campaign had made GT a star.

"I went to the spy camera store and rented a spy camera for the afternoon," explains Alex Bernard. "I did a little underground scouting for a conference room. I rounded up four or five people and said I'd buy them lunch. Then I shot it, let the people go, and I did some variations with the props in the end frames. Despite the low-budget approach, it ended up being a lot of people's favorite ad."

"Getting the hallway right was hard. We needed to make sure it was dressed right, not overdressed," states Alex Bernard. "This is my favorite," adds Markham. "I like the purity. It's like a great Far Side cartoon. Every piece of information needed to tell the story is right there, but nothing else."

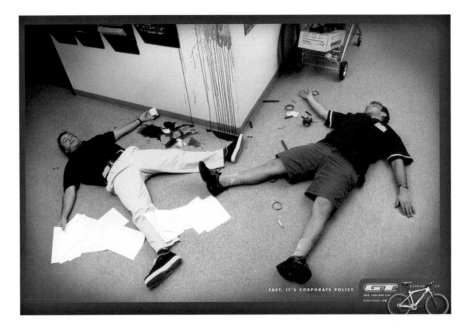

"This was shot at GT with all real employees," says Markham. "The lady in the foreground worked in the accounting department. She was upset because she was afraid people might think she really got a ticket. The cops were real. We rented them from the Santa Ana police department."

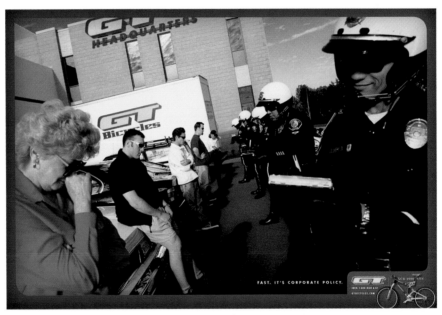

"When we did it for the comp, we just went inside our elevator, turned over on the floor, and put our feet up. To do it for real we built an upside-down elevator set and had the people do handstands," explains Alex Bernard.

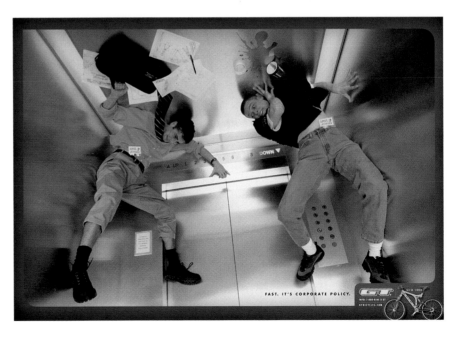

John Hancock "We never set out to cause a controversy," states Todd Riddle, creative director and art director of the television spot for John Hancock that shows a gay couple with their newly adopted baby.

So how is it that a simple thirty-second spot for an insurance company was the impetus behind forty thousand e-mails, a call from the Chinese government, a refusal to run the spot on the Olympics, and even a death threat?

"All we were trying to do was show that that's what's really out there. It sticks out because it's the truth." Todd is quick to point out that for every negative response, there were hundreds of positive ones. "Read some of the positive responses and you'd be amazed," he states. "There was an overwhelmingly positive response."

Great advertising takes courage, and luckily there was a client who most definitely has it. "Our client believes that if you're afraid of controversy, you shouldn't be in there," says Jonathan Plazonja, creative director/copywriter on the campaign.

Hancock has been running a campaign based on the theme "Real life/Real answers" for the past fifteen years. The campaign has always covered a wide range of real-life situations, and through osmosis people realize the company has products that would be appropriate just for them. The point of the campaign is to make everyone feel included. Hancock has a simple message that has helped build their brand over the years. It states, "We understand how you live. And we have a wide variety of products/insurance that helps you no matter how you live."

The challenge in this case was to make the campaign find a new, modern family. So the creative team traveled to San Francisco, Chicago, and Boston to do focus groups. They asked people "What keeps you up at night?"

There are a lot of really universal issues, regardless of income level, age, race, or gender. The health and happiness of your family, aging parents, and saving enough for college came up again and again. The challenge was to tell the exact same story in a unique way, in a way that says Hancock understands the world we live in today. Hancock had always done advertising that said in subtle ways, "We're not the same old insurance company."

The team felt they were lucky to be working with a great client who has a clear understanding of what makes people tick. The client, John Hancock CEO David D'Alessandro, said he wanted the campaign to be voyeuristic, like a fly on the wall, and to put things on TV that hadn't been seen before.

Script
"Immigration"

VIDEO
Two American women, Colleen and Rachel, are at an airport entering the United States through Immigration. Colleen is holding a Chinese newborn. Rachel struggles with their luggage and a pile of baby paraphernalia. There is a long line. Colleen looks at the baby. The line moves slowly.

AUDIO
SFX: Ambient airport sounds.

COLLEEN: This is your new home.

RACHEL: Don't tell her that. She's gonna want you to go back.

COLLEEN: Hi, baby.

COLLEEN: Do you have her papers?

RACHEL: Yeah, they're in the diaper bag.

COLLEEN: Oh, can you believe this?

RACHEL: What?

COLLEEN: This.

RACHEL: Yeah. We're a family.

SUPER: Annuities, Life Insurance, Long Term Care Insurance, Mutual Funds.

Colleen kisses baby.

SUPER: Insurance for the unexpected. Investments for the opportunities.

www.jhancock.com

The creative team found from the research that the traditional family is not that traditional anymore. So they set out to capture that in a way that was as real as possible. "The spot about the gay couple is really just about a family. You could have a man and woman saying that same dialogue, and it would still ring true," remarks David D'Alessandro in his book, *Brand Warfare*. "We are not saying, 'If you're a lesbian about to adopt a child, you need our products.' We're saying something much bigger: 'Whoever you are, we'll go out of our way to understand your concerns.'"

In the end, what that creative team really wanted to capture was that one small moment when it suddenly hits you like a ton of bricks that your life has changed in some irreversible way. And that moment that is so universal, the creative team thought, is when you suddenly realize you're holding the diaper bag—a big, pink, silly-looking diaper bag. It's a symbol—a symbol that you're crossing over to a new part of life.

Tony Kaye, who most recently directed *American History X*, was the director and cameraman. It was all shot with natural light—there was not one extra light bulb. He was chosen because, as Todd puts it, "He has soul. He gets the emotional angst, understands drama. He gets people." Tony also works very fast just trying to capture a moment. The adoption spot was literally shot in fifteen minutes. There were hundreds of extras in the Los Angeles airport, the baby fell asleep, and that fifteen minutes when the baby was sleeping was enough to shoot the entire spot.

The commercial certainly struck a nerve. The client received over forty thousand e-mail messages; the spot won the GLADD Media Award in Washington; the campaign was written up in *The Boston Globe*, *Washington Post*, *Entertainment Weekly*, *Chicago Tribune*, *USA Today*, *TV Guide*, *The New York Times*, *Adweek* best spots, and *CA annual*; and John Hancock got thousands of hits on their Web site. They spent a fraction of the money their competitors spent, yet got an estimated $10 million worth of free press to go along with it.

The death threat came from a white supremacist. And the call from the Chinese government was because Chinese adoption laws forbid adoptions by a same-sex couple. International adoption agencies worried that the commercial might prompt an official in China to clamp down on the number of adoptions of Chinese infants it permits. To be sensitive to that concern, the commercial was changed to include an airport announcement asking passengers from Phnom Penh, Cambodia, to have their documents ready. In the end, both creatives say it's the proudest work they've ever been associated with because it made a difference outside of advertising.

Script
"Tour"

VIDEO

Long shot down a hallway of Ben, a man in his fifties, getting a tour of a nursing home, guided by Mrs. Noble, a woman administrator. He is obviously very apprehensive about the whole experience.

They enter a room. It all feels very institutional. We see the view from the window.

AUDIO

SFX: Ambient sounds

MRS. NOBLE: We have a great Game Room... It's open from six to nine, but people can pretty much use it whenever they want.

MRS. NOBLE: And this is one of our rooms. And as you can see, all of them have a nice view over to the courtyard.

MRS. NOBLE: Is your father staying with you now?

BEN: No....

MRS. NOBLE (Finishing his sentence): No, he's not.

BEN (Off camera): So this is home, then, huh?

MRS. NOBLE (UNDERNEATH): Um-hmm.

BEN (UNDER): I just want to make sure he's well looked after.

BEN (UNDER): I mean, this...this could be his last move.

SUPER: Annuities, Life Insurance, Long Term Care Insurance, Mutual Funds.

SUPER: Insurance for the unexpected. Investments for the opportunities.

"Tour" shows a man looking for a nursing home for his aging father. In his book, *Brand Warfare*, John Hancock CEO David D'Alessandro states, "You will never be memorable if you cannot understand that we don't all lead lives in which rice is being thrown at the wedding."

Swiss Army "We wanted to **make** the **Swiss Army** itself our **Michael Jordan**," states Jim Garavanti, **creative director** on the **Swiss Army brands** account.

So to do so, the creative team dove into the history, started collecting facts, and found that "everything was so interesting." The Swiss Army itself was a "gentlemen's army" that came from a country made up of "ever-ready civilians who needed to always be prepared to fight so that they would never have to," and they needed knives.

Little did the Swiss Army know the decisions they made at that time would impact the advertising of those knives over a century later. First of all, the army gave the contracts to manufacture its knives to two different companies. The thinking was that the army certainly couldn't afford to be ill-equipped should one company fail to come through. But the army's foresight has led to confusion over the years as to who has the "original" rights to the term "Swiss Army Knife."

⊘ Art director Monica Taylor had enough money in the budget to shoot only one ad; for the others she needed to find visuals that would still represent the quality and heritage she needed to convey. This image was taken from an old postcard.

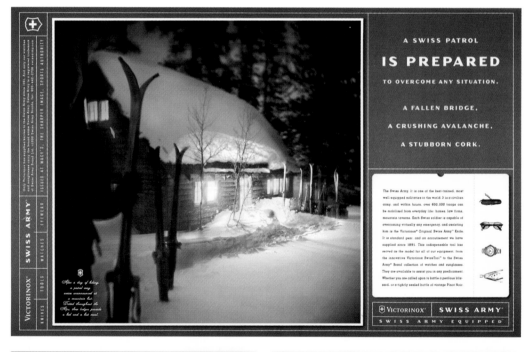

⊘ "The ad was designed with nice compartments, much like the way the knife has different areas of usefulness," explains Greg Boker, creative director. "For example, it even gave us an unusually good way to show the two logos that we needed to show."(Photographer Benelux Press/ H. Armstrong Roberts)

THE LENSES CAN STOP

A **6MM STEEL PROJECTILE**

FIRED FROM CLOSE RANGE AT

100 METERS / SECOND.

DO WE REALLY NEED TO TALK ABOUT

UV PROTECTION?

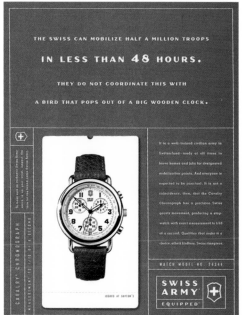

THE SWISS CAN MOBILIZE HALF A MILLION TROOPS

IN LESS THAN 48 HOURS.

THEY DO NOT COORDINATE THIS WITH

A BIRD THAT POPS OUT OF A BIG WOODEN CLOCK.

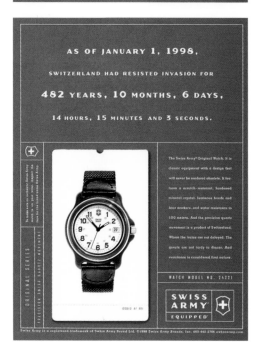

AS OF JANUARY 1, 1998,

SWITZERLAND HAD RESISTED INVASION FOR

482 YEARS, 10 MONTHS, 6 DAYS,

14 HOURS, 15 MINUTES AND 3 SECONDS.

THE SWISS

NEVER BEGIN SENTENCES

WITH

"IF I ONLY HAD A..."

The product ads bring out the specific features and benefits of each product in ways that relate back to the history of the Swiss Army. Art director Monica Taylor "liked the idea that the ads could look like they had been issued by the Swiss Army. Official. Engineered. Authoritative." (Photographer Geoff Stein)

It became a case of "Will the real Swiss Army please stand up?" explains Greg Bokor, also creative director. "It became really important to reclaim the Swiss Army brand because there had been a lot of confusion," adds Jim.

Facts like the Swiss Army's decision to make the knife red (because red would show up best should the knife be dropped by a soldier in the snow) fueled a need for the creative team to figure out a way to have the history and heritage of the Swiss Army be a part of the advertising story. But they needed do so in such a way that it would still be applicable to new products coming out. At first, there was a lot of talk about the "gadgetry" of the knife, but it soon became apparent that you couldn't really apply that to the other products that are part of the Swiss Army brand. No one wants to think of sunglasses and watches as "gadgets," for example.

So the notion of "being equipped" was a strategy that made sense for not only the knives but also other products down the road. And "being equipped" could provide a really good platform for an overall branding message that spoke to history and heritage, but could also be applicable to product ads that made the knives relevant for the everyday person in the twenty-first century.

The branding campaign focuses on the interesting stories of the Swiss Army, and product ads bring out the specific features and benefits of the products in ways that relate back to the history of the Swiss Army. All of the elements work together to tell that story. The copy in many of the ads tells about the foundation of the Swiss Army itself. For example, "The Swiss Army. It is one of the best-trained, most well-equipped militaries in the world. It is a civilian army, and within hours, over 600,000 troops can be mobilized from everyday life: homes, law firms, mountain taverns...." And those troops and civilians alike will rely on all the "new, important things you can do" with the knife, as touted in the posters.

So just how did the art direction come together? Art director Monica Taylor explains her approach as "wanting the look of the campaign to reflect the craftsmanship and heritage of the products. A little Swiss, a little military, a bit romantic. But not antique." Inspired by everything from Swiss municipal forms to Swiss graphic design to Swiss airmail stamps, she "liked the idea that the ads could look like they had been issued by the Swiss

A variety of photographers shot the main shots in this poster series. This very distressed chair was shot by William Huber. Bottom: (Photographer Susie Cushner)

Army. Official. Engineered. Authoritative." With this direction in mind, the design of the ads was constructed within a tight, formulaic grid that could gracefully contain substantial blocks of copy and product information while reflecting the organization and craftsmanship of the product itself. And the same red color that makes the knives themselves stand out in the snow also makes the ads stand out in the magazines.

Regarding the extensive research that went into the project, Dylan adds that the authentic look and feel didn't just come as an epiphany one morning in the shower. "Seriously," he says, "we read everything from John McPhee's *La Place de la Concorde Suisse* to wee Swiss Army fact books we dug up in used-book stores." At first, he admits, maybe they were a little too extreme with the genuine military angle. "The client didn't like anything we first presented, about four campaigns. They said our Swiss Army ads were too...army. But we crafted and honed differently and ended up with the red heritage ads. Hooray." The team no doubt appreciates the success of their efforts. "We're really happy with the design and writing," Dylan says, defending the more conventional headline-visual layout. "This is a classic brand and we felt we served it best by doing classic ads—not wacky, 'let's win some awards' ads." Their good intuition can only be applauded.

Jim closes with one more interesting little story—one more "I bet you didn't know this." Every Swiss Army knife has a little hook on it, but few Americans seem to know what it's for. But in Europe, you use it all the time: You hook it around the strings on boxes of pastry to bring your pastry home from the market. Although some of the most practical parts of the knife may have been forgotten, it is hoped the advertising will keep people "ever-ready and ever-prepared."

⌂ Above: "It was actually very difficult to find a prison that looks like your typical prison," states Greg Boker, creative director on this series of posters. "We finally found this in Idaho." (Photographer William Huber © 2001)

H&R Block Is it **possible** to **create** really great spots **on the fly** without the months of planning that **usually** take place? The creative team for **H&R Block** found the **answer** to that the **hard way**.

⊗ John and Rick were knee-deep in pre-production when the client dropped a bombshell: Both of the tax services spots had been killed, but they still needed to air something in the same time frame. So they locked themselves in a room and started writing furiously.

John Metejczyc and Rick Castilles, writer and art director, respectively, were working at agency Y&R out of Chicago. They were in Los Angeles to shoot two spots for tax services and about five other spots to introduce other H&R Block services. They were knee-deep in pre-production when the client dropped a bombshell: Both of the tax services spots had been killed, but they still needed to air something in the same time frame.

The original concept was to shoot a *Blair Witch Project* parody. The idea was to hand someone a camera and have him or her film themselves filling out their tax forms. The concept was sold to the client months before the shoot was scheduled, and the creatives learned their first lesson: timeliness. "As we approached the shoot date, there were more and more *Blair Witch* ripoffs being created. We were getting worried; the client was getting worried. Finally it was the lawyers who killed it," recalls Rick.

So what do you do when you need to shoot a spot in two days and you have no idea, no storyboard—all you have are three people that you had originally cast for a spot that was now defunct? You lock yourself in a room and start writing furiously.

"We had already been casting, and we had a man, woman, and child we liked, so we thought 'what can we do with them?'" explains John. "We developed a loose outline of what a spot could be and sold it to the client. At that point, we were still planning to shoot just a couple of thirty-second spots."

Because there was no lead time to fully develop the spots, a lot of things happened right on the set—including the scripts. "The script supervisor would come running over saying, 'I don't have a script for this,' and we'd say, 'that's because there is no script!'"

A lot of the spots' strengths come from the lead character, a dad named Bill. The campaign is a countdown of the days until tax day, and over the course of the campaign Bill keeps getting a little crazier the closer he gets to the deadline. As they were shooting, they got to know the lead character's strengths. A lot of what happened on the set was a direct result of the director and the creative team saying, "Boy, this guy looks like he'd be great doing that," or by continually asking themselves, "What would Bill do here? How would Bill act?"

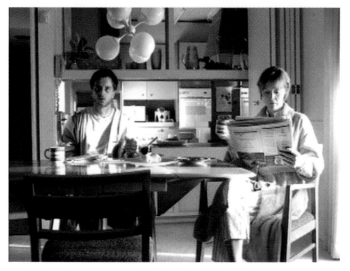

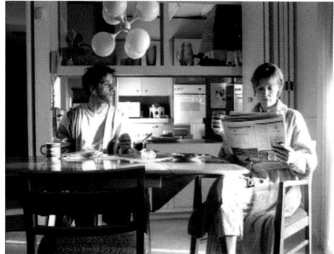

Sometimes the lines were just ad-libbed by the actors. In one spot, the action is just the mother and daughter reading very quietly. All you hear is the ticking of the clock. The only dialogue occurs when Bill says, "Hey! Dad needs a quiet house, OK!"

As John explains it, "The original script had Dad saying, 'Would you please be quiet!' But on the first take, the talent just came to the railing and spouted out the 'Dad needs a quiet house' line. And we just knew that was so much better." The ad-libbing and improvisation made for some very funny times on the set. "All during the shooting, crew members were actually biting their arms, trying to cause themselves pain so they wouldn't laugh out loud," remembers Rick.

"The director, Craig Gillespie, was great. He had the sensibility to play stuff straight and small. In fact, his direction to people was almost always, 'Could you play that smaller?' Our sensibilities would probably have been to play things a little broader. But he really kept things real, which gave the spots that universal feeling. People relate to them because they feel it could be them," John remembers.

⬡ A lot of the spots' strengths come from the lead character, a dad named Bill. The campaign is a countdown of the days until tax day, and over the course of the campaign Bill keeps getting a little crazier the closer he gets to the deadline. A lot of what happened on the set was a direct result of the director and the creative team asking themselves, "What would Bill do here? How would Bill act?"

It wasn't until they were on the set that they realized the cast was really amazing and that they had such a fast director of photography that they could just keep on shooting. And it wasn't until they got into edit that the fifteen-second versions were conceived. Originally the plan was to go in and take three or so vignettes to make up a thirty-second spot. It ended up being eleven separate spots that were fifteen seconds each.

"We thought we could use the same people as a link. It works episodically really well because the dad gets a little crazier each time. The campaign gives the audience credit for being able to follow along," Rick states.

If you back up strategically, that's what the agency really wanted to do all along. But it took a long time to convince the people at H&R Block that tax advertising can be funny. The winning argument was that if H&R Block can help me laugh about my taxes on the air, they could help me remove a lot of stress. Also, the creative team felt, if you show the problem to people, then people really associate with it. An attempt to show the solution a few years back ended up, as Rick puts it, "abysmally—a lot of smiling, happy people shaking hands."

The meeting where they presented the rough cuts for "Worrying about Bill" was one of the worst meetings of the creative team's lives. That was mostly because there were five other campaigns being presented, and they all had problems. But when the fifteen-second spots were played, they were very well received. The client knew what the team was trying to do; they laughed at every spot and wanted to get them on the air right away.

Overall, the creative team thought it was a wonderful experience. Rick has one final comment: "Sometimes the stars line up like never before."

◇ The director had the sensibility to play stuff straight and small—his direction to people was almost always, "Could you play that smaller?" The creative team admitted that their sensibilities would probably have been to play things a little broader. By keeping things real, the director was able to give the spots that universal feeling. People relate to them because they feel like it could be them.

Tax day 1

Sometimes the lines were just ad-libbed by the actors. In this spot, the action is just the mother and daughter reading very quietly. As John explains it, the original script had Dad saying, "Would you please be quiet!" But on the first take, the talent just came to the railing and spouted out the "Dad needs a quiet house!" line. And they just knew that was so much better.

H&R BLOCK

Hamburger Abendblatt Chirpy, almost saccharine-sounding music plays alongside visuals where almost nothing happens. It's a funny juxtaposition, giving this campaign a visual/audio style that makes it almost mesmerizing.

The *Hamburger Abendblatt* is the most popular daily newspaper for the city of Hamburg. Its advertisement sections for cars, jobs, and property have always been a big reason for many people to buy this newspaper. But suddenly the Internet—with all its unexpected results, both good and bad, on business—has become a fierce competitor. The client and its agency of thirteen years, McCann-Erickson, were aware of this development, but as there was no extra budget, there was no plan set to especially work on this point.

Instead, serendipity set in. One day, McCann's head of TV, Guntram Krasting, and creative director Jochen Mohrbutter had an appointment at Wunderfilm, a television production company. The two companies had developed many projects together in the past and had a good working relationship. After the meeting was over, they sat together talking and drinking beer.

Suddenly Stefan Jaehde, one of Wunderfilm's owners, came up with a new show reel of a young talent. Jochen tells the story of what happened next: "His work didn't thrill us at all, but what inspired me was the intro to his reel: a two-minute scene showing a dreary little detached family house—but nothing else happening. I stared at the monitor, looking at it as if spellbound. In this moment I knew what kind of strength an interesting picture can have, even if—or because—nothing is happening in it. I took paper and a pencil and went off to sit down in a quiet corner for about ten minutes. When I returned, I asked Stefan to show me that intro again. While the scene was running, I held up four text sheets (one after the other) in front of the TV set. As Guntram and Stefan saw how the obviously monotonous picture was loaded with sense by the text, they were enthusiastic about the idea, too. More bottles of beer were opened."

On the next day in the agency, Jochen showed the idea to Nicole, a copywriter. Together they created a layout version of the film "House" in the TV department and developed two other ideas for the advertisement sections: "Cars" and "Jobs." They called the client on the same day, telling him that they had to show something to him very urgently. Two hours later they sat in Konrad Frank's meeting room. The advertising manager of the *Hamburger Abendblatt* is "one of the rare clients who is not only able to recognize an unconventional creative idea but also has the courage to decide something according to a gut instinct," says Jochen. "He saw the layout commercial, heard the other two ideas, looked at the rough calculation, smiled, and said, "Wonderful. Let's do it.""

Production began in earnest. Two locations were found quickly, but the third one, the gatehouse, was difficult. There are lots of gatehouses and doorman's offices in Hamburg, but none that made the creative team really happy. Then one morning, Stefan passed by the Hamburg trotting course and saw the little cabins in front of the gate where the tickets are sold. The cabins were perfect: They had casters and could be moved into a perfect position.

Because of the very small budget, Guntram took the part of the director, something he had done very well several times before. Guntram was in love with the idea and very engaged in its production. There was no money for the actors, so the man sitting in the gatehouse is Stefan; the man lying under the car Jochen. Says Jochen, "It was very, very cold, but of course we had a lot of fun with our little crew. All three commercials were shot on one single day; the most time was needed for the framing. We wanted every scene to communicate the dreariness of everyday life, without any artificial touch."

This is Bob.

Maybe he needs some help.

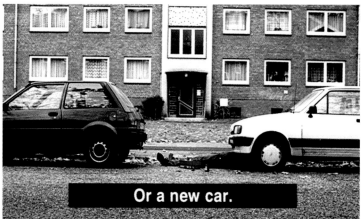

Or a new car.

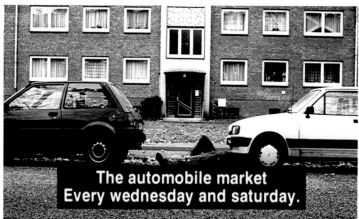

**The automobile market
Every wednesday and saturday.**

So they had the pictures, they had approved copy, they now needed sound. And they wanted a lot of sound for very little money. In order to have music, the team knew they had to concentrate on stock material. Again, Stefan had the "golden grip": He found old and unknown German pop songs from the 1980s. They lyrics speak of "getting the sunshine," "filling every hour with zest," and "luck that is very close to you." The country song for the "House" spot was made by two musicians that the agency had a very good relationship with.

The rest came together very quickly: Choosing the right takes, building in the copy, setting the music, and heading for the client. Luckily, the client was just as excited as the agency and production company were. Two weeks later the commercials were seen in most of the big theaters in Hamburg. In between all of those very loud, quickly cut commercials full of action, these quirky, visually arresting little episodes stood out.

The campaign was awarded by the Deutscher Kommunikationsverband (German Communication Association), appeared on the "Shots" reel, and received an award at *The One Show*. Indeed, the team was given enough reasons to open up some more bottles of beer.

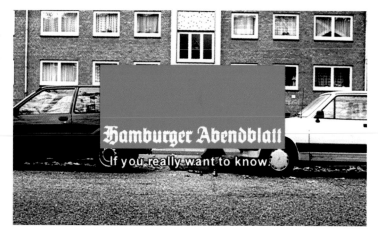

Top left: Creative director Jochen Mohrbutter was watching a director's show reel one day while concepting, and the opener to the reel was two minutes of a house—no movement or action, just a house. This is what spurred the idea for these commercials. He realized the power that a single image can have. The budget was so small for this project that they could not afford to pay a director or talent, so the agency's head of production took on the role of director, and the owner of the production company Wunderfilm was the lead actor in one of the commercials.

L.L.Bean "It's **not about** the outdoors with a **capital O**," says Edward Boches, speaking **emphatically** about the **campaign his agency**, Mullen, did for **L.L.Bean.**

"For most people, the outdoors isn't about climbing Everest or whitewater rafting. It's about the little 'o' outdoors, the outdoors we actually spend more time in.

"A key insight we had about the company was that L.L.Bean had always been narrow in its definition of the outdoors. They saw it in a way that was cold, snowy, New England-like, but the reality is that the consumer didn't see the outdoors as that narrow at all," says Edward, the agency's chief creative director. What consumers wanted to do, the agency found, was to define the outdoors in their own terms. "If the outdoors is taking a kid to the beach—that's okay," explains Edward. "If the outdoors is watching someone building a tree house, that's okay, too."

Defining the outdoors in those terms was a perfect way to reconcile that the company that sold snowshoes and high-end hiking boots could also sell flannel shirts and pink fuzzy slippers.

According to Edward, L.L.Bean was a company living in the past. Their target market had gotten older; potential customers saw it as a place where they would buy something for their uncle or grandfather, but not for themselves.

To get the right look and feel for the photography, the team headed to New Zealand, because, Greg Boker, art/creative director, states, "we wanted a landscape that was otherworldly."

FIRST-AID KIT ☑
BUG REPELLENT ☑
FLASHLIGHT ☑
MONOTONY ☐
MATCHES ☑
POCKET KNIFE ☑

"It never came up that there was no body copy. What could you say, really? There just wasn't anything left to say," says Jim Garavanti, writer and creative director.

"New Zealand is known as the 'land of contradictions,'" says Greg of how they chose the location. The varied landscape of the country allowed them to get a real range of types of looks and activities.

(recess)

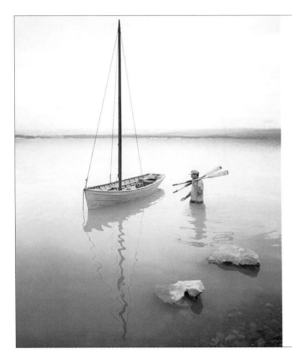

DON'T MISTAKE
A Street Address
For Where You Actually
LIVE.

Jim explains how they were able to keep the layouts so simple: "There was no issue at all about brand recognition, no concern about logo sizes, because L.L.Bean is already such a well-established brand. The client was confident that everyone knew who they were and how they were sold."

"If people want to define the outdoors as just going to the beach, that's okay," says Edward Boches, chief creative director.

CHILDREN: don't talk to strangers.
PARENTS: don't become strangers.

But there was good news—people still liked L.L.Bean.

The problem with the former advertising, the agency thought, was that L.L.Bean would talk about things people already knew about—waterproofing techniques, extra stitching, the quality of the cloth—but none of that made a bit of difference because it wasn't relevant.

So Jim Garavanti, writer and creative director, and Greg Bokor, art/creative director, set out to do a campaign that updated L.L.Bean, made them relevant, and talked about the outdoors with a small "o," not a capital "O." "We wanted to be about inspiration, not perspiration," Jim explains. "Competitors were all talking about the outdoors in a very extreme way. We wanted to talk about the outdoors in a more universal way."

"No one had ever made the little outdoors as poignant and emotional as the big Outdoors," adds Edward.

How they shot and looked at the outdoors became really important. Greg comments, "We wanted the campaign to be really beautiful. There's so much sameness out there. And we felt it needed to be classic, timeless, and really unique to L.L.Bean." Also of importance was to have all six ads feel different and be about different types of people—families, groups, solo people.

To get the right look and feel for the photography, the team headed to New Zealand because, Greg states, "we wanted a landscape that was otherworldly."

A final problem the creative team needed to solve was "How do you show the catalog?" There was a real desire on the client's part to showcase the catalog, which had stood for the brand for so many years. But "if you shot it real, you'd almost have to do something to make it like TV packaging—it would be really difficult," explains Greg. "We finally thought, wouldn't it be better if we just had a symbol of a catalog." The aging of the pages hints at the history of the company. It's a nice nod to their heritage.

Luckily, it wasn't a hard sell to the client. When they saw it they thought it looked really beautiful. Greg notes, "Internally, at the agency, there was a lot of second-guessing, but it really worked for the client when they saw it."

When the ads started running, the creative really touched a chord. It seemed to make an emotional touch point with consumers, a reason to get them to say, "Wow, this is L.L.Bean." In post-advertising research, the perception that "L.L.Bean is a store for me" went up considerably. The campaign also exceeded all previous efforts for lead generation. But Jim says that what sticks with him is the description a creative director at a rival agency wrote about the ads: "The ads for L.L.Bean just captured the feeling of a wonderful spring day."

⊘ "For most people, the outdoors isn't about climbing Everest or whitewater rafting," says Edward. "It's about the little 'o' outdoors, the outdoors we actually spend more time in."

① BRUSSELS SPROUTS
② BATHS
③ THE DENTIST
What else will your kids remember you introducing them to?

Sony PlayStation Just what is **the name** of that **thing** that hangs down from the back of your **throat?** While most **creative** teams **debate** the relative **merits** of a piece of art or copy, the Sony PlayStation team debated whether that **thing** is called an **"epiglottis"** or an **"uvula."**

The quirky commercial depicts a family of four sitting around a table. They all begin making odd video game-like noises. The camera takes us inside the mouths of the family, where it's revealed that the thing in the back of their throats is actually in the shape of the symbol for Sony PlayStation.

The brief for this commercial was simply to launch Sony PlayStation's PSone to an international audience. Trevor Beattie, creative director and copywriter at TBWA in London, thought it was a great assignment, but there was one caveat. He needed to come up with a concept within twenty-four hours. The client needed a spot to run in Croatia, and fast.

So what's a creative to do? Graham Fink is a commercial director who had worked with Trevor on some previous projects for PlayStation. As he explains, "Trevor rang me out of the blue and asked me if I had some ideas. I'm always experimenting, and I had shot a test of someone who had two of those things in the back of their throat hanging down."

Graham brought his experimental test to Trevor, saying, "Isn't this cool? Can we do something with this?" Trevor, in the meantime, had been thinking that if those who were obsessed with gaming were to express themselves, it would be via gaming sound effects. It was then easy for him to make the logical leap that those sound effects would "obviously be produced by throats containing natural-grown PlayStation uvulas."

Uvula is, in fact, the correct name of the thing hanging down from the back of your throat. It's humorous to think that although most people don't know what it's called, it's still an instantly recognizable visual icon. The team developed the idea to be a group of people talking and making strange noises—the actual noises in the Sony PlayStation games.

The "Blood" ad depicts blood photographed as if it were seen under a microscope, with the PlayStation symbols interspersed with blood cells. The hospital prepared some glass slides of photographer Graham Fink's own donated blood, which he photographed and then added the game symbols via retouching.

The insides of the actors' mouths were shot with a special camera that actually went down the actors' throats. The lifelike uvulas were six-inch-high rubber models in the shape of PlayStation icons. They were shot against a blue screen and, in a painstaking edit, the actors' real uvulas were painted out and replaced with footage of the models.

It was Graham and Trevor's first idea, and the only idea they presented to the client, who luckily loved it on first sight. Producing the ad was an interesting exercise. Graham, naturally, was the director. For the location, they found an old-fashioned gentlemen's club in London. Since part of the idea was that everyone gets involved with Sony, they cast a family. If they had only teenagers in the commercial, Trevor and Graham thought, it would have been too expected. They also cast for "normal-size mouths, but deeply surreal actors." In order to make the sound effects seem real, they gave each actor a tape of the game they were going to portray, and made them learn it. On the shoot, the creative team was trying very hard to take it all very seriously. The cast, on the other hand, seemed to think the whole thing was a riot. They were "bonkers," notes Trevor wryly.

The inside of the actors' mouths was shot with a special camera that actually went down each actor's throat. The lifelike uvulas were six-inch-high rubber models in the shape of Playstation icons. They were shot against a blue screen and, in a painstaking edit, the actors' real uvulas were painted out and replaced with footage of the models.

A related print campaign, which also uses the idea of Sony PlayStation symbols as a part of the human anatomy, is called "Blood." The ads depict blood photographed as if it were seen under a microscope, with the symbols interspersed with blood cells. "Most people who create advertising feel as if they give blood to get the ad produced, but they rarely do that literally," says Graham. But since Graham needed the help of the hospital to get the blood photographed, he donated blood in return. The hospital prepared some glass slides and delivered them to Graham three days later, which he then photographed and then added the Playstation symbols via retouching.

The work for Sony has won its fair share of awards, and sales of PSones have boomed. The only thing left to wonder is where the campaign will go next.

> Right and opposite: The team developed the idea to be a group of people talking and making strange noises. Graham explains that he "had shot a test of someone who had two of those things (uvulas) in the back of their throat hanging down." And meanwhile, Trevor Beattie, creative director, figured obsessive gamers would communicate by sounds "obviously produced by throats containing natural-grown PlayStation uvulas."

DO NOT UNDERESTIMATE THE POWER OF PLAYSTATION

www.playstation-europe.com

Priceline.com

There's a very **famous** actor who portrayed **Captain Kirk** on *Star Trek* for years. And suddenly a young Internet company gets him to not only be a **celebrity spokesperson**, but to **reestablish** a singing career he abandoned years ago. How did that **happen?**

Ernest Lupanacci, a copywriter, tells about the campaign's start. "I was freelancing in New York on a Friday afternoon. I was on my way to a weekend at the beach when I got a call from Hill Holliday, wanting to brief me on Priceline. I had heard the account had landed at Hill Holliday and I knew William Shatner was the spokesperson."

"I said 'I'd love to work on it but I'm at exit 71 on the LI expressway and it's a Friday afternoon. There's no way—it would take me hours just to get back into the city.' So the agency folks said, 'We really want to work with you, but maybe this isn't the right assignment.'

"But all weekend long I kept thinking about it. I thought, 'They have William Shatner. The client chose Shatner.' I knew that if I could come up with a great campaign that used Shatner it would be sold. I also knew that when I was a kid I saw Shatner singing on the SF awards and that image was burned into my retina."

"Monday morning came, and I called up the creative director. 'I have an idea,' I said. 'I don't expect you to pay me, because you didn't really give me the assignment, but here it is.'"

David Wecal, creative director at Hill Holliday New York, recalls that moment: "When Ernest first presented the campaign to me, I laughed so hard I almost fell down. It was one of the funniest ideas I had heard in a long time." David's one concern was that it was Monday morning and he wouldn't be able to pull it together for a Thursday meeting.

But pull it together he did. He created over a dozen spots, all revolving around the idea of William Shatner singing the benefits of Priceline.com.

The presentation began. Ernest began his spiel: "Just remember, you guys picked Shatner. So what I'm about to present is grounded in the fact that you guys picked Shatner and that people love Shatner and Shatner loves to sing." And as Ernest recounts it, "it's a good thing you couldn't deny any of those individual pieces, because the next thing I had to do was actually sing the William Shatner song."

The campaign that finally aired wasn't even the wildest idea out there. A campaign that didn't get sold had a storyline about Shatner's getting fired from the role of Priceline pitchman. It's a very public firing—kind of like *Spinal Tap* meets *The Player*. The story line of the campaign showed a search for a replacement for Shatner, interviewing all kinds of celebrities, with Priceline finally settling on Regis Philbin. At the very end of the campaign, it's revealed that Regis is really Shatner in disguise.

So, around a very formal conference room table, with a very formal client, Ernest Lupanacci started singing "Leaving on a Jet Plane," "There's No Place Like Home for the Holidays," and "Little Red Corvette." "I'm climbing over the table, performing for these clients who were all buttoned up, very executive types."

Ernest knew he had to win over a certain client, Jord Poster, and so he sang his heart out to Jord in particular. Once Jord was behind the campaign, it was pretty clear that Priceline wanted to go with it even though "it was way out there." The idea was sold to the client, and Shatner came on board. But then weeks went by. The spots were tested, re-presented, and then re-presented again. "It was as bad as the process gets," exclaims Ernest. Dave remembers that time clearly: "We finally just pushed and pushed and pushed the client—told them they had to run it."

Once on the set, the fun really began. Recalls Ernest, "Shatner and I were like the Dick Burton/Liz Taylor combo of the twenty-first century. We were fighting all the time, we had different points of view, we were screaming at each other at the top of our lungs. And in the height of all the craziness, I would look around and think, 'How surreal is this? I'm getting reamed out by Captain Kirk. And not only that, Captain Kirk never loses."

The reason for all the arguing says Ernest, was that "what I really needed was for Shatner to be me doing him. He needed to be a caricature of himself and that gets pretty tricky." Dave concurs, "The funniest thing to watch was Ernest doing Shatner and then telling him to do it that way."

Everything was shot very real. Ernest had found from listening to Shatner's old album that the straighter it was played, the funnier it was.

The production was designed to seem like the last thirty seconds of a four-minute music video. On one set Ernest was watching Shatner sing "Age of Aquarius." As he was watching Shatner, he thought, "We are going to get in so much trouble for this. This is so wrong."

"While we were filming it, we were in front of a whole live audience," remembers Dave. "It had a very surreal quality to it. At one point I looked around and thought, 'Oh my god, what have we created?'"

The spots started running, and within four days *Good Morning America*, Howard Stern, David Letterman, CNN, and the *Daily Show* had William Shatner on the air. It seemed everyone was talking about it. Says Ernest, "When Jay Leno has Shatner on and in the first ten minutes they play two of the spots, you know something is working." Dave recalls, "The day after the spots aired, the guys on the *Tonight Show* were singing "Convoy." Until that point I'm not sure the campaign had really even been approved."

Priceline has gone through its problems. But with 94% brand awareness, they're doing something right. There's a lot of really outrageous Internet advertising out there.

"As far out as this campaign seems, if all you do is listen to the words, you get what this company is about," says Ernest. "We're not doing wacky, gratuitous Internet advertising."

Dave sums up the reaction to the spots: "The reaction didn't surprise me. Ernest had done this incredible Shatner impersonation that made everyone laugh. So it really didn't surprise me that the rest of the world picked up on it. What did surprise me was that the campaign polarized a lot more than I thought. People either loved it or hated it. But in the end even that was good, because it got people talking about it. That was one of the goals all along, to have it get talked about. We were at a point in time where people wanted to hear what he was talking about. I was granted a great opportunity to see something great happen."

Ernest recalls, "Shatner and I were fighting all the time...we were screaming at each other at the top of our lungs, [arguing because] what I really needed was for Shatner to be me doing him. He needed to be a caricature of himself and that gets pretty tricky." Dave concurs, "The funniest thing to watch was Ernest doing Shatner and then telling him to do it that way." Ernest says, "when Jay Leno has Shatner on and in the first ten minutes they play two of the spots, you know something is working." The day after the spots ran, the *Tonight Show* was singing "Convoy." How's that for good PR?

Outpost.com

Each spot in this **campaign** ends with an odd call to action: "Send **complaints** to **Outpost.com**." Sending a pack of **wolves to attack** a marching band, **tattooing** children's foreheads, and **shooting gerbils** out of a cannon would seem to **warrant** a complaint or two, and **complaints** they got.

SCRIPT
"Forehead"

(Open on the narrator talking to the camera. He sits in a leather chair in a makeshift room, like "Masterpiece Theater.")

Narrator: We want people to remember our name, Outpost.com. That's why we went to day care centers all across this great country of ours and met with the youngsters.

(Footage of cute three-year-olds running around day care centers, laughing and smiling.)

Narrator: Then we permanently tattooed their foreheads with our name.

(Cut to footage of a tattoo artist and kids with huge Outpost.com tattoos on their heads. The kids are now crying. Cut back to the narrator.)

Narrator: Excessive? Maybe. But we're on a mission.

Super: Send complaints to Outpost.com.

Logo: Outpost.com. The place to buy computer stuff online.

But what Outpost.com also got—and what they were banking on—was an inestimable amount of free PR and a stock price that soared from $1 to $45 a share.

When Outpost first appeared on the market, their name was Cyberian Outpost. "No one understood the name, especially on the radio," says Brian Mulhern, account executive at Cliff Freeman & Partners. So the first agency recommendation was to change the name to Outpost.com. The second recommendation was to get people to remember it.

Outpost.com was one of the first companies that sold computers over the Internet. By the time they came to Cliff Freeman, there was already enough competition to make them nervous. The holiday season was fast approaching, and they knew they needed to get spots out there quickly. The good news was that there was now a clear-cut market leader. Outpost.com had a chance to take the number one spot if they moved fast enough. The bad news: They didn't really do anything different from any of their competitors.

So the strategy was almost deceptively simple—how could they get the brand name out there in as intrusive a way as possible? With only $4 million in media money, it had to be very breakthrough.

Describing the campaign that was presented to Outpost.com as "breakthrough" is a bit of an understatement. It's nearly impossible to watch these spots without having a strong opinion of them, for better or worse. Mixing kids, animals, and violence is almost sacrilegious in advertising. But, boy, did it get people to remember the name.

Darryl Peck, founder and chairman of Outpost.com, gave the go-ahead for these concepts, and while he was certainly brave enough to run them, "There was fear all the way up until the stock price kept climbing," states Brian. "He spearheaded the whole thing," even though Darryl's experience was in software and not marketing, and Outpost.com sailed through the uncharted waters of the Internet boom. "For better or worse, we were the poster child of Internet boom advertising," recalls Brian. "We were the first of what people would say was 'in-your-face dot-com advertising.'"

For this spot, which features a tattoo artist tattooing "Outpost.com" onto the foreheads of young children, copywriter Eric Silver explains, "We specifically cast for kids that would cry when separated from their parents." Brian adds, since their wailing kids got cast for the commercial, "the parents were over at the craft services table, munching away on the food, thinking it was great."

There were three spots in the campaign. All three begin with a re-spectable-looking gentleman sitting in a leather chair discussing different ways to make people remember the Outpost.com name. Here's one way. Get a marching band to spell out the name of the company, and then sic a pack of wild wolves on them. Eric Silver, copywriter and creative director, was understandably a bit nerv-ous when shooting this spot. "The wolf trainers kept assuring us that there would be 'no worries, no worries,'" he explains. It soon became obvious why. The wolves ran right up to the band mem-bers, then started nuzzling and licking them. A bit of resourceful-ness did the trick—German shepherds were brought in and painted to look like wolves. The wimpy wolf problem was solved.

A second outrageous way to get people to remember the name? Fire gerbils out of a cannon through the "O" in an Outpost.com sign. Yes, it was done using one of the oldest tricks in the book: Show a live gerbil near the cannon opening, shoot a "really fake, obviously stuffed gerbil" flying through the sign, and then show a real gerbil at the end, scampering away. Despite Eric's worry that the gerbil might seem too fake, this spot attracted the at-tention of a significant number of animal rights activists in a re-action Eric could describe only as an "outcry."

The final way to imprint Outpost.com's name in people's psyches? Imprint it first on children's foreheads. Imagine a day care center with children playing and enjoying themselves. A beefy, biker-type tattoo artist comes in and just starts tattooing the kids. "Exces-sive? Maybe. But we're on a mission," explains the narrator. "The funny thing about creating this spot," says Eric, "is the way we got the children to cry. We specifically cast for kids that would cry when separated from their parents." Far from being upset that their children were wailing away, "the parents could not be hap-pier to get their kids to cry." Perhaps it's because usually it's those very same kids who don't get picked for commercials because they cry, but "the parents were over at the craft services table, munching away on the food, thinking it was great," adds Brian.

While some would describe the campaign as "tasteless," at least one notable ad reviewer, Bob Garfield, begs to differ. He wrote in *Advertising Age* soon after the campaign launched, "These stunts were so hyperbolic, so over-the-top, so essentially silly, they weren't tasteless at all. What they did, brilliantly, was suggest tastelessness without actually inflicting it." The campaign was successful in garnering attention, getting the stock price to rise and—yes—increasing sales. Outpost.com had their first million-dollar sales day once the spots began to air. Their media buy was pretty scattered: a little on cable, a lot on Fox, and Brian adds, "You could see the jumps in the stock prices when brokers were watching." Sales were consistent, and their revenues went up every quarter while the ads rode the wave of dot-coms. Unfortu-nately, "Wall Street giveth, and Wall Street taketh away," notes Brian wryly. While Outpost.com is still in business and having increasing revenues, the stock price has yet to rebound to that of the glory days.

The campaign took home a slew of awards and boosted a com-pany that otherwise could have become lost in the infinite dot-com abyss. Brian credits Darryl Peck's faith in Cliff Freeman & Partners and these commercials. "The client was very brave," notes Brian. But, then again, "no other agency would have had the *cojones* to go to a client with this work."

SCRIPT
"Band"

(Open on the narrator talking to the camera. He sits in a leather chair in a makeshift room, like "Masterpiece Theater.")

NARRATOR: In an effort to get people to remember our name, Outpost.com, we contacted the local high school marching band and asked them to help us out.

(Cut to footage of high school kids marching...they are dressed in their band outfits and playing their instruments...they spell Oupost.com on the football field.)

NARRATOR: And to help make this memorable, next we decided to release a pack of ravenous wolves.

(Cut back to footage of marching band and a pack of wolves entering the field. The band members drop their instruments and run off screaming as the wolves attack.)

NARRATOR: (Proud) That's good stuff.

SUPER: Send complaints to Outpost.com.

LOGO: Outpost.com. The place to buy computer stuff online.

⊗ In "Band," a marching band spells out the name of the company, and then a pack of wild wolves is set loose on them. Eric was understandably a bit nervous when shooting, but "the wolves ran right up to the band members, then started nuzzling and licking them," so more aggressive German shepherds were brought in and painted to look like wolves.

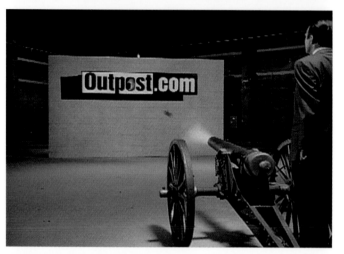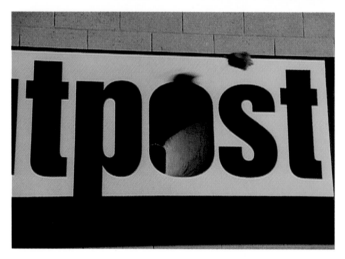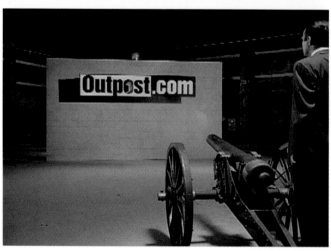

Above and opposite: This spot featured gerbils being fired out of a cannon through the "O" in an Outpost.com sign. A "really fake, obviously stuffed gerbil" was shot flying through the air and hitting the sign, and then a real gerbil was shown at the end, scampering away. Despite Eric's worry that the gerbil might seem too fake, the spot attracted the attention of a significant number of animal rights activists.

Send complaints to

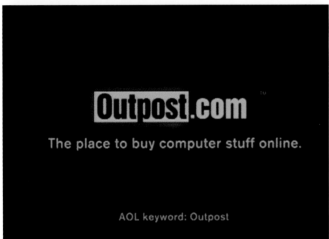

The place to buy computer stuff online.

AOL keyword: Outpost

SCRIPT
"Cannon"

(Open on the narrator talking to the camera. He sits in a leather chair in a makeshift room, like "Masterpiece Theater.")

NARRATOR: Hello. We want you to remember our name, Outpost.com. That's why we've decided to fire gerbils out of this cannon through the "O" in Outpost.

(Camera reveals the set and an Outpost.com sign hanging from the ceiling. The "O" in Outpost looks like a target. A (fake) gerbil shoots out of the cannon and flies through the air, hitting the brick wall. Then the gerbil is scurrying on the ground.)

NARRATOR: Cute little guy...Fire!

(This time the fake gerbil shoots out of the cannon and goes over the whole structure.)

NARRATOR: And again.

(Cut to a series of shots showing the fake gerbils hitting the sign.)

NARRATOR: So close.

(The fake gerbil goes through the "O." A siren goes off. The narrator shoots us a cocky look.)

SUPER: Send complaints to Outpost.com

LOGO: Outpost.com. The place to buy computer stuff online.

Guinness If it can be said that Guinness is good for you and refreshes your spirit, its latest foray into advertising isn't far behind.

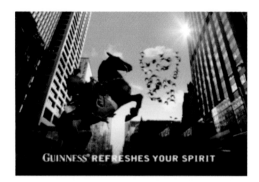

⬦ "It's [Guinness is] maybe the most meaningful way to get intoxicated on the planet, and no two people say the experience is the same," states Zach Watkins, associate creative director at Weiss Stagliano.

Adam Stagliano, principal and strategist at Weiss Stagliano Partners, explains the need for an evolution of Guinness's brand advertising in North America over the last decade. As one of the fastest-growing imports in the United States, "the strategy had to morph and evolve as the brand started hitting critical mass."

A first creative piece in the process included "Dream," a spot that was one of a three-part black-and-white campaign and the brand's first major TV effort in North America. "It worked well around the world, largely because of the strategy," Adam says. "Guinness saw the product virtues as vices, but we saw them as real virtues, so that's what we wanted to hype. After all, Guinness is the most unique beer in the world."

Creative director Marty Weiss shares his outlook. "It's a completely unique product," he relays. "There's even a little ritual about how you drink it. Pour. Settle. Pour it a second time. You can't rush it. The unique ritual is almost educational—so revered by drinkers, but misunderstood by people who don't drink it." Which is largely what demanded a shift in the advertising strategy.

Marty tells, "We've done about a zillion focus groups with people who will go on for hours as to what Guinness is all about. What we kept hearing is that the beer itself is not necessarily refreshing—but the experience itself can transport you. Drinking a Guinness can take you somewhere, and everyone has his own individual experience." Associate creative director and copywriter Zach Watkins echoes the sentiment. "It's maybe the most meaningful way to get intoxicated on the planet, and no two people say the experience is the same."

Adam further explains, "Everything we did was designed around the thought that beer is religion, and Guinness is God. But we were also looking to evolve the brand beyond just the beer virtues, away from the product itself to the unique experience of drinking it." And so the makings of a campaign were born.

"Since it's a radical, epic beer we wanted to make it a radical, epic viewing experience," Zach recalls. "We wanted to combat a lot of people on the client side who thought of it as needing to be slow and mellow, so we created this rush and energy to thinking about the campaign."

Marty recognizes similar stereotypes they had to hurdle. "People said 'Guinness is stuck in the Irish ghetto,'—that its only drinkers were in Irish pubs. But really it's not just about enjoying it when it's dark and wintry and you're sitting in front of the fire. It can also be something magical."

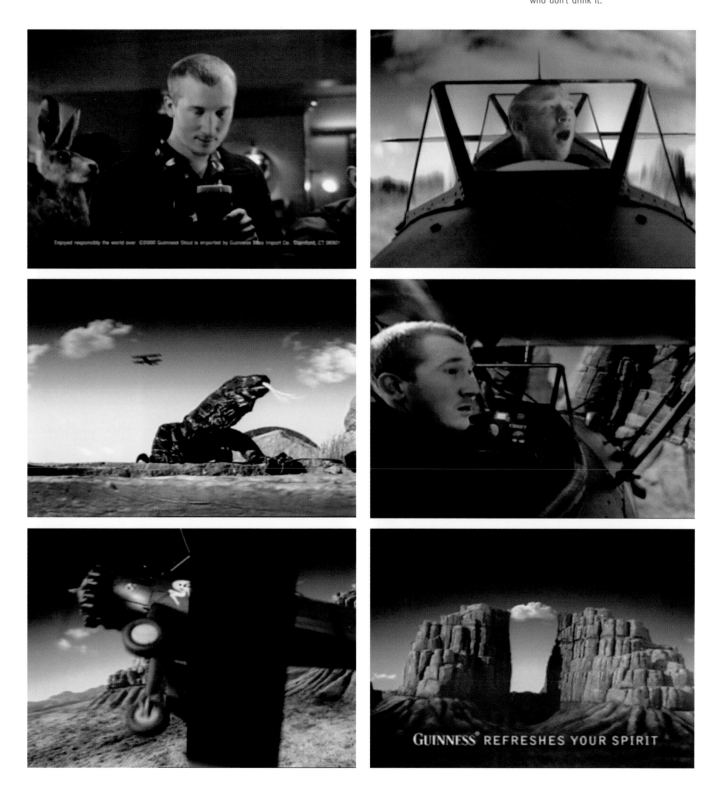

This spot entitled "Dream" was one of a three-part campaign of black-and-white ads for the agency's first advertising push. "Guinness saw the virtues as vices, but we saw them as real virtues, so that's what we wanted to hype," remarks Adam Stagliano, partner and strategist at Weiss Stagliano. He adds, "After all, Guinness is the most unique beer in the world."

GOOD THINGS COME TO THOSE WHO WAIT.

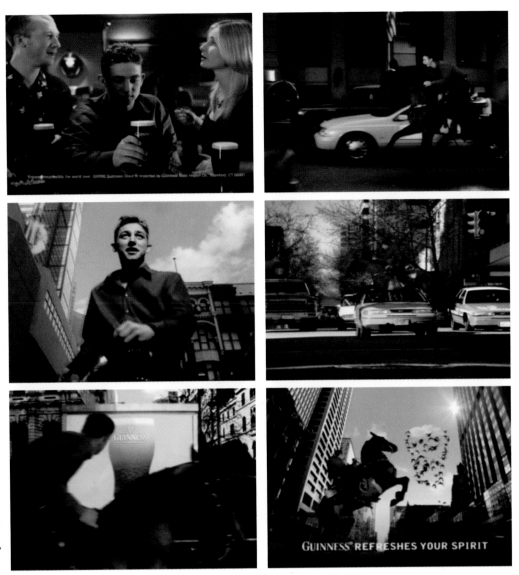

During focus groups, the creative team found that "The beer itself is not refreshing—but the experience itself can transport you. Drinking a Guinness can take you somewhere, and everyone has his own individual experience," explains Marty.

GUINNESS REFRESHES YOUR SPIRIT

So with this approach in mind, he also got wise to his audience. "There are parts of the world where Guinness is a part of daily life," Marty continues. "It's got very natural ingredients, fewer calories than a glass of O.J., and people are very loyal to it. The really exciting part of producing these spots was figuring out how to hold on to the loyal Guinness drinkers but also touch people who'd had some experience with the brand but weren't drinking it regularly."

The campaign that was developed the following spring pulled it off with two dynamic spots, "Biplane" and "Western"—spots that Marty cites as having "a certain energy level to talk to a slightly younger group of people."

Both start out with two friends in a pub, each with a pint of Guinness, and when one takes a sip something magical happens and an adventure ensues. "We wanted to be clear that it was Guinness that triggered this experience," he reveals, "so what we do is go into our hero's pint glass with a microscopic camera. We incorporated the product naturally so it's as much about the experience as the flight and the ride are."

From the pint glass, the viewer is transported to a surreal, magical world enhanced with all kinds of special effects. "The creative

team wanted it to be both the hero in the ad and the viewer watching it that are simultaneously going on this magical journey, which we were able to accomplish through some fancy camera work," Marty explains.

Fancy is an understatement. In "Western," the camera view dives into the pint of Guinness and what emerges is a black stallion with the commercial's hero in the saddle on an incredible and seemingly impossible ride through New York City. As he gallops along, a knee-cam pointed at his face and a body cam capture his point of view.

The effects for "Biplane" were equally as thrilling. The hero takes his sip of beer and finds himself in the cockpit of a vintage biplane, flying through a majestic desert landscape. As Marty tells it, "The camera was mounted to the front of the plane as it was flying just to get the main character's expression." The creatives also wanted to get a great shot of the Guinness icon on the side of the plane. "Difficult to pull off? It depends on how you look at it," he muses. "All they had to do was hire a guy who parachuted out of another plane with a camera and shot the icon."

Zach recollects how they chose the memorable Iggy Pop track for "Biplane" and Slim Whitman for "Western." "We experimented

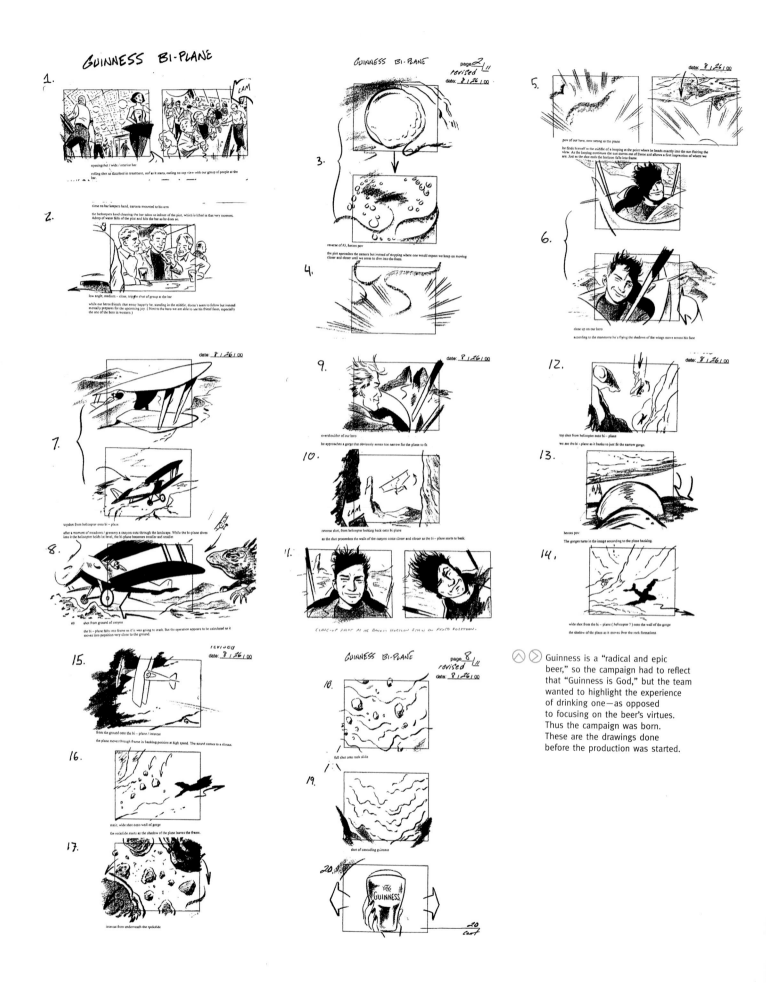

Guinness is a "radical and epic beer," so the campaign had to reflect that "Guinness is God," but the team wanted to highlight the experience of drinking one—as opposed to focusing on the beer's virtues. Thus the campaign was born. These are the drawings done before the production was started.

tracking shot, starting close on the pint in the hand of the memphis belle

we move out of the pint revealing the memphis belle and the fact that we're looking at an image on the

close on our hero

wide shot, from helicopter looking back at the bi – plane

we pull away from the arch as the bi – plane moves through it. We see the shape of the pint formed by
the arch as the plane exits frame in a swift maneuvre.

Super: Guinness refreshes your spirit

with so many things, but we wanted music that was radically different. There was a billboard we did that said, 'It's like drinking your favorite song,' and we wanted to capture the essence of that. We knew the music had to be unusual, unique enough that anyone could put it on."

When the spots were wrapped, Marty expressed his satisfaction. "We pulled together a group of incredibly talented people to pull off this very natural, very magical, but very real world that these Guinness drinkers are going through. They had tremendous experience in pulling together these moments, effects, jumps of horses—a number of things that will give us all the sensations."

James Verrier, a planner for the team, recognizes one of these sensations as a sense of communion. "The spots relay a certain world brand essence, a camaraderie. They bring people together and move you in a certain way, even though everyone's experience is slightly different. If more people spent time over pints of Guinness, who knows where the world could go!"

Suppose that depends if you could get them off their barstools.

San Francisco Jazz Festival

You know it's been a good day in advertising when **a little agency** pulls off a **big spot** for a pro bono client on a tight **budget**. And even better when that **client's message** spreads a little **good karma** on the cultural sandwich **along the way**.

CAR'S P.O.V.
CAM CAR

DRIVER REACHES FOR STEREO

SWITCH TO HIP HOP STATION

DRIVER PRESSETS HIS SEAT BACK AS EVERYONE DROPS LOWER

So goes the story of the San Francisco Jazz Festival and the agency that not only helped promote the event but also, as creative director Ryan Ebner explains it, connected it to the public as "something very believable that resonates universally with real people." The project launched when the festival committee approached Butler, Shine & Stern and asked them to pull off a miracle: a respectable TV spot on not much more of a budget than favors from directors and producers.

But Ryan immediately recognized the potential of doing an ad promoting jazz. "The music—being a true American art form in itself—lent to the ability to play with it. The challenge was how to show that jazz is what people enjoy *deep down*." With this in mind, he figured that the commercial itself "more than anything needed to be intriguing." And how better to intrigue than to take something readily stereotyped in pop culture and stand it on its ear.

The original idea for the spot involved showing the heavy metal band Metallica, best known for its hard-core guitar rock, playing some smooth jazz behind closed doors in the studio and the lead singer walking in on the others jamming. The band liked the idea and was interested in doing the commercial but, as luck would have it, their tour dates coincided with the shoot. Ryan and the creative team had to rethink the concept and ended up taking it a step further.

He recounts, "We augmented the idea into low riders with the big, booming car stereo because we wanted to pick a very recognizable pop culture icon. We were conscious of the fact that changing the script would make it controversial for a lot of people, but we wanted to push the point that what you generally see in people is a facade. There's very much more to them than meets the eye—or ear."

As the spot plays out, three badass-looking guys in an old-school convertible are cruising around, tapping their fingers and lilting their heads to the jazz that's playing on the car radio. That is, until they approach a benign student-type on the corner waiting to cross the street at a light. One of the passengers alerts the driver to the situation and he punches the radio button to a bass-heavy rap station, as the trio slumps down and scowls at the now nervous pedestrian. The light turns green; once they're out of earshot, they sit up again, switch radio stations back to the jazz tunes, and resume their easy-listening ride.

Ryan Ebner, associate creative director at Butler, Shine & Stern, was conscious of the fact that it might prove controversial for a lot of people but, "We wanted to push the point that what you generally see in people is a facade."

The pre-production did not take very long; they cast in the beginning of the week and scouted locations at the end of the week. The crosswalk location that was chosen was "not in a good section of town," Ryan observes. He recalls people were running behind the flatbed truck waving their arms and saying, "I'm on TV! I'm on TV!"

PED FLINCHES.

GREEN LIGHT.

CAM DOLLY/PANS
AS THEY PULL AWAY.

DRIVER REACHES
FOR STEREO.

"CLEAR."

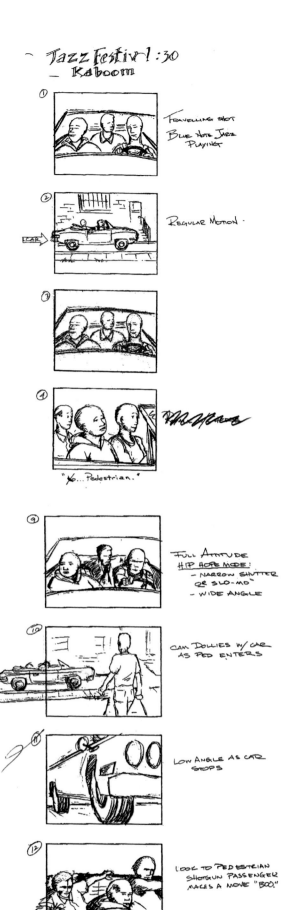

The client bought it right off the bat and handed over the reins to Ryan, who in turn enlisted director Brandon Dickerson of Kaboom, who had done some small music videos for local bands. To Ryan's good fortune, Kaboom got behind him and said, 'Hey, let's invest some money in this kid.' Then things started rolling out fast. They cast actors early in the week and began scouting locations for a crosswalk, which ended them up in Hunter's Point. Ryan observed it was "not a good section of town. We were attracting so much attention that people were running behind the flatbed truck waving their arms and saying, 'I'm on TV! I'm on TV!'"

It was a "run and gun" shoot—which means that there wasn't time for elaborate shots or lighting changes. This allowed the team to shoot everything in one day, a feat aided by the fact that the client was content taking a backseat to the creatives. "They loved it—especially when you're doing it for free. They're not going to say 'Shouldn't people be smiling more?'" Ryan says. "The client did ask one question of substance: 'What type of jazz is going to be on the radio?'"

With a successful wrap under their belt, Ryan muses about a moment of camaraderie. "At the end of the day, we're driving in the flatbed, the light's going down, and tensions are running high when we pass another production trailer. It was a crew filming Don Johnson, and as we passed each other, we all cheered and waved."

No doubt the Jazz Festival would be proud.

⊘ The shooting board shows the ambitious amount of shots that needed to be included in just one day. The only way it could be done was through a "run-and-gun" approach—no time ofr elaborate shots or lighting changes. The finished spot looked remarkably similar to these sketches.

De Beers

De Beers "**Forty** or fifty **years ago**, it wasn't even **customary** to give a **diamond** when you **proposed** to a woman," **explains** Chris D'Rozario, copywriter and **creative director** at J. Walter Thompson.

"Now you pop the question, give the ring, no questions asked." And it was De Beers behind this phenomenon—a company that single-handedly made diamonds inseparable from the notion of giving the ultimate "gift of love."

De Beers had been successfully marketing their diamonds with a campaign that had been running for years that used shadows of women with diamond jewelry superimposed as earrings, rings, and necklaces on the silhouette. So successful was that campaign, in fact, that the music used in the television commercials is one of the most popular songs at weddings today.

So Chris and his partner, Ed Evangelista, got the assignment to update the De Beers brand and shed its old-school image as what he calls "your *mom's* jewelry company." According to the team, the previous campaign had worked because "all women could put themselves into it," and yet something was missing. Although it appealed universally to women, the shadows were also perceived as cold, as disconnecting the jewelry from the human emotional connection to it.

To evolve the campaign, they did a print campaign that showed more of women than just a shadow, but still kept the people in the ads rather mysterious. Shot by famed fashion photographer Albert Watson, the campaign tried to keep the equities established by De Beers while moving it into a more contemporary space.

But the team also decided to try something drastically different. They decided to market the diamonds to men, not women. Men, after all, are the primary purchasers of diamonds, even though women are the ultimate end users.

How do you talk to men about diamonds? After much scrutiny, the team came to the conclusion that, as Ed explains it, "Talking to a man is not like talking to a woman." Chris adds that "There are about a hundred thousand books out there that explain the differences—we just have to acknowledge it." And when they pushed the envelope of this insight to include diamond-giving, they came to the truth that appealing to the male psyche is what would boost sales. "A man always needs to feel rewarded; he has to feel like he's a hero for giving a gift." And from this revelation evolved a series of headlines that went straight for the male consumer's jugular.

De Beers single-handedly made diamonds inseparable from the notion of giving the ultimate "gift of love."

HONEY,
WOULD YOU
AND YOUR
FRIENDS
LIKE MORE
BEER AND
SANDWICHES
WHILE YOU
WATCH THE GAME?

DE BEERS
A DIAMOND IS FOREVER

REMEMBER
WHEN YOU GOT
THAT VARIABLE SPEED
HAMMER DRILL?
IT'LL MAKE HER
FEEL KIND OF
LIKE THAT.

DE BEERS
A DIAMOND IS FOREVER

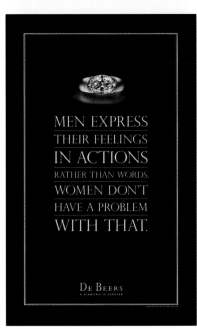

MEN EXPRESS
THEIR FEELINGS
IN ACTIONS
RATHER THAN WORDS.
WOMEN DON'T
HAVE A PROBLEM
WITH THAT.

DE BEERS
A DIAMOND IS FOREVER

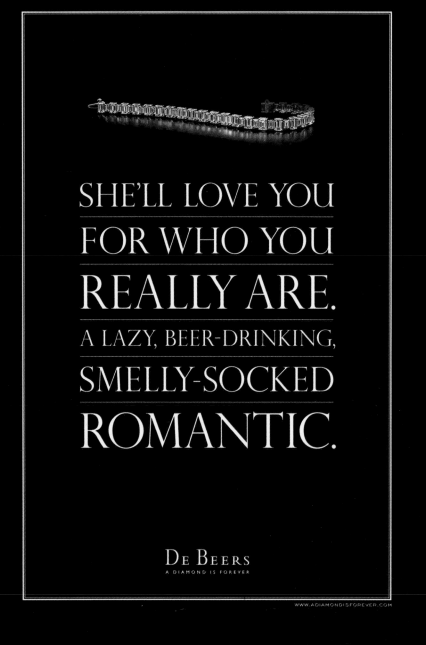

SHE'LL LOVE YOU
FOR WHO YOU
REALLY ARE.
A LAZY, BEER-DRINKING,
SMELLY-SOCKED
ROMANTIC.

DE BEERS
A DIAMOND IS FOREVER

WWW.ADIAMONDISFOREVER.COM

"You go in a jewelry store and they lay the diamond out on black velvet," states Ed Evangelista. To retain this quality, they decided to shoot the diamonds as if they were in a jewelry store, coupled with headlines that went straight for the male consumer's jugular.

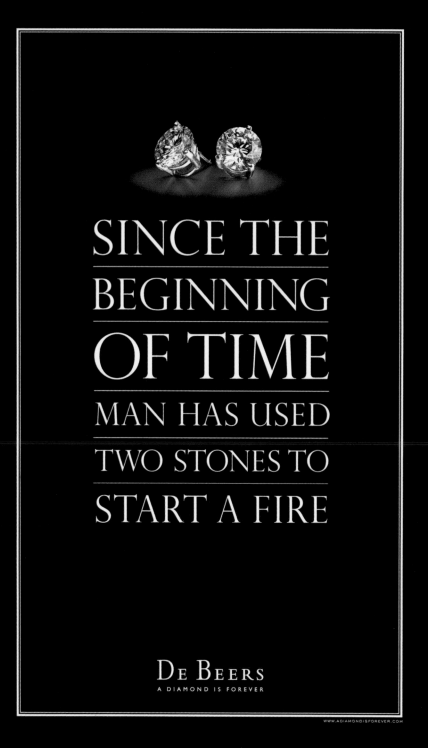

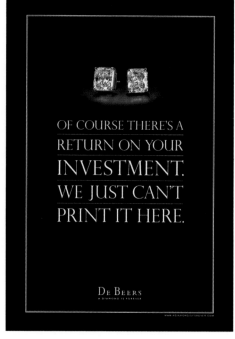

This page and opposite: With expectant wives, girlfriends, and mothers to please, men were targeted through an outdoor campaign that blanketed "everywhere they might walk, to give them a high degree of guilt," explains Ed.

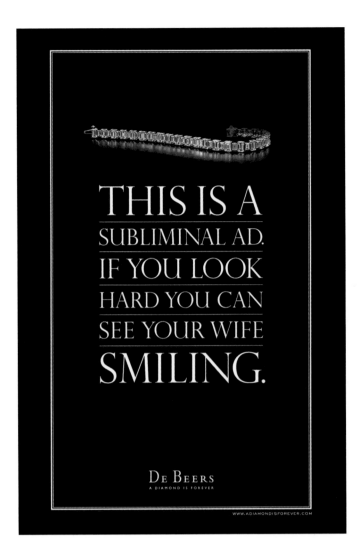

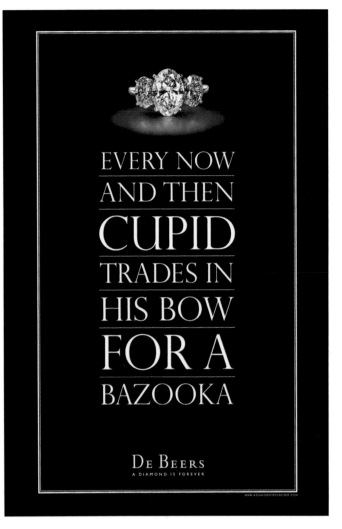

In thinking about the details of the campaign, the team wanted to build on equity established by De Beers while at the same time updating it and making it particularly appealing to the male audience. As Ed tells it, the first conclusion they ran with was that "De Beers had never really showcased jewelry as well as it could be. You go in a jewelry store, they lay it out on black velvet." To retain this quality, they decided to shoot the diamonds as if they were in a jewelry store. "That's our equity," notes Ed.

Their rationale in place, the team went to London to sell the campaign to the client. Ed acknowledges, "The assignment had been that they wanted a new women's campaign and also a Christmas effort, but really—diamonds are fashion. And this advertising should be thought of as a fashion effort." When it came to the outdoor campaign directed at men, they presented only one option but had about thirty executions with all the same art direction. He remembers, "As soon as the client saw the first few ads it was 'Eureka!' It was the first time they had seen a major effort that included both men and women in the same branding effort."

When the initial euphoria of the campaign's potential had worn off, the team had to navigate the part of the process where the ads were really scrutinized. Each ad went through an extensive number of filters and the campaign developed into something more humorous and more risqué. At the time, Chris knew they had to wrap up a winner because the Millennium would be the most important time to launch.

Production began, and the decision needed to be made as to how to shoot the diamonds. "Men like to see the hardware," Ed states flatly; to achieve this they got photographer Steve Hellerstein on board for the shoot. "He spot-lit them on a black background and made them look incredible," he recalls. Which was a good thing, considering "the company had a tongue-in-cheek attitude about him—like this guy had better step up to the plate." The look and feel of the campaign was further solidified when one of the agency's typographers came up with a brilliant typeface whose letters had jeweled facets.

It was this effort that went on to deck the halls, sidewalks, and subways as a holiday push for De Beers, just a year before the Millennium. With expectant wives, girlfriends, and mothers to please, men were targeted through an outdoor campaign that blanketed "everywhere they might walk, to give them a high degree of guilt," explains Ed. Although the strategy was different than the client had anticipated, they were quickly won over.

All things considered, Ed gives considerable credit to the client for letting the campaign evolve, admiring the fact that "They saw the power of it"—a power that eventually delivered Best of Print awards at the Addys and Obies, and a Lion at Cannes for the "She'll love you for what you are" campaign. But for De Beers, no award can rival their rise in diamond sales every year since the advertising's launch. "We couldn't have sold that campaign the first year," Chris admits. "But it shows how the consumers' level of acceptance has grown along with the client's."

An acclaimed win for both creatives and clients—true, but awards and profit margins aside, we're quite sure that the De Beers company sleeps well at night simply knowing they're not considered "your *mom's* jewelry company" anymore.

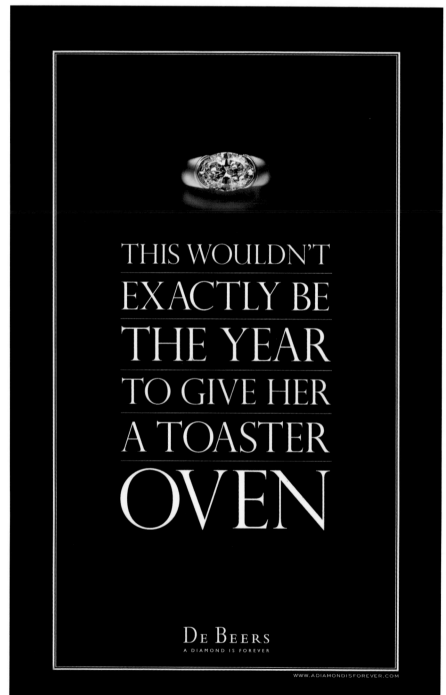

Chris D'Rozario, creative director at J. Walter Thompson, knew they had to wrap up a winner because the Millennium would be the most important time to launch, and launch big they did. In the year 2000, in addition to an overwhelming amount of outdoor regional placement, they not only covered a whole section of O'Hare International Airport, but took out the entire concourse of the World Trade Center to boot.

WHAT ARE YOU WAITING FOR,
THE YEAR 3000?

De Beers
A DIAMOND IS FOREVER

SIR, WOULD YOU KINDLY COME UP HERE
AND GET YOUR WIFE DOWN.

De Beers
A DIAMOND IS FOREVER

NO, YOUR WIFE DIDN'T
PAY FOR THIS AD.
(BUT SHE DID GIVE US YOUR ROUTE TO WORK)

De Beers
A DIAMOND IS FOREVER

IT'S ONLY HER EARS
THAT NEED ENHANCING

De Beers
A DIAMOND IS FOREVER

Levi's USA Japan has contributed many things to American pop culture over the years, not the least of which is the odd but strangely gratifying phenomenon of karaoke.

These commercials were shot during the actors' strike in 1999, which forced the creative team to pursue real kids, and real kids that really sing karaoke.

Sure, the bouncing red ball is studied by many a late-night barfly and leagues of underage college kids—but the subject of a Levi's sixty-second commercial? Who knew?

When Chris Witherspoon, account director, and creative director Chuck McBride of TBWA\Chiat\Day, San Francisco, were first assigned a branding project for Levi's, they faced the daunting task of once again reaching the youth audience by breaking through mainstream advertising that feels like, well, exactly that—advertising. And they nailed it by figuring a young, cynical target would most likely respond to a "lo-fi" approach.

The thinking was this: Brands go through cycles. The top of a big-budget, highly polished ad cycle always ends up as a predictable thirty- or sixty-second spot. But the problem with this formula is that it's consistently losing younger audiences to advertising that feels less like marketing and more like reality and truth. Which in essence is what Levi's is all about.

For Chris, it was a great chance to work on a powerful brand that already had a lot of equity. "One thing we were seeing in the industry was everyone creating a look and saying, 'Hey here's *The Look*,' whereas Levi's messaging was much more individualistic than that. Their focus is on self-expression and empowerment—you make the jeans, they don't make you." It posed an interesting creative challenge: How do you sell a unique product story for a brand that champions the consumer over promoting its own label?

For this team, the idea of the tag came first. "I was being more of an observationalist than a writer," Chuck says of the simple yet astute line "Make them your own" that gave direction to the entire campaign. "We were on to something very big—it was time for a tag line to have a real brand truth, one that sinks in culturally. Once people understand what the brand's about, it will only further galvanize the tag and vice versa."

The line integrated perfectly into Levi's philosophy—from the product design level to their retail space approach—each point of contact with the consumer encouraging self-awareness and personal integrity. Chris recalls how the campaign development shot off like a rocket when "instant light bulbs went off in our clients' heads: 'That's a great line.' There was a time where they pushed us and we pushed back, but we presented them with two positioning lines to calm the waters instead of creating a storm—because it's the calm waters you can skip stones across. It was a pretty seamless process."

"We went to a bar with our company and got to see which songs made people tick," recalls Jennifer Golub, and they came away with a memorable set list, including "Karma Chameleon."

With a brilliant tag to surf on, Chuck led the group's emerging creative with Spike Jones's intimate peeps into retail dressing rooms. With this in his back pocket, inspiration knocked on his door one night when they were out at a karaoke bar. "It was a personal interpretation of songs—a gutsy interpretation—like a talent show that made the song your own experience," he remembers. Striking the balance between form and product became the mission. "We were figuring out what the brand can really carry because if you have a great brand hit, you'll have a great product hit." And so began the process of translating karaoke into an interpretation of Levi's brand messaging.

With the budget always a concern, the team quickly narrowed music choices down to a few selections that were a blend of old, new, and funky pieces. Producer Jennifer Golub shares how creative director John Soto "pored over hundreds and hundreds of songs. We went to a bar with our company and got to see which songs made people tick. John was at this bar, leaping up and down, cheering people on." They came away with a memorable set list, including "Karma Chameleon." "It had to stay in," she states flatly. "It's just too absurd."

But the real challenge was in the casting. Jennifer credits casting director Jennifer Vendetti for scoring some amazing talent. "She has the eye of an artist, a really special sensibility. She found people with beautiful yet individualistic forms, people with real distinctions. She went to clubs and stores, out on the street, and in the end we had such wonderful people that we extended the project and decided to have as many people and spots as we could."

Chris notes, "It was all real kids during the actors' strike—but it was a matter of going out and finding kids who would really sing karaoke. We told them, 'We want you to think you're on stage with your girlfriend in the audience and really ham it up.' The three or four ads change out how the kids were singing the same song but all singing it their own way, ultimately making the song their own."

"It was interesting," Jennifer adds. "The kids hadn't heard of these songs but they still really resonated with them anyway. There was no right or wrong when it came to the performances. Even freezing up was sometimes welcome," Jennifer muses. "Embracing diversity calls into question what's cool. Well, everyone's cool."

In keeping with the "lo-fi" approach, they decided to shoot the spots on video, not film. This not only cut costs incredibly but provided the authentic look that they were going for. "It was a minimal experience that allowed for more spontaneity," says Jennifer.

She goes on to relay how shooting on videotape added to the authenticity of the spot. "It was a minimal experience that allowed for more spontaneity, unlike big television productions that are much more contrived," she recalls. Lauding Chuck as a brilliant writer and filmmaker, she appreciates that "there's a certain immediacy in having the process be from the person who conceived it—the person who really understood it. The spot was not directed as much as observed."

With a truck full of jeans and a stylist who went with his gut, the team shot sixty kids in one day. "It was like one big celebration," Jennifer remembers. "Jeff Rohr, the line producer, used to be a linebacker—so he was the perfect person to corral everyone through the process. Post-production was interesting to say the least because there was just reams of material."

At the end of the day, Chuck maintains, "We had a very strong interpretation of what we wanted to do and I never wanted to be on the other end of people asking, 'What's your motivation?'" This was no affront to directors. Producing the spots is simply recounted as refreshing—"like taking twenty consecutive showers"—and a lot of fun; when relating it to the creative process for real musicians, Chuck says that "in a weird way you've done the next generation of Levi's blues. We appreciated the realness of the talent, the anti-Gapness of the world they represent."

Jennifer agrees. "We were looking for charm and vulnerability, and watching the talent I got the feeling you sometimes get as a producer. It's the feeling of your body levitating off the ground. You just *know* you got it and you want to scream it to the world."

So did the team in fact *get it*? For the first time in five years Levi's saw an increase against the core target. And what's more, they found a way to communicate to a market seemingly immune to the overhyped, glossy marketing of mainstream media.

Not to mention they got "Karma Chameleon" into a spot. (Like that wasn't the real victory.)

The first spots in the "make them your own" campaign were simple observations of people in dressing rooms looking at themselves in a pair of jeans they're obviously comfortable with. "I'm more of an observationalist than a writer," says Chuck.

PBS, the American Public Broadcasting Service, has always been a "brand with integrity," states account director Scott Moore of Fallon. They were in a dominant position with an exclusive audience.

"Dishwasher" :30

VIDEO: The screen is completely black except for a small round hole. Through this hole we see some movement. The camera goes directly through this round hole and reveals the whole scene.

SFX: Dishwasher washing.

VIDEO: It's a boy about 10 or so, standing in the kitchen, in front of a running dishwasher. We watch him simply standing there for a bit. Then the dishwasher stops. As soon as it does, the boy immediately opens it. It's full of dishes, pots, pans, etc. He pulls out the still dripping bottom drawer and reaches for something that appears to be illuminated. It's a Ziploc bag. He opens it and pulls out a video camera that has obviously been recording—the red recording light is still on.

SFX: Video camera rewinding.

VIDEO: He rewinds it a bit and presses play. We watch the camera for a bit.

VIDEO: The camera backs out of the scene through the round hole we established at the beginning of the spot. When the camera stops the hole is filled with the PBS logo.

Super: Stay curious (next to logo)

 PBS

But suddenly the Millennium rolled around, and there was a combination of aging viewers and a slew of new academic TV stations. With prime-time ratings suddenly dropping, PBS's position turned precarious. It was time to grow visibility and revitalize a brand. It was time for action.

"PBS used to own the turf of intellectual programming," creative director David Lubars explains. "Then all of a sudden you have the History, Learning, and Discovery channels to contend with, and PBS ends up just looking old."

Scott adds, "When you ask people 'Who is PBS?' it comes back as some stuffy old professor—very smart, but not someone you'd want to spend time with. Channels like Discovery were being perceived as much cooler, hipper, and easier to talk to." Compounding this image problem was the fact that unlike other stations that rely on paid commercials, the only advertising PBS had ever run were fundraising efforts.

So PBS and the team joined forces for some serious brainstorming to find a solution to one crucial question: How could they get people to think differently about the PBS brand? "Other agencies often just go off and 'have a think,' but the answer they come up with often doesn't address all the core issues," Scott contends. "Instead we spent a long time poring over research to try and come up with just the right target."

What they found was that TV viewers generally fall into one of three different "need" states: informational, tranquilizing (brain candy), and stimulating (brain food). PBS, it was clear, was in this last category, so the Fallon planning team then needed to find a way to get stimulation-seekers to tune in PBS instead of the Discovery Channel.

The research was augmented by picking the brains of the executive producers at PBS on how they come up with show ideas— what the motivation is to go out and do the shows they do. Scott tells how "The producers say, 'It's curiosity. That's why I go do this. I'm interested in something and so I'm going to go out and create this whole program.'"

Interestingly enough, viewer focus groups had similar responses for why they enjoy "stimulating" programming. Responses ranged from "I just consider myself a person with a big 'Why?'" to statements like, "Learning separates us from vegetables," and "Humans need to get up every day to learn something."

"What's universally true about people who are drawn to PBS is that they're just curious—intellectually, that is, not in a voyeuristic way," states art director Chris Lange. This shows a young boy who's curious about what happens when you close the dishwasher door and turn it on.

"These viewers feel a love of learning," Scott reflects, a sentiment echoed by copywriter Michael Hart and art director Chris Lange. "What's universally true about people who are drawn to PBS is that they're just curious, intellectually that is, not in a voyeuristic way. We all have that when we're kids and most lose it. But if more people stayed curious during their lifetimes, more would be watching PBS. So let's celebrate curiosity and drive."

They moved forward with a creative brief that simply asked, "Curious?" David remembers how they wanted to "hold up a mirror to viewers and give them credit for being the curious intellectuals they are. The tag line 'Stay curious' seemed to sum it up, and we tried to demonstrate it."

The team started developing numerous scenarios about people simply being curious. "We said—let's not do the usual here. What viewers like about us is that we're uncompromised and pure, not just special. And there are a lot of different executions of this campaign that are exactly that—pure," says Scott. Mike and Chris agree. "We had ideas that were more about other shows, but this one felt pure. It was something big that PBS stands for—that people are curious about everything."

One initial concept that hit the mark was that of a little boy who wanted to know what happens inside a dishwasher during a wash cycle. In the spot, he cleverly Ziplocs a mini camcorder and sticks it in the rack with the dishes and runs the machine, only to take it out after the wash to watch the waterworks on screen. "That idea really emerged as being unique," Mike and Chris relay. "We honed in on the fact that the boy was not just curious, he came up with a unique and creative way to satiate his curiosity. And the idea goes beyond the dishwasher; it goes beyond the appreciation of how things work."

To produce the spots, they were drawn to the work of Errol Morris because he's a documentary filmmaker they recognized could really tell a story. They were to be shot with the subtlety and storyline of a mini film, in part because PBS is "not an in-your-face station; it's thoughtful," David says. "We investigated the look of all colors on the palette."

"Photo Booth" :60

VIDEO:	The screen is completely black except for a small round hole. Through this hole we see some movement. The camera goes directly through this round hole and reveals the whole scene.
VIDEO:	It's a man in his early 30s standing outside a photo booth in a mall. He puts a bunch of quarters in the machine and steps inside the booth.
VIDEO:	Cut to him in the booth, posing in a series of strange facial expressions.
VIDEO:	Cut to him putting more quarters in and repeating the process several more times, each with different facial expressions.
VIDEO:	Cut to a close-up of a dozen or so photo strips that have come out of the machine. He grabs them and the screen fades to black.
VIDEO:	Open on the man in his living room. He puts a record on the turntable and sits down and picks up a small booklet.
SFX:	The scratch of the needle at the beginning of a record. And then Pavarotti singing "Di quella pira."
VIDEO:	As the music starts, the man begins to flip the pages of the small booklet. He's made a flipbook out of the photos from the booth. It's him, lip-synching the Pavarotti piece, with gestures and all.
VIDEO:	The camera backs out of the scene through the round hole we established at the beginning of the spot. When the camera stops, the hole is filled with the PBS logo.
Super:	Stay curious (next to logo)

 PBS

◇ Mike and Chris recount, "For the opera spot, he [director Errol Morris] made us realize we had to cast an opera guy. That's a real guy—he really did that!" This spot involves a guy who's taking strange, amusing headshots in an instant photo booth. He collects the series of freeze frames, takes them home, and makes them into a flip book that mimics his singing to an old opera record.

TV viewers generally fall into one of three different "need" states: informational, tranquilizing (brain candy), and stimulating (brain food). Again we see a child's curiosity get the better of her as she goes over to her barn in the wee hours of the night to see if animals really do sleep.

"Light" :60

VIDEO:	The screen is completely black except for a small round hole. Through this hole we see some movement. The camera goes directly through this round hole and reveals the whole scene.
VIDEO:	It's a dark bedroom at night.
SFX:	Alarm clock going off.
VIDEO:	A bedside lamp gets turned on. In the light, we see we're in a little girl's room. She checks the clock. It reads 2:00 am. She gets out of bed, revealing she's been sleeping in her clothes.
VIDEO:	Cut to the outside porch of an old farmhouse. The door opens slowly as to not make noise, and the girl slips out and starts running toward a barn.
VIDEO:	Cut to the girl right outside the barn wall. She's got a big spotlight that's on and she's grunting as she slowly raises it up against the wall of the barn.
VIDEO:	Cut to inside the barn. A shaft of light breaks the darkness. Seeing the light, a rooster abruptly raises his head and gives a loud COCKADOOOODLE DOOO!
VIDEO:	The camera backs out of the scene through the round hole we established at the beginning of the spot. When the camera stops the hole is filled with the PBS logo.
Super:	Stay curious (next to logo)

 PBS

Another spot in the campaign involves a guy who's seen taking strange, amusing headshots in an instant photo booth. He collects the series of freeze frames, takes them home, and makes them into a flip book that mimics his singing to an old opera record. Mike and Chris give the casting credit to Errol. "For the opera spot, he made us realize we had to cast an opera guy. That's a real guy—he really did that!"

David admits, "Casting is always difficult. It could've been saccharine. You need to know what you're looking for and Errol has this pool of actors who know what not to do. Reality is what you're going for and he knows when to pull back on the reins and not to work it too hard." Chris adds, "The people he casts aren't made of beautiful angles, they aren't epic."

In addition to having a talented filmmaker on the project, Chris is thankful for what an easy client PBS was to work for. "We had a client trust us to arrive at a solution. They were involved but not smothering." With just a single drawn image of the script and no shooting board, they shot most of the spots right in people's homes with one setup, at one angle. "We really just wanted to show a person doing their thing. No more than that—just doing their thing."

What resulted was, in Scott's opinion, "a pretty special campaign. There was a time when we all said, 'Wait a minute; this is going to be pretty good!' But in this case it's hard to quantify the results. The creative was designed to run only on PBS's airtime with the hope that the campaign would be embraced by member stations. Ultimately we had to motivate the stimulation-seekers, but also win over local stations."

Win them over they did. David recalls, "The stations loved them—they kept asking for more and were running them all the time."

Guess they were curious.

E*trade A monkey who does nothing but waste two million dollars. How do you sell that to a client? Luckily, it was possible to not only sell such a spot to a client, but also to have it make perfect sense and be one of the most-talked-about ads on during the Super Bowl.

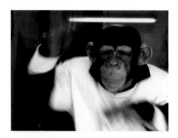

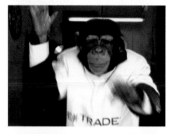

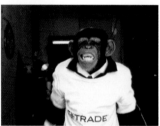

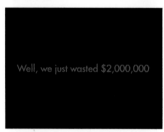

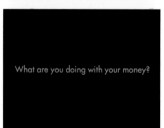

In a Super Bowl commercial that broke all the big budget rules, absolutely nothing happens. Rich Silverstein, partner at Goodby, Silverstein & Partners, even offered to pay for the production of the commercial himself.

The media time was already bought and paid for by E*trade when they came to Goodby Silverstein & Partners for a concept. The Super Bowl is a unique advertising phenomenon. After the holidays are through, families gather around the television one last time in January. And not just for the game anymore: Everyone's paying attention to the commercials. The task of creating a spot for such an event can be quite daunting. People are unusually critical and scrutinize the commercials—from the TV audience to the clients.

In fact, the first round of creative presented to the clients at E*trade did not go over very well, so it was back to the drawing board. Art director David Gray and copywriter Gerry Graf were thinking long and hard about the Super Bowl environment and the challenge ahead. The usual Super Bowl fare calls for enormous, extravagant productions with helicopters and explosions. The team came up with an idea for a spot that was born out of a conscious decision to cut through all the usual hoopla. "What if we did the antithesis of those big productions?" asked David. "What if we just wasted the money?"

Luckily, the E*trade brand had already established itself as one that used humor to make people feel comfortable with investing on-line. Previous executions told people that they weren't going to get rich winning the lottery or having a sugar daddy, so they should consider on-line investing. One particularly memorable ad depicted a man with "money coming out the wazoo."

So the agency and creative team presented their idea, which consisted simply of two elderly men sitting in a garage with a monkey dancing in between them. The kicker? A title card that comes up and says, "We just wasted two million dollars. What are you doing with your money?" The ad was presented and "the folks at E*trade thought we were nuts," admits David, "but we were so convinced that it was a great ad." So much so that Rich Silverstein, partner at Goodby Silverstein & Partners, even offered to pay for the ad production if E*trade was too hesitant to run it.

The folks at E*trade did eventually come around to the spot; in fact, "they thought it was hilarious, but wow, they've always been a great client," remarks David.

David Gray, art director at Goodby Silverstein & Partners, is quick to point out that Brookes the Chimp is not a monkey, even though the titles of these two commercials bear the latter name. David also notes that Brookes is "the best talent I've ever worked with."

Frame #1: Open on two guys and a monkey.

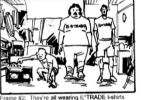

Frame #2: They're all wearing E*TRADE t-shirts and...

Frame #3: there's a boom box blasting next to them.

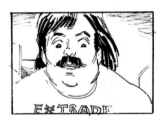

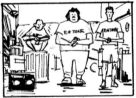

Frame #4: As the boom box plays...

Frame #5: the three of them clap to the song. That's it. They just clap.

Frame #6: After about 20 seconds of this we cut to a Super.

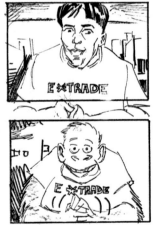

Frame #7: Then we come back and they're still clapping along.

Frame #8: Cut to another Super.

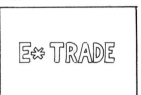

Frame #9: E*TRADE endslate comes up. VO: It's time for E*TRADE. The number one place to invest on line.

ALT. SHOTS

"MONKEY"

After the first round of creative presented to E*Trade was killed, the team presented these storyboards. Although the first reaction was shock and disbelief, the folks at E*trade did eventually come around to the spot. "In fact, they thought it was hilarious," recalls David.

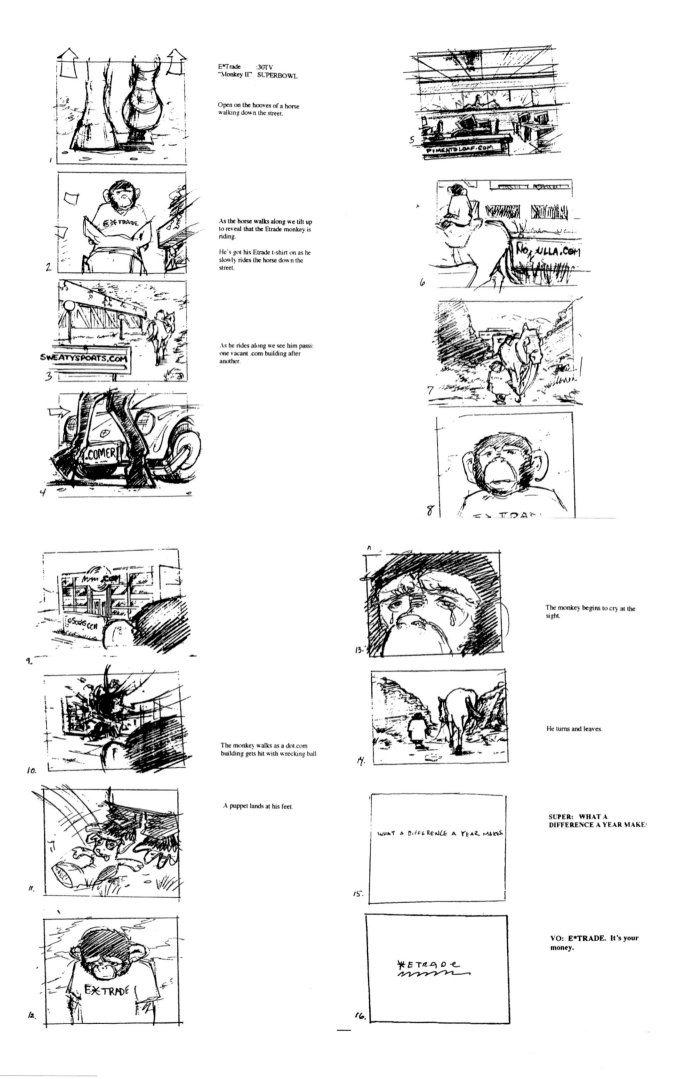

E*Trade :30TV
"Monkey II" SUPERBOWL

Open on the hooves of a horse
walking down the street.

As the horse walks along we tilt up
to reveal that the Etrade monkey is
riding.

He's got his Etrade t-shirt on as he
slowly rides the horse down the
street.

As he rides along we see him passi:
one vacant .com building after
another.

The monkey begins to cry at the
sight.

He turns and leaves.

SUPER: WHAT A
DIFFERENCE A YEAR MAKE:

The monkey walks as a dot.com
building gets hit with wrecking ball

A puppet lands at his feet.

VO: E*TRADE. It's your
money.

The search began for the talent. Brookes the Chimp was flown up from Florida. (David is quick to point out it's "Chimp, not Monkey," even though the title of the commercial bears the latter name). Far from an overpaid prima donna, Brookes in fact was "the best talent I've ever worked with," states David emphatically. "He nailed everything the first time. The two guys next to him had to do take after take, but the chimp was just nailing it."

So the commercial created the necessary buzz, Brookes the Chimp reached instant stardom, and E*trade was happy. But suddenly it's another year, another Super Bowl. David remembers thinking, "I'm not one that is big on sequels. I didn't know if we should bring the monkey back or not." Besides, much had changed since the previous year. By October 2000, many of the dot-coms that had been advertising heavily the whole year suddenly started collapsing.

"But the great thing about E*trade is they're always very timely," and in advertising "we are reflective of the world around us," notes David. E*trade offered a tool to control your finances even during an economic whirlwind. And a whirlwind it was. So the decision was made to bring back the chimp riding through a stylized representation of Silicon Valley—on horseback. As the monkey passes through the ghost town, he passes a Porsche Boxster with the license plate "DOTCOMER" with a police boot locked to its wheel and tons of unpaid parking tickets. A wrecking ball next destroys a building. Finally, the chimp passes a building where a Pets.com sock puppet comes flying out and hits the ground. With a sly nod to a famous commercial produced years ago that showed a Native American crying over litter, the spot ends with a tear rolling down our hero's face.

This time, E*trade's comfort level was much higher than the year before. They understood that the chimp as an icon was a reflection of the company—likeable, friendly, and not intimidating.

Again, Brookes the Chimp far surpassed all of their expectations. "He had never even ridden a horse before," says David. "So many actors have attitudes, but he was an amazing actor, an amazing animal. He's like a four-year-old child, so humanlike." Brookes got so much attention on the set that, says David, "we felt a little bad for the horse." Brian Buckley, commercial director at Hungry Man, was brought back for the second commercial. The first one was so simple, and even though the "dot com wasteland" seemed to be "a bigger production," Brian kept it "much simpler; he did a great job."

The idea of "using humor to make people comfortable with investing on-line" has worked very well for E*trade. The company site where you can go online anytime you want and take control of your finances owns a part of the public's minds and hearts. And it owns a spot in Super Bowl advertising history as well.

Below and opposite: The first commercial created the necessary buzz, Brookes the Chimp reached instant stardom, E*trade was happy. But suddenly it's another year, another Super Bowl. David Gray remembers thinking, "I'm not one that is big on sequels. I didn't know if we should bring the monkey back or not." But he decision was made to bring Brookes back and have him riding through a stylized representation of Silicon Valley—on horseback. This time, E*trade's comfort level was much higher.

Dexter As the adage goes: If the shoe fits, wear it. And in this case, if the creative's a winner, run with it.

Comfort in every box.

They were attractive shoes, but not exactly high fashion. Executive creative director Edward Boches explains, "They do have a real comfort story, but people don't want a dissertation on comfort. People also buy the shoes because they look good. So although the message is one of comfort, the execution needed to be fashionable and contemporary."

So goes the success of Dexter Shoes, whose recent campaign put them in a category of their own and managed to raise the bar for footwear advertising as well.

"Dexter's a great, old, classic American brand," says Edward Boches, chief creative director at Mullen. He tells how, when they got the project, Dexter was a value brand—a good value sold at a lower price. They were attractive shoes, but not exactly high fashion. So what was their real benefit to the consumer? "You can boil it down to comfort," explains art director Michael Ancevic, "It's a single premise that we could own for a while with the creative—a believable place we could go."

Reflecting on the team's first approach to the project, Edward concedes, "They do have a real comfort story, but people don't want a dissertation on comfort. People also buy the shoes because they look good. So although the message is one of comfort, the execution needed to be fashionable and contemporary."

With this goal in mind, the creative team started by focusing on what made the Absolut Vodka campaign so memorable. Michael recognized its use of timeless icons but was left with a tricky problem to solve: How do you find universal comfort icons when comfort is different to everyone? "It might be a chair with a tub of popcorn to one person and jeans with a pillow and blanket to another," he says. Exactly. Herein lay the potential of a print campaign that would include a crisp shot of a good-looking shoe in a relaxed and engaging human environment. All contained within a shoebox viewed from above.

Edward admits he appreciates that Dexter got to present the "big shoe" shot of their product, but that "it's not the same-old, same-old. It's not just another photo of a shoe that never says 'reward me for looking at this photo.' It was a great way to efficiently build our brand equity; there's continuity and yet every ad is different."

Michael also remembers how the Dexter client "didn't want to show people, because suddenly it becomes a lifestyle ad and you're left asking, 'Who's that person?'" Only the most recent batch of print ads have included people, but the creative team could get away with it because the people function as props.

Regarding the concept, Michael admits, "Early on the question was, will it have legs and be personal enough to resonate? And how do we define comfort and where else will we go with it?" But once they began fleshing it out, the answer became apparent: Illustrate different miniscenes with different shoes, each one appealing to a unique audience. "That's one of the cool things about this campaign's potential," he muses. "Everyone has a favorite."

◁ Michael Ancevic, art director at Mullen, illustrated different miniscenes with different shoes, each one appealing to a unique audience. "That's one of the cool things about this campaign's potential," he muses. "Everyone has a favorite."

Comfort in every box.

⊗ ⊗ During the conception of these ads, everyone was worried that they wouldn't be able to continue and build upon the original concept—just as Absolut has for so many years. But by the end of the shoot, the designers had pieced one together and the client loved the campaign, even fighting over which ads they wanted to run.

⊘ They didn't want people to know how the ads were done—to get the best buzz, they "wanted the whole thing to brew," says Michael. The ideal would have it feeling really even, organic, and real. The creatives interviewed four photographers, settling on Greg Sellentin. The set was constructed of both a two-story scaffolding box and a matching background box.

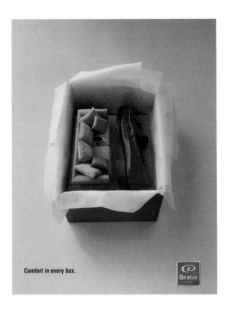 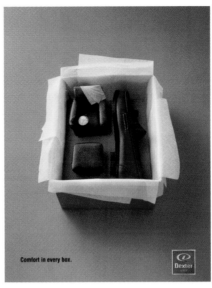 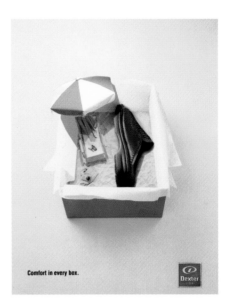

The next hurdle was how to make it happen. Michael shares how they didn't want people to know how the ads were done—to get the best buzz, they "wanted the whole thing to brew." With the ideal of having it end up feeling really even, organic, and real, the creatives interviewed four different photographers, settling on Greg Sellentin.

The agency-photographer partnership was crucial throughout the shoot. As Michael tells it, "We kept the good ideas flowing, shared a vocabulary of established flavor from monochromatic tones to styling evenness." With a handful of Martha Stewart paint chips to choose from, he reveals: "we really controlled the color palette so there was nothing your eye would go to that would be distracting. Even the couch—we didn't pick out some crazy plaid."

Constructing both a two-story scaffolding box and a matching background box, the team brought a Photoshop on set to make sure the overhead shots of the props were going to work. The setup did the trick and the team continued to push the envelope. "We were originally going to have tissue paper lining the bottom of the box, but it was obvious that it was richer with actual bottoms and floors—real carpet or sand. We tried retouching it both ways—with the tissue paper and without—but found the natural bottoms made it look more real and less cartoony."

Formerly planning to have the whole shoebox as the ad, they decided to try zooming out and giving it a little room. Michael says, "The most pleasing was what we ended up with because of the proportion of space around it. The space makes it more fashionable."

No doubt the client loved the campaign, even fighting over which ads they wanted to run. "We kept them involved so there would be no surprises. But once they saw the first photos together there was a sense of happy relief that it all worked and they would have a consistent campaign," Michael recalls. And what wasn't to like? "They're really consumer-friendly. Not overly headline 'ad guy' written. And they still made the shoe-hero more soothing."

In retrospect, it's no wonder the Dexter campaign was such a hit. After all, who doesn't love a soothing shoe-hero?

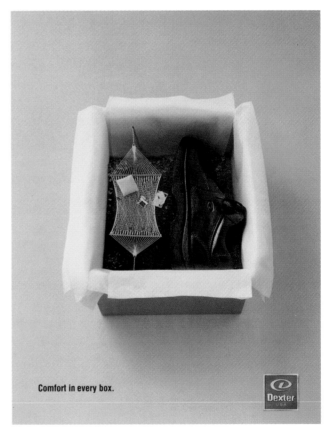

With a handful of Martha Stewart paint chips to choose from, Michael reveals: "We really controlled the color palette so there was nothing your eye would go to that would be distracting. Even the couch—we didn't pick out some crazy plaid."

FreeAgent.com "It's **one** of the **few jobs** where, if I had to **do it again**, **I wouldn't change** a thing."

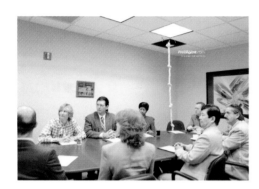

⊘ Creative director Sean Ehringer notes, "It was important to be real and resist the temptation to be too funny with the casting." They went through tons of casting—as would normally be done while casting a TV commercial.

So says Sean Ehringer, creative director, in describing this campaign for FreeAgent.com, a Web site designed for people who are looking for jobs and projects that can be done by solo entrepreneurs.

The project started with a terrific strategy, which was to celebrate the spirit of the free agent. According to the strategy, free agents were described as people who had had the courage to break free from the corporate world. The advertising was to be designed to let them know the people at FreeAgent.com understood them.

Allen Berger, who was then the head of marketing at FreeAgent.com, was described by creative director Harry Cioccolo as "one of the best clients I have ever worked with. He was very closely involved with what the advertising was saying, but trusted us to make creative decisions that he was at times a little nervous about. He understood that to get great communication you have to take risks and get out of the comfort zone."

That makes the rest seem almost simplistic in retrospect—the agency did work that was true to the strategy, they brought a campaign into the client as recommended, and the campaign's concept was approved nearly "as is."

In producing the ads, it became clear early on that because the ads are so dependant on telling visual stories, the photography was the key to making the campaign successful. Not only did the photos need to communicate the spirit of the free agent, they needed to represent the outdatedness of the old-world corporate values. The first decision needed to help achieve that goal was who should shoot it. The creative team "looked at many photographers and spoke to two or three before settling on Melodie McDaniels. She is a terrific photographer who also understands communication," explains Sean.

Next step: casting. Together with Melodie, they treated the casting as if it were a TV shoot. They looked at "a ton of people" and picked the best. Sean notes, "It was important to be real and resist the temptation to be too funny with the casting."

By the time they were ready to shoot, it was still unclear how they were going to achieve just the right look in the photos. They decided to keep it experimental; in the end, each photograph was shot using three different cameras, with no preconceived notion as to which would yield the final photo. There was a standard professional camera, a regular autofocus camera, and a supermarket disposable camera. Sean explains what happened next: "We ended up using the disposable camera prints as reference for the printing because they had the bad, flat, washed-out look we were after. We used the professional prints as artwork because they had the detail we needed."

Although the campaign consisted primarily of print ads, there was one sixty-second television spot as well. The spot documented the life of a company man. We see him spend forty years in a job, get his gold watch on retirement, then leave the building and drop dead of a heart attack. The end line says, "The company man. May he rest in peace. FreeAgent.com. For a brave new work force." The commercial was a combination of print and stills. Noam Murro directed it. The spot was produced by shooting for a day and a half with a combination of 35 mm film, plenty of 8 mm and video, as well as 12,000 stills.

Perhaps one of the best testaments to the campaign's success is that FreeAgent.com is one of the few dot-coms that are still around today.

The creative team credits the success of the campaign to an unusual ingredient: fun. Sean explains: "Tom Christman, Josh Kilmer Purcell, and I had a lot of fun creating the campaign, and I think that's the biggest reason why the ads turned out so well."

◇ Keeping it experimental, each photograph was shot using three different cameras, with no preconceived notion as to which would yield the final photo. There was a standard professional camera, a regular autofocus camera, and a supermarket disposable camera. Sean explains what happened next: "We ended up using the disposable camera prints as reference for the printing because they had the bad, flat, washed-out look we were after."

Dockers A **woman** standing in front of a skyscraper with a **parachute** draped at her **feet.** A man **hang gliding** above an airport runway. A youth playing with a **Hacky Sack** high atop a **forty-story building.**

Both art director Adam Scholes and copywriter Hugh Todd realized that by showing people doing typically outdoors activities in a big city, they could reinforce the idea that the Dockers brand is not only tough and practical, but also fashionable and stylish. It gives people a new reason to believe the brand is really cool.

An ongoing element in Dockers advertising is the idea of cropping the photos so as not to reveal the models' faces. "We didn't want people to get involved in good-looking people with beautiful skin and chiseled cheekbones," explains Adam. "We wanted people to look at the situations and products more."

Two guys carry a canoe past stopped traffic. It's all very stylized, with beautiful models wearing the Dockers clothing. It's fashion advertising with a twist.

Why parachutes, canoes, and hang gliders in a city environment to sell khaki pants? "We were taking a slightly ironic look at the fact that more and more people buy incredibly strong, weather-resistant clothing," explains Adam Scholes, art director at Bartle Bogle Hegarty, a London agency. "The Dockers pants are highly practical clothes that are more appropriate for the great outdoors than traipsing around SoHo. So we thought, why not push that idea a little further." The team realized that by showing people doing typically outdoors activities in a big city, they could reinforce the idea that the Dockers brand is not only very tough and practical gear, but also incredibly fashionable and stylish. It gives people a new reason to believe the brand is really cool.

The single copy line, "No Restrictions," is part of an ongoing theme for Dockers. "It's all about people moving freely in their Dockers clothing and also in their attitude to life," says Hugh Todd, copywriter. "You don't have restrictions in your mind or in your wardrobe."

Another ongoing element that had been previously established in Dockers advertising was the idea of cropping the photos so as not to reveal the models' faces. "We didn't want people to get involved in good-looking people with beautiful skin and chiseled cheekbones," explains Adam. "We wanted people to look at the situations and products more."

When it came to shooting the photography, the team chose Guzman. Guzman, in fact, is a married couple named Connie and Russell. "Very famous fashion photographers," notes Adam. "They've done lots of high-profile work for Evian, Kookaï, etc. We chose them for their distinctive graphic style."

A distinct color palette was developed for each ad. The backgrounds were designed to be relatively neutral, but in each ad there was one object in a bright color that became the focal point of the ad.

Adam and Guzman had the palette in mind by the pre-production meeting. They knew the tones they were looking to achieve across the campaign and also knew they wanted to create a look for each execution where one single color would punch out. They

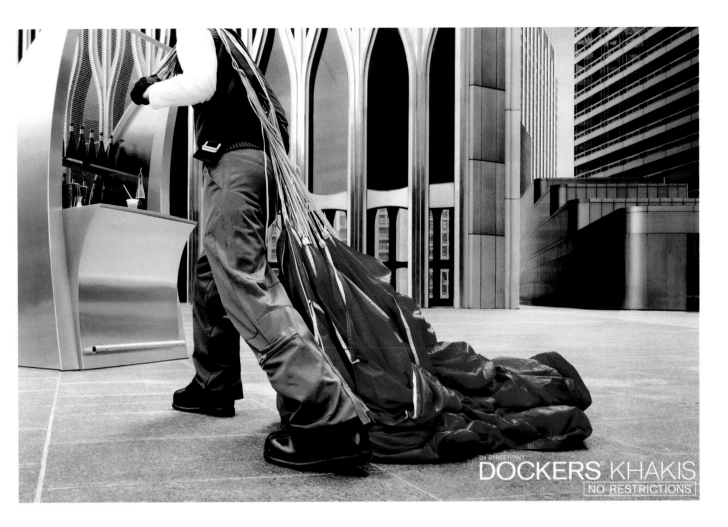

D4 STREETPANT
DOCKERS® KHAKIS
NO RESTRICTIONS

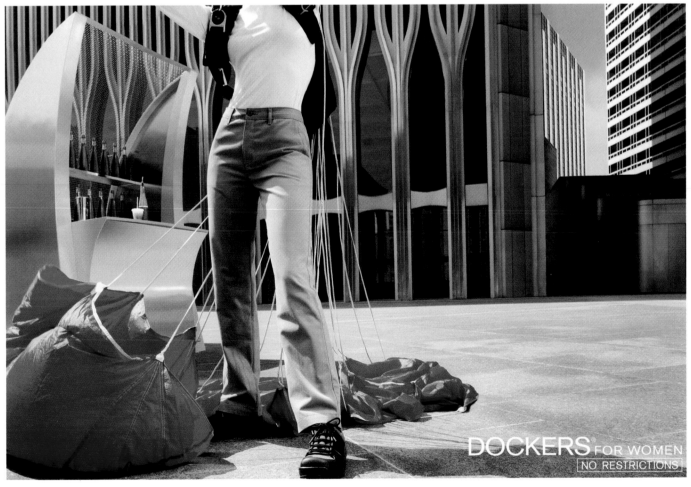

DOCKERS® FOR WOMEN
NO RESTRICTIONS

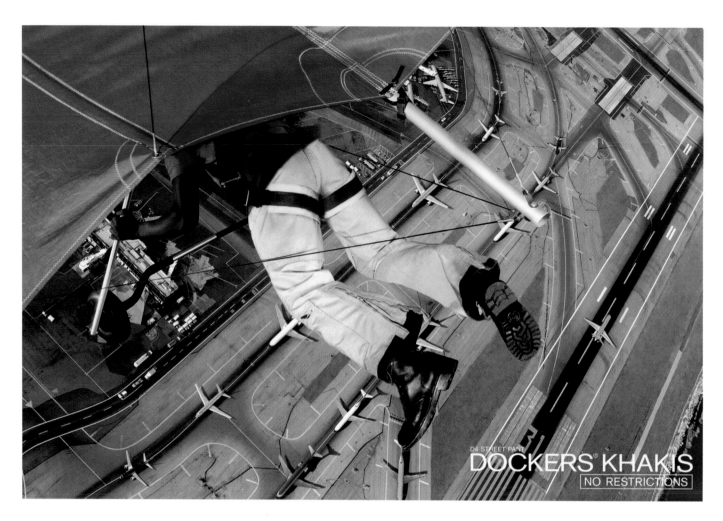

D4 STREET PANT
DOCKERS® KHAKIS
NO RESTRICTIONS

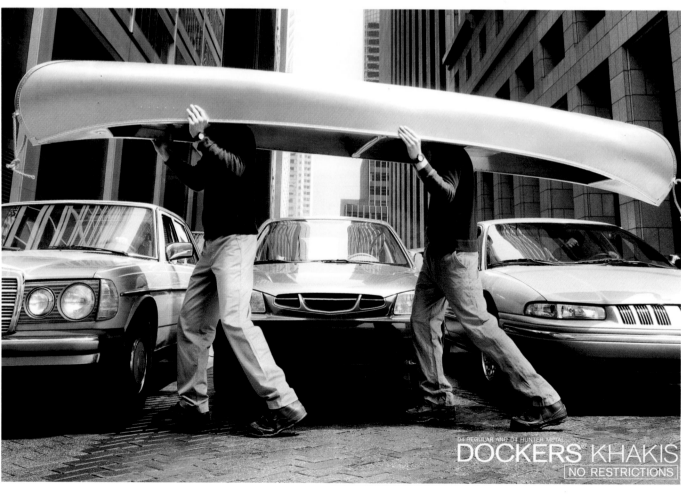

D4 REGULAR AND D4 HUNTER METAL
DOCKERS® KHAKIS
NO RESTRICTIONS

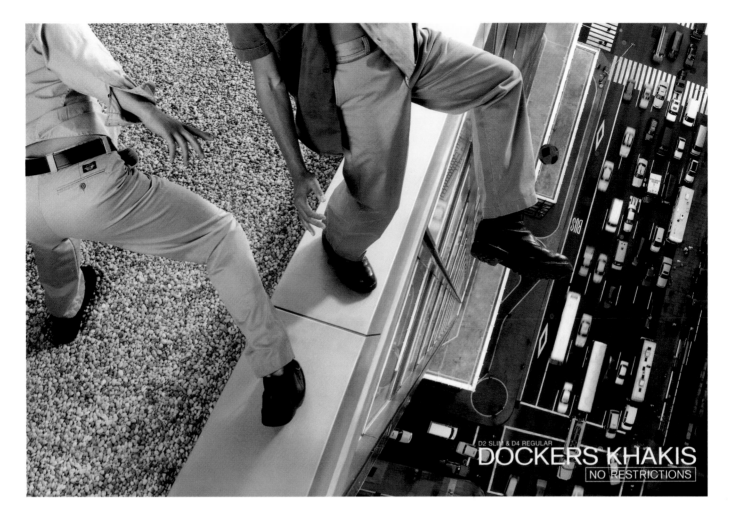

D2 SLIM & D4 REGULAR
DOCKERS KHAKIS
NO RESTRICTIONS

⊘ This one, entitled "Hacky Sack," was shot for real. They brought the two models to the top of a building and they actually leaned over the edge while playing. Although, Adam admits, the camera angle makes the whole scene a lot more dramatic than it really was.

◁ Opposite top: The most complex ad of the series was "Hang Glider." The airstrip was shot for real from a helicopter at an unused airstrip, and some of the planes were duplicated from ones they were able to get that day. Next, the guy in the glider was shot in a photo studio, suspended from the ceiling.

◁ Opposite bottom: For each ad, a distinct color palette was developed. The backgrounds were designed to be relatively neutral—saturated color, but not so much so that the khaki would fade away—but in each ad there was one object in a bright color that became the focal point of the ad.

aimed for very saturated colors, but nothing that would make the khaki tones recede too much. Because they were complicated shots involving locations and models, the team controlled what elements they could and then further refined the color scheme in post-production.

The most complex ad of the series was "Hang Glider." The airstrip was shot for real from a helicopter at an unused airstrip, and some of the planes were duplicated from ones they were able to get that day. Next, the guy in the glider was shot in a photo studio, suspended from the ceiling. "Hacky Sack," which shows a guy right at the edge of a towering skyscraper, was done for real, but the comp made the angle of the models more dramatic.

The campaign appeared in over a dozen countries, including the U.K., Switzerland, Greece, and South Africa, and it ran in a huge variety of fashion magazines, including *GQ*, *Vogue*, *Gulliver*, *Volkskrant*, *Premier*, and *Directions*.

The team is happy with the results, saying the feedback has been very positive. The campaign won an award in Spain, was showcased in *Archive* magazine, and has had good PR around Europe.

eBay was a **company founded**, in many ways, by serendipity. The story goes that **software** developer, **Pierre Omidyar,** started the site simply so his fiancée could **trade** and communicate with other **Pez dispenser enthusiasts.**

As the Pez collection grew, so did eBay—to become a multimillion-dollar company in the span of five years.

The company had been doing just fine without any advertising at all, but eBay believed the time was right to begin to proactively communicate about the eBay brand.

So they set out to do a campaign that fit the culture of who they were, but also to let people know that there was a lot more practical merchandise at eBay, things like DVDs and chain saws. The site was no longer just for Pez-type collectibles—they were selling stuff as large and diverse as a used bulldozer for $23,000.

The strategy was, simply, "Anything you value, you can find on eBay."

"Quirky, but not weird—almost charming," was how Karin Onsager-Birch, art director at Goodby Silverstein & Partners, described the feeling and image of eBay that she wanted the advertising to convey. It's a description that certainly fits with the story of the company's origins. The creative team set out to do a campaign that showed a variety of things of value, and to do it in a way that was charming and slightly offbeat.

As they were working on ideas, Karin and her partner Blake Kelly, copywriter, struggled to portray the idea that merchandise had value. They decided the best tactic was to hook the viewer emotionally by showing reasons people might need valuable merchandise. So a campaign evolved that showed need by the destruction of things of value—with the kicker that it all could be replaced through eBay. Each television spot would finish with a line that summed up the idea: "If you broke it, lost it, wish you still had it, need it cheap, or just can't find it anywhere else. eBay." It was humorous, it was a great way to show multiple objects of value, and it was, well, charming.

⊗ The ads revolved around the tag "if you broke it, lost it, wish you still had it, need it cheap, or just can't find it anywhere else, eBay." To demonstrate the idea, this spot showed disobedient dogs destroying their owner's possessions. Turns out it's not so easy to get a well-trained dog to misbehave. "The dogs kept looking up at their trainers with a look on their face as if to say, 'please don't spank me.'"

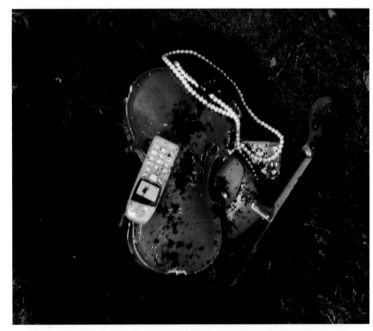

if you
lost it

eBay liked the campaign, but still was not completely comfortable with the thought of "going commercial." To help sell the concepts, Goodby put together "rip-o-matics," relevant images mixed with music and the voice-over to give a much clearer picture of how the advertising would work. Seeing the spots in action won the client over.

Goodby brought in commercial director David Shane in order to have a lot of collaboration on the set. "We didn't have money for special effects, so we did the whole thing practical," remembers Blake. It was a very involved project for what eBay wanted to spend, but the director really wanted to do the gags. They shot in Vancouver to get more production value for the money and because Vancouver is beautiful. "Tom Walter and Maria Lee, both of eBay, were great," remembers Karin. "They understood that we were very ambitious." They worked late nights, every night. "No one ever said, 'Oh, you can't do this,'" adds Blake.

During one of the shoots, dogs were to wreak havoc on the house and bury all of their owners' personal objects, like a violin, cell phone, and string of pearls. But they ran into a few problems. A really well-trained dog isn't supposed to be this bad, so "the dogs kept looking at their owners as if saying 'Please don't spank me.' The dogs were just too smart," laughs Blake. In one scene, the dog was supposed to lift his leg on an ottoman, but instead he circled the ottoman for twenty minutes. The director had to shut the camera off to conserve film, and naturally, the dog finally relieved himself so quickly that they barely got the shot. Another dog was supposed to pull a tablecloth off a table that would send a turkey and the entire set table onto the floor. The dog had been trained to do it perfectly, but in the training everything was made of plastic. When the shot was done for real, the glasses and plates were "candy glass," which is literally made out of sugar. It provides a great way to shatter objects safely, but it also provided something unanticipated by the dog—noise. As soon as the first glass fell to the ground and smashed, the dog ran frantically away.

In another spot, a newlywed couple buys a new home. As the husband carries his wife over the threshold and closes the door with a kick of his foot, the outside porch light falls off and smashes on the ground. This is just the beginning of their home maladies. A refrigerator door falls off, a washing machine moves across the floor, toasters blow up, a bathtub crashes through the floor, and finally, the dormer window falls off the house completely, landing on their car in the driveway. "People walking by the set almost had a heart attack" when they saw that, laughs Karin. The team soon learned that large, inanimate objects don't behave much better than trained animals. The first time the bathtub fell through the floor, it naturally broke into pieces, but not nearly as many as everyone would have liked. It was left up to some poor production assistants to painstakingly glue the pieces back together for a second take.

In controlled scenarios that depict terrible happenings, the eBay team certainly had their share of pitfalls. Thankfully, eBay's Tom and Maria "were very 'roll with the punches,'" Karin recalls. "It was a really fun project, one that makes you think, 'Why can't they all be like that?' There was just a warm wind of goodwill that kept following us."

The first time the bathtub fell through the floor, it broke into pieces, but not nearly as many as everyone would have liked. It was left up to some poor production assistants to painstakingly glue the pieces back together for a second take.

Giro "Every year the campaign for Giro is one of the most difficult assignments to solve," says Alex Bogusky, creative director. "Their brand is about design. And design is one of those fleeting qualities that as soon as you begin to talk about it, it begins to go away.

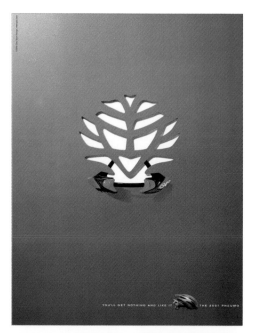

Top: **"Pneumo"** Dave altered the original drawing for the Pneumo helmet to be more aggressive—"more in line with the personality of the helmet." Tom adds that the campaign "says we look at helmets differently, and screams, 'Stop! Look at me!'"

Bottom left: **"E2"** "For the second campaign in the series, 'Nothing,' the design was still a big part of what they wanted to say, but they needed to add a benefit," says Tom Adams, copywriter. The benefit, in this case, was the vent. "We realized a key insight," adds art director Dave Clemens. "You're not buying the helmet, you're buying the holes."

Bottom right: **"Havoc"** When the ads were sold to the client, the agency creatives explained, "What we're going to do to sell your helmet is not show it." The team originally wanted to die-cut the page to show the "nothing" concept, but with a limited budget Dave reversed-out the visual idea instead.

"But it's our job to talk, and we have to find ways for the consumer to see the design for themselves without having us overtly bring it up."

"Giro as a company has a commitment to design," adds Rob Strasberg, copywriter on the "Symbols" campaign. "They try to push the envelope with their products in terms of design, and Giro didn't want a regular ad. They were pushing us to break through." Rob adds, "The first decision we made was to not talk about protection. Everyone talks about protection." Instead they focused on the beauty of Giro's sports helmets, and the creative team soon realized that the helmets themselves are pieces of art.

The creative discussion turned to all the different things the helmets could be, and they realized the design of the helmet could become a symbol of the qualities that the helmet stood for. They tried arranging the helmets into different shapes, different symbols, and as the campaign started to take shape, the creative team knew they had something. "I showed it to an art director down the hall, and he just looked at it and said, 'F*** you,'" says Rob. "I think that's the best compliment you can get."

As for the concepting stage, Rob was not sure the campaign could have been done without computers, as used to be the way. Not so long ago, art directors would pick up a sketchbook and draw the ideas. Nowadays, it's all done on Photoshop, Illustrator, and Quark. These design programs allowed them try a lot of different things in a fraction of the time.

There were a lot of ads that didn't make the cut. One depicted a helmet as a turtle and was discarded because it was a little too obvious, a little too much of the protection story that they had sought to avoid. Others didn't make the cut simply because they didn't work as well—a yin and yang symbol for their black and white helmets, and a snow angel for the white helmet.

As per agency protocol, they presented more than one campaign to the client. This campaign was the agency favorite. As Rob puts it, "It was one of the few times in my career when I just put it on the page and immediately thought we had something terrific. It looked different, it felt different."

The client liked it as well. They intuitively understood that buying the helmet is more of an emotional choice than a logical one. And they realized that the ads represented their feelings about design. The client was also easily sold on the idea that everyone could

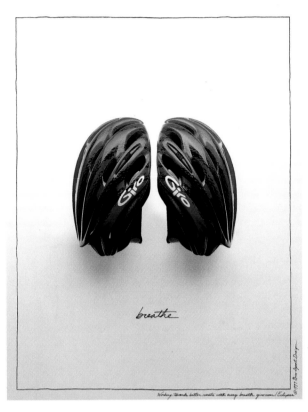

breathe

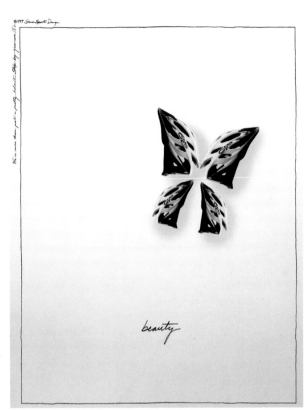

beauty

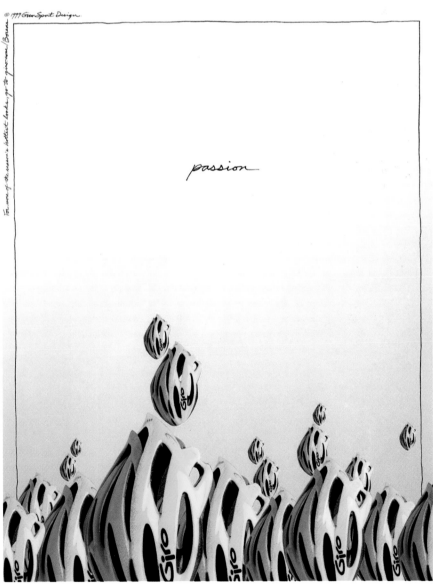

passion

△ Above left: **"Breathe"** The creative team soon realized that the helmets themselves are pieces of art— "beautiful in and of themselves," says art director Tony Calcao. The discussion turned to all the different things the helmets could be. They realized the design of the helmet could become a symbol of the qualities that the helmet stood for.

△ Above right: **"Beauty"** "This ad came after our first meeting with the client," says copywriter Rob Strasberg. "We wanted to make sure the helmets were still seen as tough. We didn't want it to be a granola brand, and when you have a butterfly visual in there, you can start to go that route."

▷ Right: **"Passion"** The client liked the campaign as much as the creatives. They intuitively understood that buying the helmet is more of an emotional choice than a logical one. And they realized that the ads represented their feelings about design.

© Giro Sport Design 2001

get all the info they need from the Web site. The symbols became animated icons on the Web site itself. The one bit of resistance came when the ads had to be sold to the European dealers. "In Italy and Germany, the dealers said they all wanted to see was Lance Armstrong riding and wearing the helmets. But once they saw the ads in the magazines, they all wanted to run them," says Tony Calcao, art director.

Tom Adams worked as a copywriter on the second Giro campaign, the "Nothing" campaign. "The first campaign—the 'Symbols' campaign—was the bar. For the next campaign in the series, the design was still a big part of what they wanted to say, but they needed to add a benefit," he says.

The benefit, in this case, was the vent. Everything that made the helmet great was because of the holes. "We realized a key insight," says Dave Clemens, art director on the "Nothing" campaign. "You're not buying the helmet, you're buying the holes." It seemed simple, but the creative team struggled with how to depict that in a way that would keep the same voice as the original campaign but do something a little different. "We had a lot of headlines that said things like, "What's great about our helmets? Nothing," says Dave. "We kept showing Alex, our creative director, and he kept saying, 'Yeah, yeah, yeah, keep going,'" adds Tom.

At one point, the creative team noticed that someone would start drawing vents before they'd draw the helmet. So they talked about that idea and kept simplifying and simplifying it.

When they finally showed it to Alex, he said, "Oh, that's it."

Giro has made huge leaps in the helmet category. People love the ads and the client is always forwarding e-mails from people saying how much they like it.

Alex explains, "It's one of those assignments that makes people push themselves. After three weeks of concepting without the answer coming to anybody, there is often a feeling that there is no good solution left. Ten minutes later, it's solved."

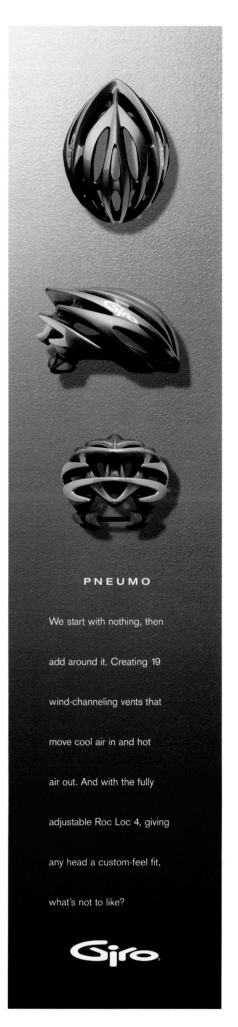

PNEUMO

We start with nothing, then

add around it. Creating 19

wind-channeling vents that

move cool air in and hot

air out. And with the fully

adjustable Roc Loc 4, giving

any head a custom-feel fit,

what's not to like?

Giro

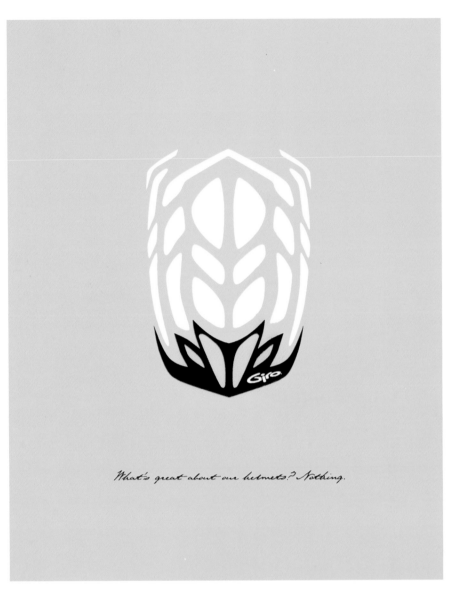

What's great about our helmets? Nothing.

THESE ARE A FEW OF THE
EARLY COMPS. AS I LAID
THEM OUT PEOPLE KEPT
WALKING INTO OUR OFFICE
TO ASK WHAT THEY WERE.
THAT FELT GOOD - THESE
CRAZY SHAPES HAD A
MAGNETIC QUALITY TO THEM.
I DIDN'T WANT TO MESS
THAT UP, SO I KEPT IT
VERY SIMPLE, ALL ABOUT
THE SHAPES WITH THE
ART DIRECTION. THE CLIENT
LOVED THEM. IT WAS
GOING TO HAPPEN.

Comps

Above and Opposite: The creative team struggled with how to depict showing the holes in a way that would keep the same voice as the original campaign but do something a little different. At one point, the team noticed that someone would start drawing vents before they'd draw the helmet. "And then we just kept simplifying it and simplifying it to get the positive and negative look," says Tom.

Corona How can you **sell** the idea of having a **thirty-second** television spot where almost **nothing** happens? **No** dialogue, **no** smiling **spokesperson**, **no** special effects, **no** dramatic **action.**

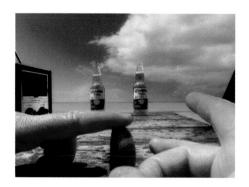

"The whole goal of these spots was to make them like a little vacation on the TV," explains Jim Baldwin, creative director and art director. "The campaign associates Corona with those times when you don't have to worry about anything."

"The whole goal of these spots was to make them like a little vacation on the TV," explains Jim Baldwin, creative director and art director. "The campaign associates Corona with those times when you don't have to worry about anything."

"It's not as if nothing happens," Mike Renfro, creative director and copywriter, is quick to add. "They all have some little twist. You always start somewhere but end up somewhere in another place. It's all very smart and tongue-in-cheek."

For example, in one spot, you see a stone skipping across water and think you're on a beach by an ocean. You see a guy who dumped his pockets out—change, watch, beeper. And the next thing you know, the beeper goes skipping across the water.

Mike describes the germination of the campaign idea this way. "Every day there is something new. There are so many things on TV. The whole idea of drinking a Corona is against all of that stuff that is happening out there.

"What's obvious in all the spots is that the main character is not thinking about all that stuff—he just wants to relax." This spot in particular reminds you that for a while you can just chuck the whole world. The beeper is one little symbol of all of those things.

Mike continues: "The minutiae you go through is amazing. The object being thrown started out as a cell phone. It evolved over the months into a beeper. Then there were numerous arguments and debates over just the beeper—does it vibrate, light up, or what? Finally we got a beeper that did both, so the next question was, should we shoot options where it vibrates only or beeps only."

And for such a simple concept, the shoot itself had its own set of complications. It started with the casting. Mike explains, "We shot all the spots in Mexico. We cast out of Mexico City. There are tons of Europeans. The casting seems easy because all you're really seeing is someone's right arm. But believe it or not, it's very difficult to get a really good right arm. What happens is that a lot of the people who get sent are these beefcake model guys, but we really wanted an everyday type of guy. We cast both males and females. We finally cast a gentleman from Belgium based on

The original script opens on a stretch of beautiful Caribbean water. A stone goes skipping across the water, then another. The camera pans to a Corona Extra, a few stones, and a cell phone sitting on an old wooden table. The stone-skipper is reaching for another stone when the cell phone rings, and he decides to skip the phone instead. The shot closes with his cell phone skipping across the water and the super that reads: "Miles Away from the Ordinary."

Courtesy of the Gambrinus Company

"LAGOON"
TV :30

Video

Open on a beautiful
caribbean water.

Audio

SFX: Waves softly breaking
against the shore. Seagulls
in the distance.

A stone goes skipping
across the water.

SFX: Stone skipping.

Then another stone goes
skipping across the water.

SFX: Stone skipping.

We then reveal a Corona
Extra, a few stones and a
beeper sitting on an old
wooden table. As our guy
goes to grab another stone
his beeper goes off. He
decides to skip the beeper
instead of a stone.

SFX: Beeper sound.

Beeper goes skipping across
the beautiful caribbean
water.

Super: Miles Away From
Ordinary.

SFX: Beeper sound. Fades
and abruptly stops as it
sinks in the water.

 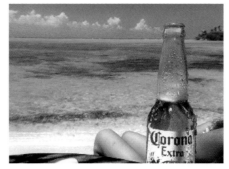

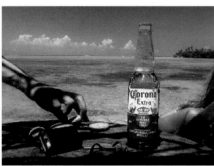 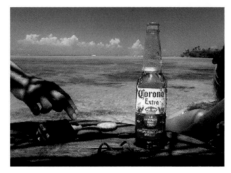 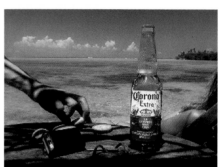

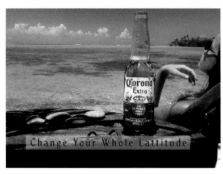

In this spot, you see an arm pick up stones from a table and skip them across the water. A beeper starts to vibrate, so the arm picks that up and skips it across the water as well. The ad closes with a super that reads: "Change Your Whole Latitude." "It's amazing the minutiae you go through with a spot as simple as this," says Mike Renfro, copywriter.

his arm physique and his assertion that he could skip stones across the water." But, alas, on the day of the shoot, he could get it to skip only once, maybe twice at the most. Jim describes what happened next. "So we were there with the talent on this beach in Yucatán, sitting under a big tent that was needed to house the motion control equipment. The director started shouting, 'He's throwing it like a girl, he needs to throw it like a man.' We were aghast; we didn't know what to do."

Finally the account executive said, "Hey, I've been skipping stones all my life." He stepped right in; he was a pro. The creative team later bought him a case of Corona for helping to save the day.

The second problem came from the sleight of hand needed to do multiple takes of the shoot without throwing away a $400 beeper every time. Explains Mike, "The action is that the beeper on the table starts to vibrate. The talent was supposed to pick up the real beeper, then we'd swap in the hollow beeper, and he'd throw the hollow beeper across the water. Then there was a guy who would run out and retrieve the hollow beeper.

"So of course during one take the swap didn't happen and the real one went in the water. If you look on the tape, you can see the guy running out to try to retrieve the real beeper. He immediately realized what was happening, and tried to beat the throw to rescue the real beeper. Of course he was too late. Luckily we had two real ones. So we only lost one." That's the fun of shooting TV.

The team also did a lot of location scouting. "It's always something. I was worried we wouldn't be able to find the perfect setting—we needed the blue, blue Caribbean water, but we also needed some shelter so the water would be really calm and the stone would skip," explains Jim.

The spot was just one out of three or four spots that the creative team concepted. There were many they threw out at the agency. As Jim explains it, "We're always trying to come up with stuff that really breaks through. The ideas can't be too complicated. We often have to force ourselves to discard spots because they are too complicated."

Mike describes an example of how they are allowed to go a little outside the box. It was a spot they did for a promotion for Cinco de Mayo. Cinco de Mayo is a holiday kind of like St. Patrick's Day—you don't really know why it's celebrated, but you know it's an excuse to drink beer. In this spot a guy is walking through the Irish countryside. He opens a door to a pub, and there's a big Mexican party going on—everyone in beach attire. It's a little different because you're not on the beach until the very end.

There is no testing of the spots. The client feels they're the experts. They have a notion of what the Corona state of mind is, and they have a good handle on that. Also, some things are too hard to research—commercials that are this subtle are really hard to research well. Mike explains another hazard of working on this account. "Oftentimes, people will ask me what I do for a living, and when I say I'm a copywriter on the Corona account, they say, 'Okaaaay, you're a copywriter for a spot where you don't say anything.'"

Dunkin' Donuts There was, of course, the famous chase scene with a white Bronco that was immortalized on television just before the O. J. Simpson trial. So how could that be used to sell coffee for a mainstream coffee shop?

According to Hill Holliday's Marty Donahue, the spot was designed to show the "religious affection people have for the brand." That love made it easy to do spots that showed people enjoying the coffee, but in unusual, provocative ways."

Another spot in the campaign in which a hospital patient perceives a nurse changing from beautiful to very ugly was pulled after just one day. There happened to be a nurses' convention in New York the day the spot broke, and one of the nurses was actually giving a talk on the portrayal of nurses in the media so the spot got a lot of flak.

Marty Donahue, a vice-president/creative director at Hill Holliday in Boston, explains the spot's origins. "It was one of the first spots we ever did for Dunkin' Donuts. They were a new client; we had just won the business two weeks earlier. None of the work that had been shown in the pitch was produced."

Marty was working on a campaign with creative/art director Tim Foley. The strategy was a little loose. "We were just working on funny spots. They weren't held together by anything more than the idea that there's a sort of religious affection people seem to have for the brand." That love of the brand made it easy to do spots that showed people enjoying the coffee, but in unusual provocative ways. As Fred Bertino, former president of Hill Holliday pointed out in an *Ad Age* article, "Dunkin' isn't just liked by millions, it's adored like no other brand in its class."

Two other creative teams at Hill Holliday were working on much more traditional campaigns. Marty and Tim's was obviously the wild card. They had twenty different spots, which, as Marty puts it, "were all over the place."

Eddie Binder was the head of marketing at Dunkin' Donuts at the time. And Marty explains why the presentation meeting with Eddie went so well. "Talk about serendipity—unbeknownst to us, he had just gotten his head handed to him by a bunch of the franchisees. The franchisees were up in arms; they had seen the latest round of spots done by the previous agency, and they had really laid into him. 'Why can't the commercials be funny?' the franchisees demanded."

So the meeting opened with the solid, traditional commercials being presented first. Then Marty and Tim got up, and they were very honest. They said, "You can certainly do a traditional, logical campaign like the ones you just saw, and they'll be great. But the reason we're here today is because we just wanted to do funny spots." Well, apparently the clients' eyes lit up before the first board was turned around. "Chase" was the first spot presented, and as soon as the team was done presenting it, Binder said, "I will buy that spot right now. Let's shoot it tomorrow." The timeliness of the spot added to its appeal. The O. J. thing had just happened, so it was fresh in everyone's mind.

By the end of the day, the Dunkin' Donuts client bought fourteen of the twenty spots that were presented.

This TV spot shows police in hot pursuit of a red pickup truck. Both pull into a Dunkin' Donuts, the man on the run goes into the store and comes running back out with coffee and a donut, and they resume the chase. Marty, CD/copywriter on the spot, recounts, "It was a helicopter shot and there were murderous thunderstorms rolling in....They ended up being able to shoot for only about forty-five minutes...but it kept the spot feeling so raw and simple."

Producing the spot itself was nerve-wracking for all involved. It was the last spot being done out of a group of five or six commercials that were all being shot together. The plan was to have eight hours of shooting, but it was a helicopter shot and there were murderous thunderstorms rolling in. In order to stay in budget, they couldn't go another day of shooting. They ended up only being able to shoot for about forty-five minutes. Everyone was panicked, thinking, "We can't possibly have enough film to make a spot." But in the end, it was enough to tell the story, and it's part of what kept the spot feeling so raw and simple.

Marty says there were surprisingly few negative responses to the spot. There was one call from the head of the state troopers in Maine, who thought that policemen were being portrayed in a negative light. But that was it. There was another spot that ran that Dunkin' Donuts had to pull after just one day (a spot where a patient in a hospital perceives a nurse changing from beautiful to very ugly) because there happened to be a nurses' convention in New York the day the spot broke. One of the nurses was actually giving a talk on the portrayal of nurses in the media, so that spot got a lot more flak than the "Chase" spot did. "Chase" just seemed to have universal appeal.

And overall, the client, who's not at the agency anymore, had the philosophy that any publicity is good publicity. He wanted to do anything he could to put Dunkin' Donuts back on the map. They had used Fred the Baker for so long—and as much as Fred was a solid, memorable, brand-building character, he was unfortunately just getting too old. When the previous agency shot with him, he just didn't have the stamina needed to stand in front of a camera for hours at a time. So Fred retired gracefully, and the next wave of "let's just do funny spots" came along.

One of the most gratifying things to Marty is that all the people at Dunkin' Donuts look to that spot as one of their all-time favorite commercials in the history of Dunkin' Donuts advertising. The commercial has certainly won a lot of awards, but to have the client hold it up and say, "This, this was a really great spot" is a tribute not often replicated.

Carrier
People usually don't think of **air conditioners** as **sexy**, powerful, **fast machines.** But a **campaign** from a small shop in Singapore called **10 AM** is bent on **creating** precisely that image through a series of **simple ads** with **arresting visuals.**

Carrier is an American-based company, founded by the original inventor of air conditioning. As the story goes, a gentleman by the name of Willis Carrier designed the first air conditioner for a frustrated printer whose inks and papers would not stay stable enough to print properly in the heat and humidity of Brooklyn, New York, in the summer of 1902.

The Carrier company grew into one of the leading air conditioning companies in the world, creating air conditioning systems that cool everything from the Sistine Chapel to the Library of Congress. And they eventually built a product, the Carrier IES System, which was designed to be the most powerful and fastest-to-cool system ever. So when creative director and agency owner Lim Sau Hoon got the assignment, the brief was simply to tell the world about the power and speed of the system.

Lim Sau Hoon worked with art director Eric Yeo and writer Lim Soon Huat to come up with the creative concepts. The decision was made early on to dramatize visually the claims that the Carrier IES System cools faster and more powerfully than other systems. So the team, as Hoon puts it, "directed their thoughts toward visuals that suggest maximum speed and power." The concept was not a hard sell to the client. They understood the idea immediately and were sold on the idea of the ads being visually driven and not copy heavy. In fact, there's no copy to be found on the ads—the visuals say it all. Hoon explains, "They are a great client, they like the clean look."

Then the production of the ads began. For the cheetah ad, they started off by picking a trans of a cheetah shot in high speed so there wouldn't be any motion lines. The angle of the running cheetah also had to be a perfect side shot, with a clean silhouette, to pull off the illusion. The cheetah picture was then blown up really big. Next, an acrylic mock-up was made of icicles that exactly matched the cheetah's running pose. This acrylic mock-up was placed on the cheetah picture and the whole thing was photographed. Finally, digital imaging was used to make the entire visual more 3-D.

For the volcano ad, table-size acrylic mock-ups of both the volcano and ice were made and photographed together. A trans showing a satellite shot of a swirling hurricane was picked. This was digitally placed upside down onto the volcano picture. More digital imaging was done to match the colors of the ice with the clouds.

Despite such a complicated process, the team was "pretty confident" right from the start that it would turn out well. They showed due diligence in the search for just the right photo illustrator. His skill level was such that Eric, the art director, only had to go back and forth with the illustrator a couple of times to get it looking just right.

The client loved the resulting ad because of its sheer visual impact. The ad was also very effective in that their sales target was met. The ads themselves were also creative successes; they were featured in the *Graphis Annual* and *Lurzer's International Archive*. Perhaps made easier because of a product that started out very, very cool.

This shot of the cheetah was taken from a high-speed photograph so there wouldn't be any motion lines. The angle of the running cheetah had to be a perfect side shot, with a clean silhouette, to pull off the illusion. The team then blew up that photo really big and built an acrylic mock-up for the icicles that exactly matched the cheetah's running pose. This acrylic mock-up was placed on the cheetah picture and the whole thing was photographed.

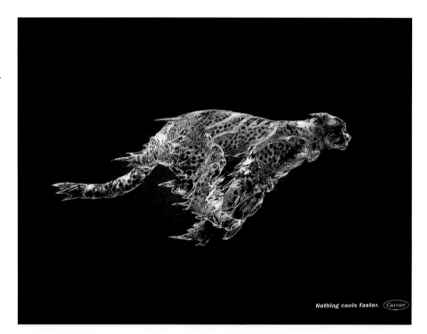

A satellite shot of a swirling hurricane was digitally placed over the volcano and the same acrylic mock-up was made for this photograph. The team chose to show images of things that symbolized "maximum speed and power" to show the cooling power of the new Carrier IES System.

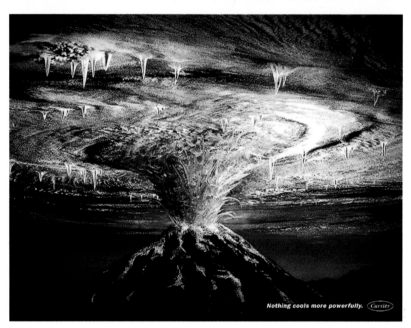

Reebok The adage is that when you're number two, you have to try harder. And if there's a big, giant monolith in front of you that zigs, you need to zag. What better way to do that than in a campaign about defiance?

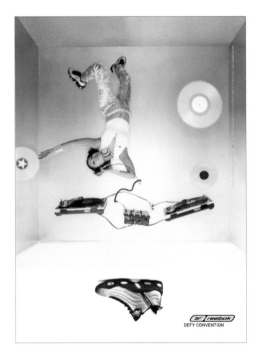

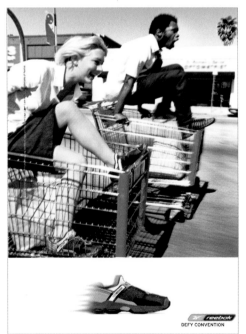

Ewen Cameron, creative director at Berlin Cameron & Partners, talks about the campaign's beginnings. "The campaign originated in Australia. We were down there with Reebok for the Olympics. What really struck us was how much overkill there was for Nike. We knew that Reebok had to have the ability to differentiate themselves from Nike—kind of the way Apple was when Microsoft was appearing to take over the world."

Nike, the number one player, was an institution. Reebok, a distant second, needed a positioning that said, "This is what we stand for," and said it loudly. "We really wanted to put a stake in the ground," states Ewen.

The campaign idea also really supported the athletes that Reebok already had as celebrity endorsers. "Venus Williams and Allen Iverson fit right into the campaign because they are that way," explains Ewen. "They are athletes that truly defy convention."

So the opening spot consists of a barrage of images, all supporting the idea of "Defy Convention," along with type supers that tell other things worth defying, such as "expectations," "red tape," "physics," and "the man."

Creative/art director Jason Peterson explains how all the images were developed. "We worked for weeks and weeks to develop the different vignettes. The director, Brian Beletic, helped us come up with a lot of the vignettes." Although the bulk of it was shot by Brian in New York and Los Angeles, there was a crew of six different directors that traveled around the world—Thailand, Los Angeles, New York, Paris, and London—to get different vignettes. The campaign is a global campaign, and one of the first times Reebok ever had a consistent global campaign. "We were constantly struggling to come up with different scenarios," says Jason. "We tried to create a sense that it was all really authentic, to have people say, 'Wow, that really happened.'" Ewen adds, "We weren't trying to do anything for shock value. We were always trying to keep it authentic, to cast real people who really did the things they were showing."

"We consciously tried to really make it require repeated viewing—to have people ask themselves, 'Did I see that?' People see something different each time," says Jason.

Top: The print has still images of people doing unconventional things, and it works well with a worldwide audience.

Bottom: "Shoes had to be part of the idea. We really wanted people to say, 'Oh my God,' Reebok sells those shoes," says art director Jason Peterson.

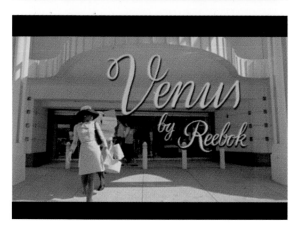 "We knew we needed different spots that would talk about 'Defy Convention' in a completely different way. So by showing Venus Williams in a fashion way, it really does defy convention. Being able to execute the campaign in completely different ways makes the campaign so much stronger," explains Jason, about this commercial that portrays tennis superstar Venus Williams as a fashion goddess.

Reebok International Ltd.

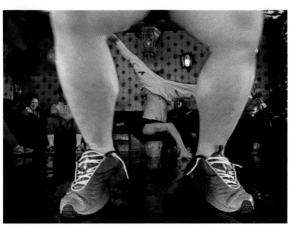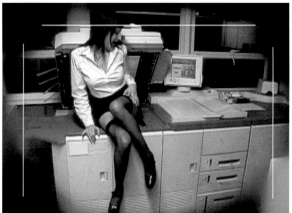

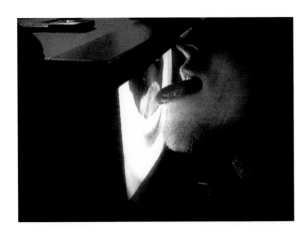

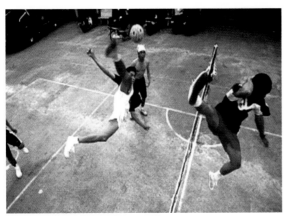

In a fast-paced series of up to sixty vignettes set to the "William Tell Overture," this commercial shows different scenarios of people defying convention. Whether it is someone streaking through a golf course or an elephant playing soccer, everyone has their own style of rebellion. "Network clearance is very tight," explains Jason. "We had to make a lot of changes before we could get it on the air. For example, the guy running naked across the golf course had to be really pixilated. But we were still able to get some stuff across that you wouldn't normally see."

And the music? Gioacchino Rossini, meet Josh Davis. Rossini wrote the "William Tell Overture" 172 years ago. The creative team "loved the energy and pace of it, but we knew we wanted to update it somehow, to not just use a classical piece of music." Director Brian Beletic recommended using Davis, aka DJ Shadow, a hip-hop artist known for his experimental re-mixing. The result is fast-paced, funky, and mesmerizing with the blend of images.

What were the results of this campaign? "When the research came back it showed incredible likeability. I was actually surprised; I thought it would polarize a little more," says Jason. "Even people that were a little older liked it, people who we thought would find it too fast." How fast was it? "There are fifty to sixty vignettes in each sixty-second spot. It was originally even faster, but it got cut down because of the need to see different things—athletes, shoes, etc."

For a shoe company, it was surprising that the client didn't complain at all about the amount of time the shoes were on the air. The creative team worked closely with the client, and always knew shoes had to be part of the idea. People had to make the connection that Reebok makes shoes that defy convention as well, or the spots wouldn't work. While the client didn't complain that the shoes were up there for only a fraction of a second, they did get a little squeamish when told of the intention to blow up the shoes at the end of the spot. Still, they understood how it fit in conceptually. A blurb on the Reebok Web site that talks about both the brand campaign and the product line states, "Reebok's intention is to confront consumers with a product that will blow them away."

Ewen expects that "Defy Convention" is a theme that will be able to carry through for a long time. "A big part of the campaign now is asking ourselves what will develop next year—how do we top that?"

SPCA of Singpore

Everyone knows how many words a **picture** is worth. And **in this case**, a picture is also a **valuable** tool for the **SPCA** of **Singapore** to get widespread **awareness** of its **lost and found** program.

Each photo had to seem as if it really could have happened in order to work. (Photographer AlexKaikeong Studio)

The SPCA (Society for the Prevention of Cruelty to Animals) had been receiving up to seventy reports a month of missing pets, but most of the time they were not the same pets that were ending up in the animal shelter. They would advertise the pets they found in the local newspaper, but many people didn't always think to look there. So letting people know that the SPCA can help locate a lost pet would increase the chances for a reunion.

Copywriter Priti Kapur and art director Koh Hwee Peng had been working together as a team at Leo Burnett Singapore for just over a year. They had done several campaigns together that they really liked, including the "Enemy Fighter" ad for the Singapore Air Force that got a nomination in the One Show in 2001, a public service ad about drunk driving for *East Magazine,* and a television campaign for breast cancer.

So the pair was excited to have the opportunity to help the SPCA. The brief was simple: Find a simple, memorable way to let people know that the SPCA can help locate a pet should it get lost. Koh explains the germination of the idea. "We wanted to show how easy it is for a pet to get lost and so we came up with various images of animals camouflaged into their daily surroundings. We threw out anything that wasn't simple and memorable, and of course it had to be in a natural setting. Finally, we found a stock transparency of a dog whose hair pretty much looked like a mop, and we knew we'd hit upon something."

The image of the dog was retouched by the agency so that when the idea was shown to the client it looked close to a finished ad. "It was almost like a visual trick, and it had to be presented pretty finished to make it happen," says Koh. "It wasn't going to be easy to explain."

Next, Koh got together with photographer Alex Kaikeong to work on the lighting and layout for the whole photographic composition. They decided to use the stock transparency of the dog for two reasons: It worked really well, and because it was for the SPCA, "We didn't want to upset any animals."

After the shoot, the next step was retouching. This ended up being relatively simple because Koh and Alex had already worked out most of the visual. Also, as Koh explains, "Phenomenon, the retouching studio, understood easily how I wanted the picture to be, which was pretty tricky as the dog had to be there and yet not there." The retouchers also elevated the combined photograph by making the mood and color just right.

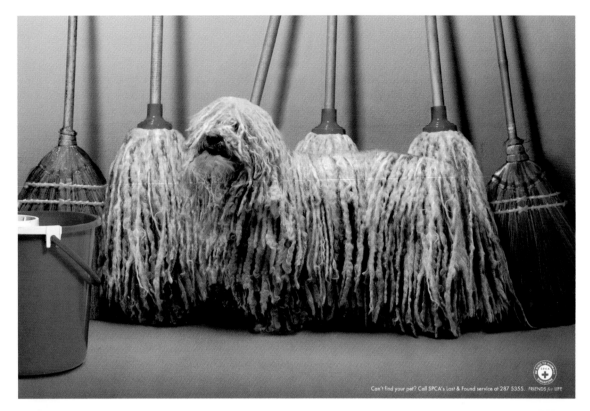

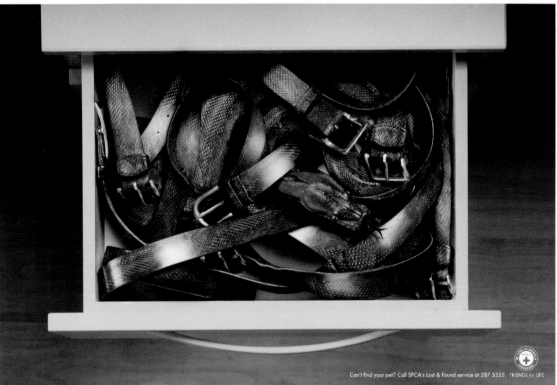

⌃ Top: This striking photo becomes an optical illusion. Is the dog made out of the mop, or the mop made out of the dog? (Photographer AlexKaikeong Studio)

⌃ Bottom: Images that weren't simple or memorable enough were discarded. This snake in the belt drawer easily fit both criteria. (Photographer AlexKaikeong Studio)

As for the results, not only did the campaign achieve its objective of bringing about widespread awareness about the SPCA's lost and found service, the SPCA also had large numbers of people calling to find out if they could buy the poster version of the ad and put it up in their homes. There was also a slew of calls asking if the dog was made out of the mop or the mop out of the dog. Some people called wanting to adopt the dog. The campaign was adapted into bus shelters, posters, Web banners, and the like. The creative team was thrilled when the client called and told them that SPCA India wanted to run the ad there. The ad also won many awards, including D&AD in London.

BMW Motors "Whenever I work on an **assignment,** I always sell **myself** on the **product,**" notes Steve Sage, **art director** at Fallon.

How do you get the perfect beauty shot? Art director Steve Sage says that for him, it comes down to color. "We love silver because it catches every nuance of the car. Black acts as a mirror, and white would be really flat—but with silver, the light hits it beautifully. Most still shots are taken at sunup and sundown for more effect."

Steve acknowledges that his agency, Fallon, doesn't often do the promotional price ads for BMW. "We know that it's hard to do them really well." Initially they wanted a comedic voice for the ads, but opted for "a touch of humor, it's more of a confident smile and a nod."

Not that anything with a Bavarian Motor Works name on it is a particularly hard sell, but this assignment was an unusual one for the team. They had to give the luxury car a hard-hitting price message.

"In general, we don't do any price ads at our agency, we only do the branding ads for BMW," he explains. "There are other agencies that work on the promotional price ads and we know it's hard to do them really well." But Steve and creative director Bruce Bildstein, who had previously worked on Porsche, also knew the BMW X5 was no ordinary product.

"BMW is all about driving and performance," Steve relays. "For years, BMW wouldn't put cup holders in the cars because they didn't think they were about the driving. And even though it's a luxury model, it's still about the driving. Some people expect a luxury car to float along, but it just holds the road; I've even gone on test drives with race drivers."

With the campaign as a whole, the team pursued a tone they felt fit with BMW's brand image as a maker of superior performance vehicles. "As with any client, there's a period of time when you're in search of a voice for them," Steve tells. "So, for example, at first there was comedy voice, and it was all over the place. But then we landed on a voice that, although there's a touch of humor, it's more of a confident smile and a nod."

Translating the smile-and-a-nod combo to a price-and-item ad was the bigger challenge. "It has a lower starting price than people expect, and we wanted to convey that in a really sophisticated way," he adds. "But it was a small box we had to work in. The cars had already been shot for other ads, so any idea we came up with needed to start with a preexisting photograph."

Staying true to BMW's biggest selling points, Steve goes on to explain how the "Closer than you think" print ad focuses on the car's engineering and technical merits. No doubt passion for the campaign derived from some of his own experiences. "I'm not a car guy, but once I started test-driving I realized that the cars are really different. The steering is tighter, the gas pedal is tighter, the brakes grab a little more."

When asked about the dynamic of a car shoot, Steve shares a few insider's tricks. "For moving shots," he reveals, "the camera sits on a big rig with a long arm. Then someone stands behind the car and pushes it about four feet, or if it's on an incline, they just put it in neutral and let it go. It's such a long exposure that it doesn't have to go very far or very fast to give the illusion of speed. You can even have it roll backward to get the same effect."

The photographs themselves—like almost every car photograph

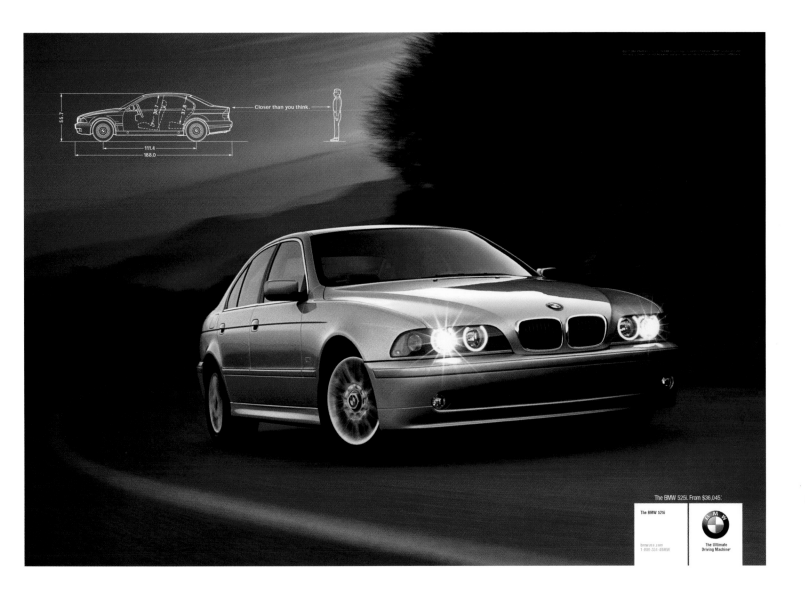

you see in an ad—is actually composed of ten or twelve shots. "We take the headlights from one, the wheel spins from another," Steve says. "The two kidney grills right in front are signatures for BMW, so we make sure those are prominent in every shot— shooting them separately if needed for more detail and clarity."

As far as getting that perfect beauty shot, Steve adds that for him, it comes down to color. "We love silver because it catches every nuance of the car. Black acts as a mirror, and white would be really flat—but with silver, the light hits it beautifully. Plus, most still shots are taken at sunup and sundown for more effect."

Long before setting up on location, however, Steve tells how the creatives put in their fair share of time at the drawing board. "If these were just beautiful car shots with headlines, they would look like every other car ad," he reasons. "So we always try to break the mold, and everyone included tries to outdo each other with headlines. For a project like this, we usually think up thirty to fifty concepts for each ad. Then, when you get something you

like, the creative director still makes us do more. By the time the ads get to the client, it's the easy part."

An enviable position facilitated in part by the nature of BMW itself. "They're an excellent client," Steve relays. "The three deci- sion makers are almost always in the room together and they look at the stuff and make a decision based on gut instinct. For these ads, start to finish was a fairly short time frame. For a new car launch, you can work on a campaign for a year to a year and a half. It's a pretty smooth process because they know what they want so there's not a lot of waste."

At the end of the day, enjoying the kudos this latest round of ads has received, Steve no doubt is in good company when he finds himself wondering, "The question for me becomes, how do I beat what I did last time?"

Sound familiar?

Kookaï "A **perceptive** psychological portrait of young **teases** talking about their **male conquests**," was how **vice-president** and chief creative officer Anne de Maupeau **described** the very first **campaign agency CLM/BBDO** did for **Kookaï.**

"There was no allusion to sex, as most of the twelve- to thirteen-year-old girls had never had sexual relations. The overall effect is highly provocative, as the girls speak like children in the hooklines but are incredibly made-up and sexily dressed."

At the time, Kookaï stores sold cheap articles, and those young girls were the customer base. In their wake, they brought in older customers—often their mothers—who wanted to play Lolita and had bigger budgets. As a result, prices went up and the target shifted.

By the mid-'90s, the campaign began to feature slightly older women and their games with men took a more sexual turn. Yet the agency and the brand felt it was important to keep the freshness and impertinence of childhood. In addition, the campaign had gone international, so the agency dropped the headlines (or "hooklines," as Anne describes them) and went for purely visual communication.

The last part of the '90s was seen by the agency as "being the era of girl power," so they came up with an even more provocative idea. The campaign evolved into "miniaturizing men—the stronger sex—to convey their domination by women. Through their size, they were turned into toys and, in the step after, willing little slaves," explains Anne. Shot by the photographer team of Guzman, the ads were whimsical, attention getting, and provocative all at once.

Since the campaign was evolving into a "can you top this?" effort, it was up to the creative team of Guillaume de La Croix and Frédéric Témin, who had to think up something worse to happen to the men than the year before. So what's the worst that could happen to a man? To lose his heart for love, to have it literally ripped out of his chest by a woman. Thus, the team came up with the idea of a visual of men with nothing on except for a huge scar where their hearts once were.

Kookaï boss Jean-Lou Tepper is a tremendous advertiser who knows just what advertising does and doesn't contribute to his brand. His relationship with the ad agency is based on mutual trust, which Anne describes as "all too rare in this business in France. When Jean-Lou doesn't like something, we don't press the point; when he is hesitant and we are convinced, he goes along with us. When he saw the scars campaign, he pulled a face and said 'Are you sure?'"

⬡ Top: What's the worst that could happen to a man? To lose his heart for love, to have it literally ripped out of his chest by a woman. This is CLM/BBDO's latest "can you top this?" effort in a string of female domination concepts.

⬡ Bottom: When the Kookaï boss man saw these ads for the first time, he asked, "Are you sure?" When the agency is convinced that the ads will work, though, he will go along with them because of the mutual trust that has been built between them.

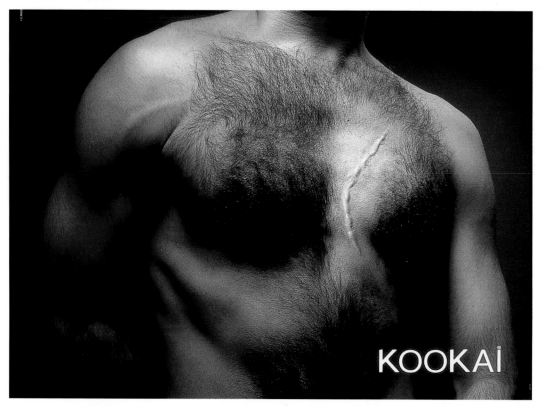

Top: CLM/BBDO decided to crop the heads of the male models in the photographs so they could "go against the prevailing trashy trends by giving the visuals a painting-like treatment suggestive of El Greco or Rembrandt," remarks chief creative officer Anne de Maupeau.

Bottom: When the ads first hit the public, some people did not instantly decode the metaphor that the scars symbolize the emotional hurt inflicted on men, but due to the insightful branding efforts of Kookaï over the years, everyone understands at least that Kookaï women are so attractive that they make men suffer, recalls Anne.

They were. So with approval firmly in place, the creative team set out to produce the ads and show "the systematic aspect of a Kookaïette's power." One decision made early on was to crop the photos so you cannot see the men's heads—thus giving the perception that women with Kookaï's powers could tear any man's heart out. Anne notes that they also wanted to "go against the prevailing trashy trends by giving the visuals a painting-like treatment suggestive of El Greco or Rembrandt." For the casting of the models, photographer Vincent Peters looked for bodies that represented every category of man, yet were handsome. For example, the heavy man is in fact a twelve-year-old boy, chosen for his fine, diaphanous skin. Finally, the scars were made for the live shoot by the makeup artist from *Star Wars*.

The reactions to the campaign were many and varied. While some people did not instantly decode the metaphor that the scars symbolize the emotional hurt inflicted on men, everyone understands at least that Kookaï women are so attractive that they make men suffer. And even if reactions to the campaign were less overwhelmingly positive than in previous years (some people were shocked by it, which, according to Anne, was never the intention), they are glad they did it. The message is all the more obvious because it has been a constant throughout the brand's advertising history. Campaigns have always been about Kookaï women's power of seduction and based on offbeat humor. Whatever the case, the campaign was a real talking point and was consistently attributed to its originator, Kookaï.

Photographer Vincent Peters looked for bodies that represented every category of man, yet were handsome. In this photo for example, the heavy man is in fact a twelve-year-old boy, chosen for his fine, diaphanous skin. Finally, the scars were made for the live shoot by the makeup artist from *Star Wars*.

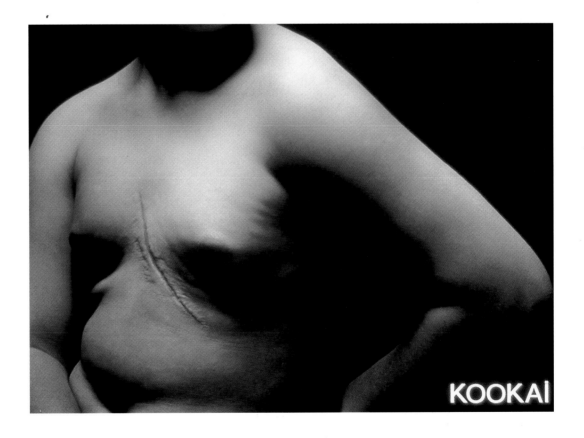

Skittles An odd, **childlike** voice whispers, **"Taste the rainbow."** It's a **surprising** way to **advertise** candy, and it started with a **question** by Paul Michaels, CEO of **Skittles.**

"He wanted to know if we could do something with the rainbow, because rainbows had always been part of their packaging," explains Dave Swaine, VP/creative director on the account. "Our first reaction was, 'Silly client, rainbows are for kids.'"

It took the agency, D'Arcy Masius Benton & Bowles, all of about five minutes to get over that. Once they looked around, they realized no one was using rainbows in a really cool way. The rainbows seen on television were indeed almost always very juvenile and cartoonish. None of them looked like real rainbows. Real rainbows, the agency thought, should be mysterious and unsolved. Besides, the team realized, the colors in a rainbow actually deliver the fruit flavors of Skittles. There was a strategic rationale for the idea. As Michael Smith, VP/creative director for art, noted dryly, "It all seemed to make sense."

So the agency decided to dust off an abused icon and, since no one was doing rainbows in realistic computer-generated images—do it right.

In the first spot created, a farmer plants a handful of Skittles, which later sprout dramatically into a fully realized rainbow. Ron Crooks, managing director/chief creative officer, notes "how simple and pure the idea is." It really gave them an opportunity to represent, "This is where Skittles comes from."

Despite the campaign's seeming simplicity, it was actually the product of quite a bit of research. Even though the campaign just prior to this one was very successful, there was clear drop-off of Skittles buyers when they reached age seventeen or eighteen. Mike notes, "We wanted to extend the age range of the people buying the product upward. We wanted to make it appealing to twenty-year-olds as much as younger teenagers. We discovered that it was really important to not talk down to them. So we decided to make the spots be more mystical than magical."

To do so, the team strived to make sure that all of the imagery was not literally connected to the story line. "We took the work to kids in a qualitative setting and got impressions about what they saw. When we asked kids to tell the story, they filled it with all the details about what they'd seen. There's a bunch of unanswered questions in the spots," Mike remembers.

The director added a lot to the spots. "He was a great detail guy," says Michael. "He really made the spots into minimovies." He also wasn't afraid to try things. "At one point on the first shoot, a bunch of pigs showed up and started eating the airplane. The director just shrugged and said, 'This is where it starts to get weird.'"

"Grower" In the first spot created, a farmer plants a handful of Skittles, which later sprout dramatically into a fully realized rainbow. Mike remembers, "At one point on the first shoot, a bunch of pigs showed up and started eating the airplane. The director just shrugged and said, 'This is where it starts to get weird.'"

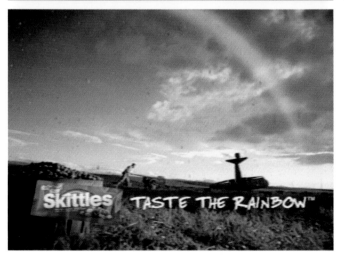

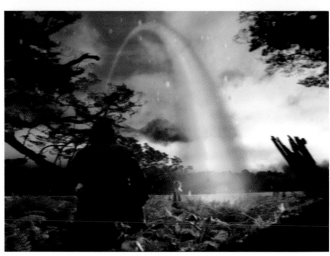

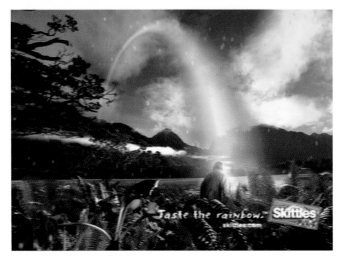

"Trail" Michael Smith, art director, notes, "We wanted to extend the age range of the people buying the product upward. We wanted to make it as appealing to twenty-year-olds as it is to younger teenagers. We discovered that it was really important to not talk down to them. So we decided to make the spots be more mystical than magical."

Dave adds that there has been learning along the way. For example, "We discovered that building an environment was simply not as effective as going someplace."

"Going someplace" is something the campaign does quite well. While "Airplane" was shot in Northern California, other spots were shot in Prague, New Zealand, Vancouver, the Mohave Desert, Jackson Hole, and Barcelona. Bran Fauss, senior copywriter, joined the account recently. He says he takes it as a personal challenge to try and top what was done the year before. This year he just returned from Spain. The question he always asks is, "How exotic can we make it?" The campaign was originally concepted for the U.S. market, but in the last few years it has aired in over twenty countries. As Dave notes, "It's very simple to re-tag."

And who is the mysterious voice at the end of the spots? "We asked a whole bunch of people to say the tag line in all sorts of funny ways," remarks Dave. "We tried children, actors, Hollywood stars. In the end, what we thought worked best was the little woman from the movie *Poltergeist*."

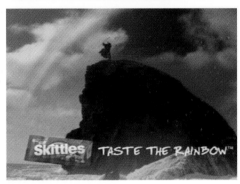

"Merlin" When D'Arcy Masius Benton & Bowles first got the assignment, they looked around and realized no one was using rainbows in a really cool way. The rainbows seen on television were indeed almost always very juvenile and cartoonish. None of them looked like real rainbows. Real rainbows, the agency thought, should be mysterious and unsolved.

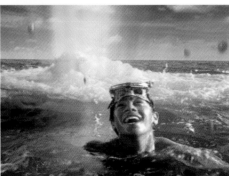
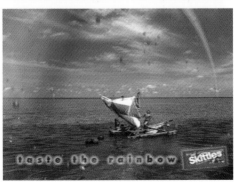

"Diver" Mike recalls how—to make the spots more mystical than magical—the creative team strived to make sure that all of the imagery was not literally connected to the story line. "We took the work to kids in qualitative settings and got impressions of what they saw. When we asked kids to tell the story, they filled it with all the details about what they'd seen. There's a bunch of unanswered questions in the spots."

Dorada The Canary Islands are sometimes called "The Happy Islands"; perhaps it's because of the beer they drink there.

The storyboards drawn up were remarkably close to the actual photographs. This is a rare occasion in advertising. The modern, sleek, and fashionable scene that you would normally find in a bar has made its way into the brewery, proving the point "the fresher, the better."

Dorada is the only beer that's brewed and distributed on these islands, which are not only a tropical paradise but also a stepping-stone between Europe, Africa, and the American continent. It was here that Christopher Columbus made his first stop in his exploration of new lands, and some historians suppose that the legendary continent of Atlantis was located here.

The beer drinkers on the islands have a variety of beers to choose from since there are many varieties that are imported from the continent or from the U.S. So the Compañía Cervercera Canaria (the Brewery Company of the Canary Islands) that brews Dorada needed to enhance the loyalty of consumers to the Dorada brand. In doing so, they also wanted to give consumers a better attitude toward Canary Islands products in general. To them, Dorada beer has some great intrinsic values: It has freshness, good smooth flavor, first-quality materials that are always fresh, and a high-tech brewery. At the same time, they also wanted to be seen as the "fashionable" beer. Reminding consumers that the beer was brewed right there on the islands was also quite important to them.

So the brewery decided to communicate something they thought was new and unknown to the public: The shorter the time between brewing the beer and its consumption, the better the taste and the body.

Vitruvio Leo Burnett took on the challenge wholeheartedly. Rafa Anton, creative director, describes the thinking about the campaign. "We wanted to bring the moment you pass into a bar, the moment of consumption, into the brewery. It is a direct and visual way to dramatize what is summed up in the selling line: The fresher, the better."

The only way to compete with the other beers that come onto the island was to point out the fact that the less time between the brewing process and the consumption, the better the beer. So Vitruvio Leo Burnett took that branding challenge wholeheartedly.

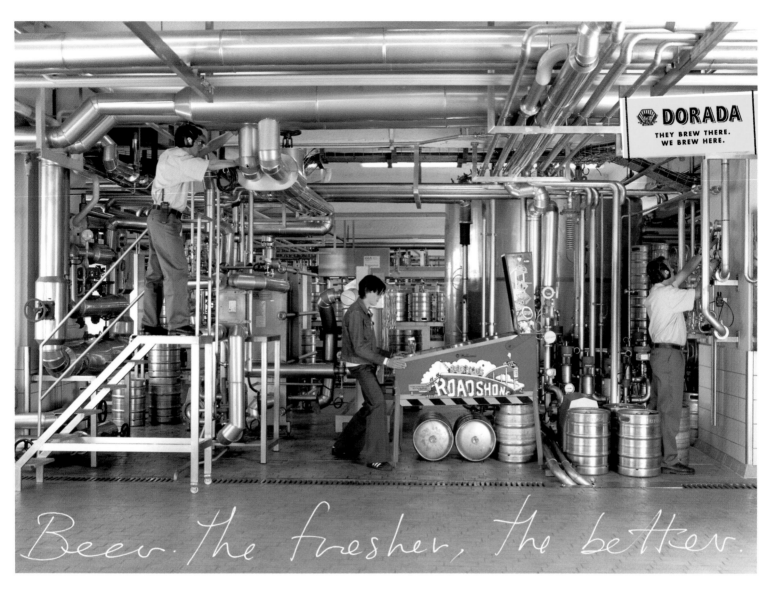

Beer. the fresher, the better.

Creative director Rafa Anton at the Madrid agency recalls, "We wanted to bring the moment you pass into a bar, the moment of consumption, into the brewery."

Casting was made a lot easier on these shoots. Besides the models in the stark poses, the machinists and laborers were actual Dorada employees going about their business.

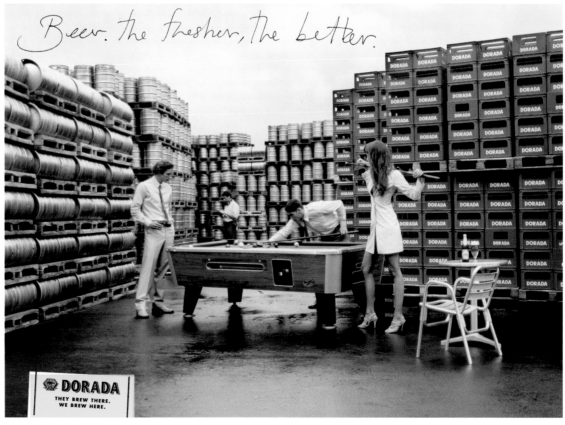

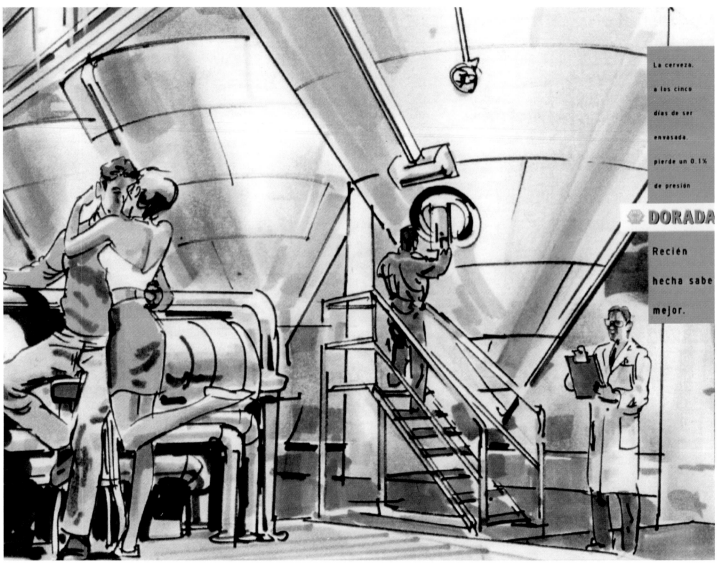

The ads take on a slightly surrealistic but captivating tone, as stylish people are shown enjoying typical barroom behavior while juxtaposed against the backdrop of a very high-tech beer-making facility. All the while, the laborers continue their work. As Rafa describes it, "To define the look of the campaign, the advertising agency chose a contemporary aspect, extremely posed and artificial, that contrasts with the environment of the factory. To obtain all this, the agency worked with the German photographer Mark Trautman."

Getting the right blend of fantasy and reality wasn't easy. As Rafa puts it, "The shooting took place during several days and the difficulty was the reality of the situation. The brewery worked at its habitual pace; the laborers were all working as usual. As a matter of fact, the machinists who appear on the photograph are people who really work in the brewery of the Canary Islands."

The headlines are written in a scrawl, or in one instance, appear to have been scratched onto the surface of the photos, giving a sense of urgency and believability to the line "Beer. The fresher, the better." The tag line "They brew there. We brew here" is directly competitive and highlights the fact that the beer is the only one brewed on the Canary Islands. Ahhh, the happy islands. Where life is good and the beer is always fresh.

Euro-ultramod would be one way to describe the look of these ads. Rafa uses words like "contemporary," "extremely posed and artificial," and "contrasts with the environment of the factory."

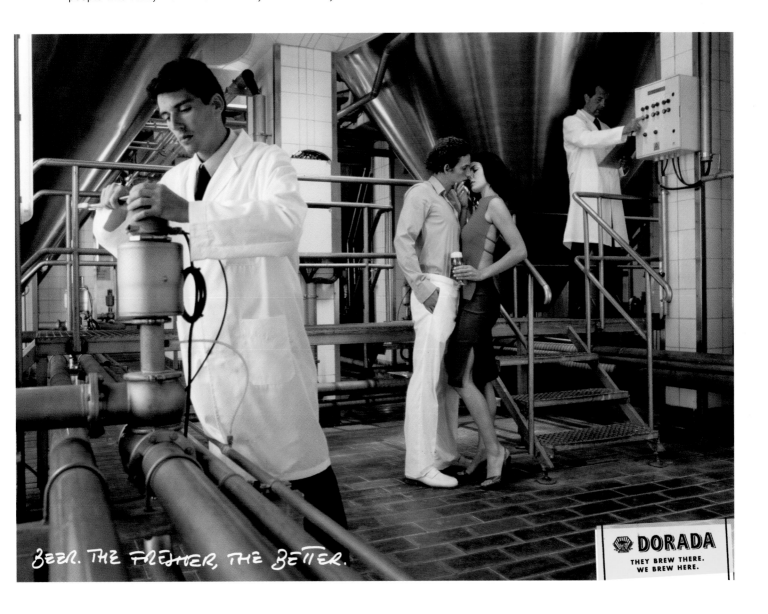

BEER. THE FRESHER, THE BETTER.

DORADA
THEY BREW THERE.
WE BREW HERE.

Monster.com During the **holidays,** when most Americans are dreaming of **roast turkey** and family **gatherings** and ripping open **presents** before a **roaring fire,** most ad **guys** have another thing on their minds: the **Super Bowl.**

Not necessarily because they're great sports fans or enjoy watching players run around in those unforgiving hot pants, but because that's the big time when it comes to media visibility that can make or break a client.

So needless to say, the pressure was on when a week before Thanksgiving, Mullen pitched the Monster.com account against Bozell and Hill Holliday. An account that had already bought airtime during the Super Bowl, and the clock was ticking fast.

Account planner Bruce Gold relays how, when creative director Edward Boches met with Monster.com CEO Jeff Taylor, there was instant chemistry. "Jeff liked Ed's passion, and we had the potential of creating a Super Bowl spot," Bruce says. "But there also were production realities—like can we actually get the spots on air with this little time? Most of the good directors were already tied up shooting other spots and we were concerned we'd have to settle for less quality to get it done."

But the team and the client put their heads together and decided to go for it. "Jeff's an eternal optimist," Bruce admires. "And he also had a distinct vision of what the spot should be. The Monster.com CEO thought the spot should be of a guy getting high-fives for leaving his old job. We obviously didn't like that idea because it wasn't breakthrough enough—but we had to pursue that angle."

Edward recalls a similar circumstance with a slightly different story line: "The client had his own idea about a guy jumping up and down on a table being all excited by his job." Whatever version they heard, the creatives knew the idea needed some, how do you say, modification.

"We had a great creative team—Monica Taylor and Dylan Lee—who had been doing a wonderful job on a lot of print stuff and I told them that whatever TV came up next would be theirs. I didn't know the next TV would be the agency's first Super Bowl spot, but I didn't want to go back on my word," Edward remembers.

With such a tight deadline, the team quickly narrowed down their strategy first. "We didn't have time to do in-depth research or focus groups," Edward recounts. "So I said we can do one of three things. We can talk to consumers and say: We have more jobs. We can talk to heads of companies and say: We have more people. Or we can take the lead from companies like Apple and Nike and rather than sell people products, tell them we have a belief system and get consumers to share in that with us."

With a strategic approach that everyone in the agency was passionate about, the Mullen team went in with three ideas: people doing high-fives, a slanted take on what children want to be when they grow up, and people in a psychiatrist's office explaining how they really don't like their jobs. Guess which one of them won?

As a prelude to concepting, Edward boiled the belief system of your average person down to five components: overall beliefs like religion, health, money, family, and career. Then came the epiphany. "We realized that we could own the career belief system the same way Nike owned health and fitness. We could tell people that they have the inalienable right to a career."

With a strategic approach that everyone in the agency was passionate about, the team went in with three ideas: people doing high-fives à la Jeff the client, a slanted take on what children want to be when they grow up, and people in a psychiatrist's office explaining how they really don't like their jobs.

Bruce admits that at first the shrink's couch was the agency's recommendation. "It was about people not feeling great and the therapist holding up and animating a paper doll to ask them 'How are you feeling?'" They were already seeking out a director when Jeff got cold feet at the last moment, concerned that the psychiatrist spot did not have an optimistic view of job-hunting. But Bruce relays how "Edward would not budge, would not go back to re-concept—even though that's what Jeff wanted."

"It got all the way to pre-production and people said they just didn't want to do the spot," Edward tells. "So I made an executive decision and said, 'We're not going back to the drawing board. Here's what you're going to do. You're going to do this [the kids' aspirations] spot, which you also liked.' That one was always my personal favorite, anyway." And so, "When I grow up" was born.

He goes on to reveal how the spot evolved from its original direction, since the creatives had envisioned it as a parody of Nike's 'If you let me play' spot—with a comic edge. "But when we cut it together," he says, "it just didn't work as well when it was laugh-out-loud funny. We were talking to department heads at big corporations and we couldn't be seen as making fun of them. We needed to be smart and soulful instead."

But this new tack posed its own problem to solve. 'When the spot was done, it looked a little gloomy—all shot in black and white. I had remembered a spot for Levi's 501 Blues shot by Leslie Decktor, which gave me the idea to put choral music in the background. It made it much more uplifting."

Of the process and finished product, Edward sounds like a kid who figured out how the Magic Kingdom was born in a Disney park. "The whole spot was a bunch of ingredients that just came together and you never could've realized the magic of it, couldn't have imagined it'd be so special. The kids' copy, the black and white, shooting in New York, Minnesota, the bayou, the cross-section of Americana, the music. All the stuff just came together executionally to make it magical. When people saw the spot, it was their own hopes, wishes, dreams, and fears."

At first, the spot's ratings sparked more fear than hope for the team and client alike. "The response was not phenomenal to begin with," Bruce admits. "The *USA Today* poll said it did not do well at first; we didn't speak to Jeff for two-and-a-half months after the spots aired. But Director Brian Buckley wanted to drive it home to the Heartland, and we started getting a ground swell on radio stations and such."

"It was a slow build," Edward agrees. "But now we're getting all kinds of recognition. A&E is doing a special on the ten best spots and this is one of them."

So how did the magic spread so effectively? Edward's theory is that, "Monster.com is part of a new force in the economy. It was a thought-provoking spot that captured what is going on—that the Internet has redefined personal freedom. The creative, radical, irreverent, and rebellious spirit is now available to everyone."

In that case, I'll take two.

Script

"When I grow up"

VIDEO: Alternating shots of various boys and girls. All kids are serious with their responses, as if it's a public service message.

BOY 1: When I grow up, I want to file all day.

BOY 2: I want to claw my way up to middle management.

GIRL 1: Be replaced on a whim.

GIRL 2: I want to have a brown nose.

BOY 3: I want to be a yes-man...

GIRL 3: ...yes-woman.

GIRL 4: (VOICE OVER) Yes, sir. Coming, sir.

BOY 4: Anything for a raise, sir.

GIRL 5: When I grow up...

BOY 5: When I grow up...

BOY 6: I want to be underappreciated.

GIRL 6: Be paid less for doing the same job.

BOY 7: I want to be forced into early retirement.

SUPER: What did you want to be?

LOGO: Monster.com

SUPER: There's a better job out there.

With phrases from each kid like "When I grow up, I want to claw my way up to middle management," "I want to be forced into early retirement," "I want to be a yes man," "...yes-woman," "When I grow up..." This commercial did not do well at first, but is now considered by A&E to be one of the ten best commercials.

Saab Take a plane. Shrink it. Cut off the wings. Add some tires. Guess it isn't such a stretch to imagine that the engineers who mastered the design of Saab aircraft during World War I would turn their expertise to creating some of the best cars in the world.

◇ Similar to the design of a Saab, the ads were designed to have an arresting power with the central theme of "vs." "It was always designed to be somewhat controversial or provocative," Kerry tells, "but at the same time, it also gave us the flexibility, the holistic answer, we were looking for. It allowed us to pick every conceivable subject and try to find the interesting stories about the 'vs.'"

When he first got the assignment, it was Saab's universal presence that led creative director Kerry Feuerman to recognize the challenge of creating a campaign that was both global and flexible, but that also embodied the design features of the car itself. "The basic premise of the campaign came out of the car itself, which isn't always the case," he notes. "It was done jointly between the Martin Agency and Lowe Brindfors, and Rob Schaparo and Jari Ullakko were the creative directors. The two agencies worked together to find a campaign that would work globally."

Expounding on the sheer breadth of a Saab's features, he says, "The advantage and predicament about Saab is that it's holistic— it does many things really well all at once. Other brands might own monikers such as 'safety' or 'performance,' but in reality, a Saab is as safe as a Volvo or as high-performance as a Mercedes."

Best known for its turbocharged engine, Saab's background of innovation sets it apart from its competition, says Kerry. "They were the first ones to have heated seats," he reports. "Someone who worked at Saab had kidney disease and was complaining about how much the cold seats hurt his back. He was riding with an engineer, who then went back and designed a way for the seats to heat up. Saab is filled with hundreds of wonderful stories like that."

But beyond the more practical features, Kerry explains how the aesthetic elements of the car are what really shaped the direction of the campaign. "The cars are clean, premium, unfettered with unnecessary features or gimmicks. We wanted to mirror the car's personality in the design of the ads; everything in a Saab has a purpose, so everything in the ad has a purpose."

And similar to the design of a Saab, the ads were all designed to have an arresting stopping power. "The creative team of Jeff Ross and Mark Wenneker came up with the central 'vs.' theme, which was somewhat controversial or provocative, but which also gave us the flexibility, the holistic answer, we were looking for. It allowed us to pick every conceivable subject and try to find the interesting stories about the 'vs.'"

The first concept in the campaign was "Saab vs. God." "It never ran," Kerry reports, "but it lets you appreciate the potential of the campaign. It's an ad about safety: God, prayers, rosary beads can protect you, but only so much. After that you need a car.

Kerry explains how the aesthetic elements of the car are what really shaped the direction of the campaign. "The cars are clean, premium, unfettered with unnecessary features or gimmicks. We wanted to mirror the car's personality in the design of the ads; everything in a Saab has a purpose, so everything in the ad has a purpose."

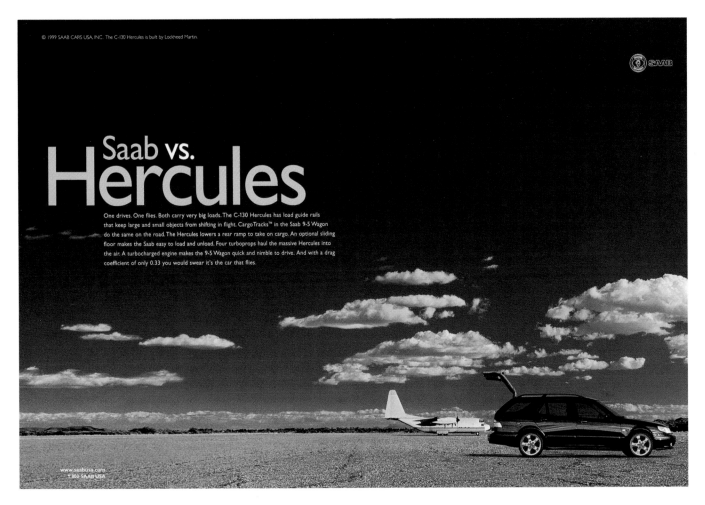

"For example," he continues, "you go through an intersection, and a car is about to hit you, and you feel vulnerable. A Saab has all sorts of side panel things to ensure your safety in the event of a side collision, but the things designed to provide safety are all relatively boring. 'Saab vs. Nakedness,' however, is anything but boring. I challenge anyone to turn the page when they see that headline."

Shock value aside, Kerry knew that although the ads were designed to be somewhat confrontational in nature, everything about the campaign had to reflect the mindset of the brand. "We always tried to be that interesting, that provocative, about stuff the car had that could be seen as relatively boring. The concepts were really hard to come up with, even though they look easy."

In the end, they produced forty-two "vs." print ads altogether that took the creative team all over the world. "'Saab vs. Parenthood' was shot on a little island between Sweden and Finland," Kerry recalls. "We shot in the Arizona desert, in Morocco, in Spain, Sweden, Hawaiian volcanoes. 'Saab vs. the Puritans' was shot in New Jersey—we just happened to see this really great barn there. 'Saab vs. Steroids' was shot in Paris."

The exotic locales posed their own production challenges, like when the team went to the Kalahari Desert in Namibia to shoot "Saab vs. Nakedness," and it rained. "We always had to deal with weather conditions," Kerry admits, "but we went to one of the driest places on Earth, and it still rains.

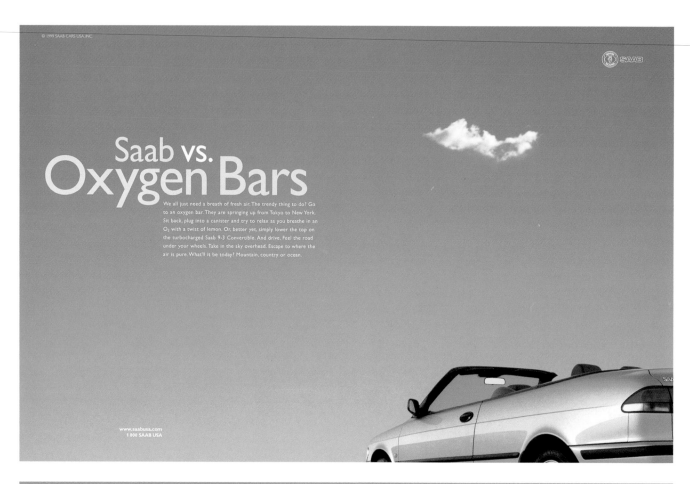

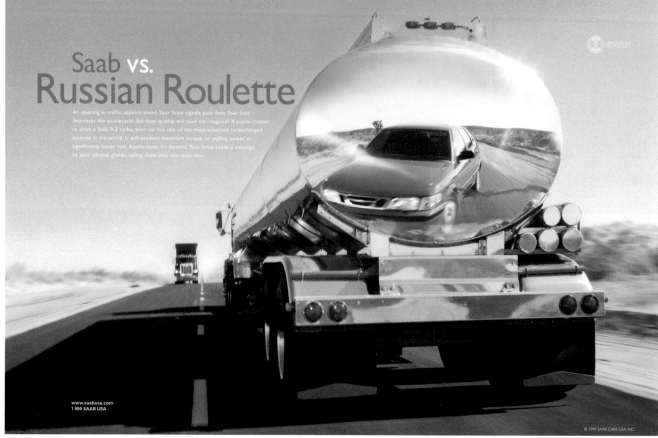

"The logistics of getting cars to all those places were very, very difficult," he relays, "and then there was the challenge of getting it to work internationally. In some cultures things just wouldn't work." Trials and tribulations aside, they were able to produce all forty-two ads over the course of fourteen months, with the bulk wrapped up in six months.

Regarding the ability of the campaign to work on a global level, Kerry believes that, "In theory, every ad should have been able to work everywhere, and I'm proud to say that in most places it did." One place where a direct translation just didn't work was Japan. There was trouble translating the "vs.," which is the whole premise behind the campaign. So in cases like that, the team used the same photography but ran a different campaign with different headlines.

Clever media buying also helped ensure the success of the campaign, as Kerry illustrates: "Sometimes two or three ads would run in one publication, so people could get up to speed on the concept very quickly. We had really positive results that did a great job of making the brand feel more progressive. It also stood out in a category as trod-upon as automotive advertising."

Lastly, Kerry gives credit to Saab's target audience for the great success and recognition of the campaign. "People with the highest education levels purchase Saab cars," he notes, "and it's those people who appreciated the sophistication and intelligence of the campaign."

And with all that technology behind the wheels of their Saabs, the next time they're in the Kalahari they'll be ready for rain.

Although the ads were designed to be somewhat confrontational in nature, Kerry tells how everything about the campaign had to reflect the mindset of the brand. "We always tried to be that interesting, that provocative, about stuff the car had that could be seen as relatively boring. The concepts were really hard to come up with, even though they look easy."

"The logistics of getting cars to all those places were very, very difficult," Kerry relays, "and then there was the challenge of getting it to work internationally. In some cultures things just wouldn't work."

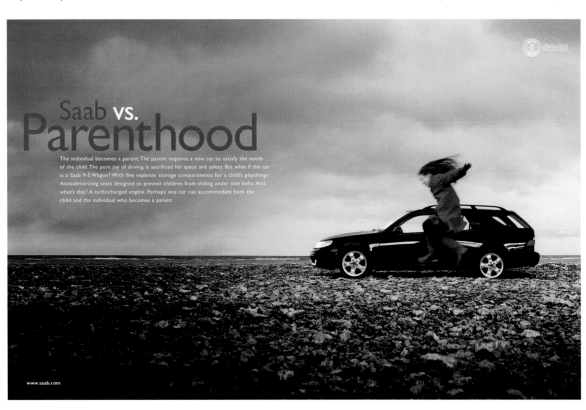

Discovery.com is exactly what it **sounds** like— a Web site **dedicated** to an **impressive** bank of **online** **brain food**, accessible with the now **indispensable** double-click.

⊘ "When we were writing the URLs, we worked both forward and backward and had to tweak a few to make them funny," Mike reveals. "For example, we knew it'd be funny to have a thing about how to find out about soap operas, so we made sure to include a TV monitor in the 'Supermarket' shot."

In addition to the Discovery Channel itself, the site incorporates all the Discovery-owned TV channels, including the Travel Channel, the Learning Channel, Animal Planet, and health- and school-based education channels. So needless to say, Mike McCommon, creative director and copywriter at Publicis, had his work cut out for him when he was assigned the campaign to cover it all.

He recalls first approaching the project and trying to hammer out a direction for the creative. "People think of Discovery like PBS," he figured, "like they're informational, not commercial. People love them and trust them more than the real commercial stations."

Discovery's objective was to leverage that positioning into a Web site where one could tap into their extraordinary databanks and find out about nearly anything. But, as Mike recalls, "They also wanted to branch out and be a one-stop resource where you could make purchases as they related to different things. For example, you'd be able to buy airline tickets when you went there to find out travel information."

The team's campaign strategy thus stemmed from how Discovery itself wanted its Web site to be viewed. "The key message in the strategy was 'your guidebook for life,'" Mike explains. "It sounds a bit boastful, but we tried to find the truth in it. So our idea was that if you sat down somewhere—anywhere—and looked around you, if you closed your eyes and randomly pointed to something, you could then go to Discovery.com and find out more about it."

With this tack established, the ads evolved to relay the fact that almost anything imaginable could be researched on the Web site, featuring everyday scenes in which dozens of items in the scene were labeled with a corresponding link on the Discovery.com site. "The ads really broke it down to the minutiae," Mike recollects. But the ads did more than simply cover the breadth of material to be found on the site. "They also work the same way the URLs do," he continues. "You can get deeper and deeper into the more minute information. If you go to the Web site, you start with five or six basic categories. Then those break down into a million other categories, and those break down into a million more categories—there's almost a limitless amount of information."

As for finding locations that would serve as a good vehicle for the multifaceted concept, the team felt strongly that it should feel real. "We had the idea of what images we wanted to use," he tells. "We knew we wanted them to be everyday, ordinary images so we shot them before we had anything written."

Mike details how they achieved such genuine locales for the ads. "For 'Bedroom' we took this real girl's bedroom that already had a lot of interesting stuff in it," he remembers. "Then we added even more interesting stuff."

How did they do it? "For 'Bedroom' we took this real girl's bedroom that already had a lot of interesting stuff in it," he remembers. "Then we added even more interesting stuff."

They repeated the process for the "Supermarket" ad. "We found a location that had some inherent interest," he continues, "then made sure there was even more stuff so there'd be a lot to write about.

Mike also knew that it was important that all the links in the ads be real. However, "some we had to reverse engineer," he admits. "For example, we'd find a part of the site that had the info, and then have Discovery.com change the way you could access that info by creating the same URL we'd written.

"When we were writing them, we worked both forward and backward and had to tweak a few to make them funny," he continues. "For example, we knew it'd be funny to have a thing about how to find out about soap operas, so we made sure to include a TV monitor in the 'Supermarket' shot."

In retrospect, Mike reveals that it took quite some time and a ton of team effort to figure out what all the links in the ads would be. "In the end, a lot of people helped out. My partner, art director Roger Camp, wrote some. Actually, anyone who had some ideas wrote some. We'd pass the ads around the agency—even the whole account team worked on them."

When it came to selling the ads to the client, he goes on to tell how, fortunately, they got the concept right away. "They loved the idea that they could be known for having all this information," he recalls, "but what they couldn't understand was why we couldn't put a logo on the ad. It took a lot of explaining to get them to

understand we were really making a statement about society, and how you gather and process information. If you put a logo on it, then the little switch in your brain goes off that says 'ad' and you're much more likely to flip the page.

"A big part of these ads is that we tried to make them un-adlike," he expounds. "For example, no headline and no logo. It doesn't beat you over the head, but instead it pulls you in."

Which is exactly what the team was going to bat for. "We were hoping that people would be pulled into the visual and the sheer amount of information," he adds. "Then they'd read some of the URLs, and realize some were kind of cute and funny. Then they'd read a few more, because they were interested, and then they'd realize, wow, I can find out about anything I want."

Mike notes how the ads did get their share of wows and were really well received by the public. "The hits went up drastically and the thing about dot-com advertising is that it ties right back to the ads as proof of their effectiveness," he says. "With a lot of advertising, you can't really tell if it works, but with a dot-com you can see how many people log on. Some clients judge the effectiveness by how quickly people log on just fifteen minutes after the ad breaks. It's a bit scary. In this case, what we had done was more of a branding campaign, but it also worked as a call-to-action."

He wraps up with a nod to the whole creative process and summarizes simply that "We had fun. They were a group of very smart clients, and the ads themselves were successful."

Who could ask for more?

EDS "Yes, it was **designed** just for the **Super Bowl**," they say. But it's not like **creative** director Dave Lubars and Dean Hansen of **Fallon Minneapolis** are **complaining.**

For starters, Dave gives some background on EDS (Electronic Data Systems) and why this TV effort was crucial to putting the high-tech company on the radar screen. "Ross Perot started the company. He invented e-business," he explains. "But after EDS was sold, the company became invisible. They did huge stuff, but weren't given any credit—nobody knew about them.

"What they do is extraordinarily complex," he continues. "They manage the entire system of dams in Amsterdam. They do global connections. GE. The military. They do mission-critical jobs—but nobody knew about them."

The first objective of the advertising was to make EDS seem big and important enough for key global IT directors to put on the pitch list. "That was the job," Dave relays. "So we decided the best place to get the word out would be during the Super Bowl because it's like a great coming-out party. Everyone sees it: the public, Wall Street, investors, heads of companies, employees. It gets talked about and it gets noticed."

Dave tells how the team's approach to the assignment came from their mutual backgrounds: "I've worked on Apple and Dean has technology experience. We know that the best technology adver-tising makes the company feel human—is humanizing. Otherwise, it makes people feel like they're obsolete."

The creative brainstorming began. Dean elaborates: "We knew the question was: What's entertainment? What are we going to put on this stage? How are we going to make it a cultural pop event?

"So when we sat down to concept it was a pretty daunting task," he admits, "but this idea actually came pretty quickly. We went with a metaphor because the story was really challenging, and we knew it had better damn well entertain people."

Proving that ideas sometimes come from the oddest places, Dean tells how "A few years ago we had another technology company as a client and someone there had used the phrase 'It's like herd-ing cats' to explain how a difficult technology worked. We had since learned that it was a pretty standard techie saying based on technology-world expressions."

When developing the cat-herding concept, the team sought to make it come alive using real American icons. "Cowboys have all the right qualities. They're independent, rugged, yet soft-spoken. We knew from the start that we wanted to use real cowboys right off the prairie. The cast was very authentic," Dean maintains.

"For the director search, at first we didn't know which direction to go in. Do you get one who is really technical, known for super special effects, or do you go for a performance director? We finally decided that people will forgive you if the special effects aren't perfect, but it's much more important to connect with the viewer," says Dean thoughtfully.

"And hey, it's only around ten seconds of special effects, really," Dave adds. "John Hagen was a performance director, and we really felt like we made the right choice."

Dean admits it was a tough shoot. "There were really high winds, dust blowing all around, cow patties flying all through the pasture—and we had to shoot right through it. But having real cowboys helped. They didn't complain. We even had to wipe their noses to keep the dust out."

As for the feline stars, he goes on to assure that, "We did a lot to protect the cats. We couldn't have cats and horses on the set at the same time because we didn't want any cats to get trampled." Extra special care was taken when the shoot required a cat ride on a horse's back.

One of the best things about working in advertising is that you learn how to do things you never thought possible. In this case, it was teaching cats how to swim. Dean describes the most un-usual process: "There was a cat Jacuzzi to keep them warm. You teach them to swim by slowly conditioning them. First you get them to run through a quarter-inch of warm water, then a half-inch, and just slowly increase it."

The second spot in the campaign involved a running of squirrels through the streets of Pamplona, and Dean shares how much more challenging the shoot was than the cowboy spot. "Cats are so much easier than squirrels. There were about fifty or sixty cats

Proving that ideas sometimes come from the oddest places, Dean tells how "A few years ago we had another technology company as a client and someone there had used the phrase 'It's like herding cats' to explain how a difficult technology worked."

The second spot in the campaign involved a running of squirrels through the streets of Pamplona. Dean shares how challenging the shoot was: "There are only six trained squirrels in the whole world and basically, when you train a squirrel you get them to run to a spoon with peanut butter on it. That's the extent of what you can do in squirrel training."

and we just cloned a lot of extras for the big, long shots. But there are only six trained squirrels in the whole world. You see the same squirrels over and over in commercials and films."

Dave adds, "Basically, when you train a squirrel you get it to run to a spoon with peanut butter on it. That's the extent of what you can do in squirrel training."

For the third spot, the challenge was simply, "How do you top the great ideas that were created before it?" A move away from animals brought an arresting visual of an airplane being built—in midair. "I think we accomplished our mission," notes Dave simply.

In retrospect, there's no doubt that the hard work and flying cow dung paid off. Asked how the client took to the creative from the beginning, Dave is proud to say, "It's one of the things we do really well at this agency. We showed them five ideas and I felt great about all of them. Every one of them was brilliant and we really explained to them what each one brought to the party. The client had an embarrassment of riches, but in the end they went with this campaign because it depicted their internal workings and philosophy so well."

Bringing their humanist approach full circle, Dean reports, "Before the spots, employees would go to a cocktail party and meet someone, and they couldn't explain what they did. But the ads became a rallying cry for the company. We didn't try to reinvent who they were and they were very proud to be represented that way. The employees really started to understand the bigger corporate mission."

On a more glamorous note, Dave tells of some of the limelight they basked in to boot. "*Entertainment Tonight* had it on both before and after the Super Bowl. It really got talked about all over the place. And then President Bill Clinton quoted the spot in a speech about China, saying something was 'like the EDS commercial' and that the cat-herding spot was one of his favorites. That's how we really knew it had become part of the popular culture."

Perhaps a more salt-of-the-earth gauge was the appearance of cowboys, in little corrals, at EDS trade shows all over the world.

After cowboys herding cats and the running of the squirrels, the question became, "How can we top that?" This visually arresting spot of people building an airplane while it's flying in mid-air answers that question quite nicely.

Top and bottom: When developing the cat-herding concept, the team sought to make it come alive using real American icons. "Cowboys have all the right qualities. They're independent, rugged, yet soft-spoken. We knew from the start that we wanted to use real cowboys right off the prairie. The cast was very authentic," Dean maintains.

Nike Imagine *My Left Foot* meets *Rocky,* and you've got a breakthrough spot for **none other** than the **mothership** of sportswear **brands.** The **swoosh** has yet again proved to be at the **top** of its own **game.**

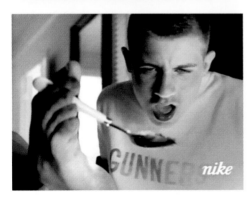

Copywriter Kash Sree, of Weiden+Kennedy, recounts his approach to the assignment. "Training was a category that had been under-explored. It used to be referred to as 'cross-training' and always included images of people running up steps and doing sit-ups. We wanted to take the idea of training and look at it in a really fresh way."

Noting that a lot of Nike's previous ads were talking to bigger athletes, he describes how the goal of this campaign was to bring things down to the level of the everyday athlete and away from hero worship. "The line 'What are you getting ready for?' led to a different way of thinking about training. Some of our first ideas were things like flipping burgers as a way of training for tennis." The "Soccer" spot actually began its life as a martial artist doing everything with his feet—but as Kash puts it, "creative director Chuck McBride didn't take much karate."

The soccer spot was directed by Lasse Hostrom, who took on the project after the original director, Alfonz Krroon, had to step out. Kash recalls his work with the directors fondly. "Both were great to work with." Kash notes that Lasse was a bit on the reserved side: "I thought I was a bad presenter until I met Lasse. When he was presenting the shooting board he would just stand there and point to the pictures and say, 'First we're going to do this, then this, then this....'" His lack of verbosity apparently has nothing to do with his finely attuned visual skills.

As Kash reveals, casting the spots for the right talent to portray more fallible, unclassic heroes was no picnic. "We went through seventy kids," he tells, "kids trying to juggle balls in a small studio. They destroyed the place!"

But perseverance prevailed and they found their man. "The guy we chose for the soccer spot wasn't classically good-looking, but he had real skills." Kash admits that, skills or not, the shoot was never dull. "I remember it took forever to get the scene where he juggles the box off his knee—I think it was thirty-two takes. Plus, he kept cutting his legs on the sharp edges of the box."

Physical hurdles aside, the team also had a minor political problem to waylay. "We had an unusual little situation with the actor," Kash relays, "because he might want to go to college on a scholarship, so he couldn't be paid by a commercial endorser. At the end of the shoot, he wanted to keep the shorts; it seemed harmless enough, but we weren't even able to give him the shorts."

⬡ Top: Copywriter Kash Sree of Weiden+Kennedy recounts his approach to the assignment. "Training was a category that had been underexplored. It used to be referred to as 'cross-training' and always included images of people running up steps and doing sit-ups. We wanted to take the idea of training and look at it in a really fresh way."

⬡ Middle and bottom: Kash believes that what really lent the spot credibility was its little references to soccer that only people really obsessed with the sport would get. For example, on the television set the talent's watching a Latin broadcast, and the T-shirt he has on is not only an English team, but it's the nickname for the team.

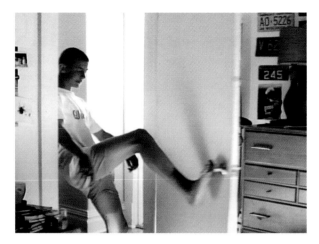

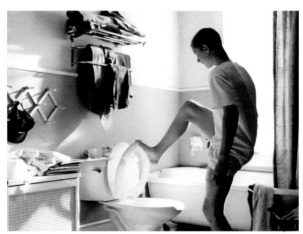

As for its perception in the sports community, Kash believes that what really lent the spot credibility was its little references to soccer that only people really obsessed with the sport would get. For example, on the television set the talent's watching a Latin broadcast, and the T-shirt he has on is not only an English team, but it's the nickname for the team. "Only a soccer player would pick up on those things," he attests, "and that reinforces the fact that Nike is true to the sport."

Kash further expounds on his favorite spot in the campaign that rang true to this message—the "Meat" spot. It's about a kid who takes a bloody piece of steak, drips it all over a soccer ball, then dribbles around town being chased by dogs hungry for blood. "I like it because you can describe it in a sentence and immediately you get it. That was the beauty of it.

"It was written two years prior by Tim Hanrahan and Jerry Cronin," he notes, "and when it was pitched to Nike, they hated it." But Chuck re-pitched it and Nike finally bought it. Kash describes how this campaign was Chuck's first task as creative director and he kept going back. "He's a dynamo. He can sell anything."

Nike didn't like the "Soccer" spot at first either because "they thought it was too quiet, not action-packed—they thought it seemed a little subtle. In the end, some of the audience found that as well. They gravitated toward the bigger, more epic spots in the campaign," Kash recalls.

As the campaign evolved, the agency found that although some ideas on paper were hilarious, they didn't necessarily translate well to film. Kash illustrates one spot in particular. "It was of this big defensive football player who stitched a tiny number four onto a sweater. The next thing you know, you see him chasing after a tiny chicken that has the sweater on. It was hilarious as a script, but wasn't quite as funny when you actually saw it as a spot. It's part of the challenge of getting a story down to thirty seconds."

It was the creative judgment to discern what worked and what didn't that produced such a memorable campaign. Focus groups were never a part of the mix to make that determination since, as Kash reveals, "Nike never does focus groups. Never. It's one of their brand's strengths—avoid testing—because if you put people together and ask, 'What's your opinion?' they'll invariably come up with one."

But he recalls the positive reception nonetheless: "The spots came at a time when everyone was starting to hate Nike. This definitely helped stem the tide."

As to be expected, in one fell swoosh.

⊘ "The line 'What are you getting ready for?' led to a different way of thinking about training," Kash reveals. The "Soccer" spot actually began its life as a martial artist doing everything with his feet, "but creative director Chuck McBride didn't take much to karate."

Volkswagen How do you reposition a **cultural** icon? This was the **challenge** chief creative officer Ron Lawner and creative director Alan Pafenbach of Arnold Worldwide **faced** as they readied to **pitch the account** that had, at various times in history, brought us everything from **"The Love Bug"** to **"fahrvergnügen."**

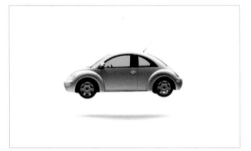

As chief creative officer Ron Lawner recounts: "When we pitched VW, we knew the new Beetle was coming. From the very start, we knew we'd need to create a campaign that could ultimately incorporate that launch."

At the time that Arnold pitched the account, Volkswagen cars were only 1-2% of the car market. Never a glass-empty type of agency, Arnold saw a huge opportunity. "When Volkswagen came to us, they didn't have a position anymore—no one remembered them," states Ron emphatically. "So we created a position for the car that made it meaningful again."

In order to do so, the team knew from the get-go that this was more than a matter of coming up with a couple of billboards and a thirty-second spot. "More than anything, a voice was created for Volkswagen," Ron shares. "Alan Pafenbach and Lance Jensen, creative director/copywriter, worked very hard on it."

Alan recalls how that voice started to evolve. "Around the time we were pitching," he tells, "I'd begun to notice people my age and younger, college kids, driving Volkswagens, but nobody else was driving them. I realized there was a secret tribe of people who knew about Volkswagen; they had an educated, liberal arts orientation and were into individual sports such as skiing and biking. They were the Patagonia crowd. We had this sense that the core consumer had a certain income, worldliness, personality, aesthetic, and attitude."

One of several agencies pitching the account, the Arnold team knew they were the underdogs. Unable to show creative in the pitch, they instead showed a video that simply illustrated their approach to the brand. "It said, 'Here's what we're thinking,'" Ron shares. "But in there were many ideas that years later became ideas for spots. The client got it right away—that we had made the car more meaningful."

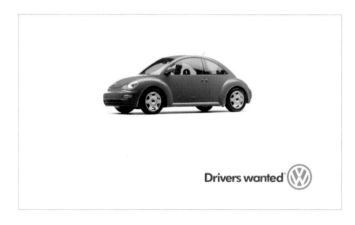

Drivers wanted

Ron addresses how the campaign's sell was executed. "The car itself is sculptural. It's art. It's an icon brand. We wanted to put our own spin on it, and there was an honesty to the clean headlines and art direction."

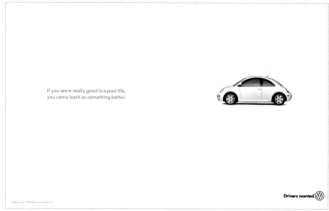

If you were really good in a past life, you come back as something better.

Drivers wanted:

0-60?

Yes.

Drivers wanted:

"They needed to get outside their four walls," Alan adds. "They'd lost touch with the audience. Suddenly we let people peek in and see the club." "Except," Ron points out, "it was a club for people who didn't join clubs."

With commercials like "Da Da Da" and "Milky Way," the Arnold team created a club that people wanted to join immediately. Great ideas, to be sure, but Alan also recognizes the importance of a great execution. "Casting is critical—it's what we tear our hair out over more than anything else. The cast has to be absolutely believable so that everyone looks like someone you'd really like." But he finds the real magic in certain intangibles. "In every commercial there's a little moment," he believes. "Life's made up of very rare little moments that define the time, not just the story line. The point is to reduce the story down to accessible moments and then execute it with beauty and elegance."

Another big part of the Volkswagen brand is the music behind it all. "There's a logical reason for that," Ron explains. "When you're driving, one of the first things you do is put on the tunes. Music is a big part of the driving experience. It's a lot of hard work to find just the right piece of music—a lot of attention to detail."

After getting the Volkswagen brand on the right track, Arnold faced its next big challenge: introducing the new, improved VW Beetle. The Beetle was an icon, yet a new one hadn't been produced in over twenty years. Ron recalls, "When we pitched VW, we knew the new Beetle was coming. From the very start we knew we'd need to create a campaign that could ultimately incorporate that launch." Adds Alan, "It was a real motivator to do something big."

Again, the advertising came out of the product. "The car itself is sculptural," Ron notes. "It's art. It's an icon brand. But for the first few years, it wasn't a car you could sell rationally—it wasn't bigger, faster, safer, better." The thought was that the ads should have a hint of nostalgia about the old Beetle brand, but with a twist: "We knew that if we just did nostalgia, we'd turn off the young people," notes Ron. "But if we just geared it to the young people, we'd turn off the older people."

Visually, the ads became a simple juxtaposition between the car and a headline. All the headlines have a duality; they start with a nostalgic reference and end with a reference to present and future. There are no people in the ads, a shift from the previous

advertising. "The fundamentally new thing about Beetle commercials was previously, the ads had always shown lots of people," explains Alan. "But with the new Beetle, we couldn't exactly say what type of person would buy it."

The launch was further fueled by a smart media buy that included everything from mirror danglers to TV to the Web. The voice had already been figured out—so the media was chosen to go along with that voice. The agency went so far as to tailor the color of the car and the headlines to the publications. In L.A., the outdoor billboard that ran said, 'You can't even see the scars.' The result? "VW is one of the smallest spenders by media, but you'd never know it," states Ron.

Then, along came another crucial creative challenge. After three years of one of the most successful launches in history, most of the people who wanted that car had that car. There were people who still liked the Beetle, but now they had a family, and they were thinking, 'Is it big enough? Is it safe enough?' The Beetle wouldn't just sell itself anymore.

"Some people had other people in their decision-making chain that they had to convince," explains Alan. "They needed to give that other person the engineering proof points—that it's a real car, a safe car, a car that performs well. The problem was you would get people into the showroom and then they'd say, 'Oh, maybe we should buy a Passat instead.'"

The engineering proof points were there, they just needed to be talked about in a way that fit the brand. "We needed to do the ads in the VW way, so we did a campaign to make the learning fun," says Ron. From that came the "Dome" and "Arch" television spots. Partnered with long copy print ads that discussed the nitty-gritty details, people were once again sold on the Beetle.

The Volkswagen brand has come a long way considering that in 1993, dismal sales numbers almost crippled the company. "They were planning to shut down factories," states Alan. "Now they're selling four times the cars," Ron adds, "They did a 180-degree shift in North America."

But far greater than any numbers can reveal is the cultural phenomenon that followed the advertising's success. As a result of the team's creative work, VW now had a cult following. 'Da Da Da' was parodied by Jay Leno, David Letterman, and David Gates.

All of this bodes well for Volkswagen's future. Alan feels that one of the best things about the advertising is that it's "seeding deep into the culture with positive things. It's a reserve of good will; it's what VW has always stood for. Even back in the '60s, VW was one of the first to talk intelligently to people about intelligent products and still sell them. It was a wonderful barrier that was broken and it's great to be able to talk to the client now and point to the fact that this was and still is a voice for them."

With no new VW models on the horizon, Ron recognizes that the team "still needs to create excitement, to capture language in hopes of making it contagious. It was a fresh voice then, and it needs to be a fresh voice now."

Going forward, Ron surmises, "The trick for us is to keep moving, not to rest on our laurels. We have a great partnership with the client. We've won just about every award in the world and sold every car that was brought into America. We had a great once-in-a-lifetime opportunity and we didn't drop the ball."

In the spot titled "Milky Way" a group of kids drive to a party in a Volkswagen convertible. When they arrive, they realize the party can't possibly live up to the experience they just had driving under the starry sky. "The point is to reduce the story down to accessible moments and then execute them with beauty and elegance," notes creative director Alan Pafenbach.

Amazon.com Truth be told, kitsch never really goes out of style, and there's always a place for campy humor. Which is what Amazon.com was banking on when they blanketed TVs everywhere with visions of holiday Sweatermen.

"Think back to the fall of 1999 when the campaign first broke," creative director Thomas O'Keefe of Foote, Cone & Belding implores. "It was the apex of dot-com advertising and everyone had an ad. Most were smart-alecky, targeting a sarcastic, cynical, younger audience. But Amazon had a broader, more general market.

"In an environment where you're either in or out, we wanted to be more inclusive," he continues. "Let's make it feel like something we can feel comfortable with, advertising that can be appreciated by everyone."

Director of global marketing for Amazon.com, Becky Roberts expands this objective with an overall approach she explains was geared toward accomplishing several things. "The first thing to convey was our breadth of product selection; that we have everything from Razor scooters to kitchen gadgets."

On a branding level, she adds, "We needed to put forth the image of Amazon.com as a very welcoming Web site, even to the most tentative newbie. But lastly, the ad also had to break through and be memorable, which is especially hard to do during the holidays."

That breakthrough was what Thomas embraced to showcase Amazon's inventiveness, its vibe of "tradition with an edge." He notes how "Amazon had a lot to say. Selection, including toys, was a huge part of the positioning, plus the combination of convenience and speed. There were several benefits and we needed to come up with a vehicle that would let us talk about a lot of different things."

As to what kind of vehicle that would result in, Becky shares, "The commercials, like the site itself, were very approachable and welcoming, but also very contemporary. But we were not about the shock value, not about 'look how cool we are selling things online.'" And so the Sweatermen were born, a collection of average, middle-aged gentlemen in matching slacks, sweaters, and ties who sang a tune about the gifts they might have bought at Amazon.com, in a spot entitled "You'll Never Guess What I Got You."

"It hearkened back to an era when holidays were about holiday TV specials, something a little odd," Thomas muses. "It was an Andy Williams-Perry Como type of singing with a jingle feel, and since it was a new song it was easy to holiday-ize it."

Becky agrees. The glee club feel was reminiscent of a simpler time. But the twist was that these authentic '60s chorus guys were singing their hearts out about something totally new—buying gifts online. The creative team had a very clear idea of how it should be done and it was critical to get the details right. There are plenty of caricatures out there, but this was created with an earnestness that made it fresh and special.

"It was important to get the singing straight," Thomas details. "The guys kind of showed up on the set and were handed lyric sheets, but we needed them to look like they really knew what they were singing." He adds, "You talk about 'feel-good' movies— and we wanted 'feel-good' advertising. We talked to a lot of directors and the most interesting insight came from the English team that shot it. They were able to look at it objectively, with an

Amazon's Becky Roberts notes how "The '50s glee club feel was reminiscent of a simpler time. But the twist was that it was a very authentic chorus—everything about it was real. The creative team had a very clear vision of how it should be done and it was critical to get the details right. There are plenty of caricatures out there, but this was real and retro and new."

IT COULD BE A TEDDY BEAR

OR GAME ON CD-ROM

YOU'LL NEVER GUESS WHAT I GOT YOU

GUESS AGAIN, A FOUNTAIN PEN

YOU'LL NEVER GUESS WHAT I GOT YOU

happy holidays
amazon.com

AT AMAZON DOT COM

Thomas O'Keefe, creative director, tells how "We wanted 'feel-good' advertising. The English team that shot it recognized that the thing that matters most is personalities, the way that they are singing gleefully, with the props just dropped in. That way nothing feels too slick, in fact it should feel a bit mechanical."

Script
"You'll Never Guess What I Got You"

It could be teddy bear,
a bike or smoke alarm.
Or possibly a new TV
or game on CD-ROM.

You'll never guess what I got you
at Amazon.com.

Looks like a telescope
Or a blender for the bar?
Guess again, a fountain pen?
Or Teachin' Tunes guitar.

You'll never guess what I got you.
Is it red or is it blue?
You'll never guess what I got you
at Amazon.com.

outsider's view of American culture. They recognized that the thing that matters most is personalities, the way that they are singing gleefully, with the props just dropped in. That way nothing feels too slick; in fact, it should feel a bit mechanical."

On the musical end, the team had a good collaboration with the Wojohn Brothers, who, according to Thomas, were a truly old-school glee club chorus group. "They really played it straight. We'd sometimes write original scripts and they'd want to know 'What's the idea?' so we went back and forth."

Thomas was relieved that the client understood what they were trying to accomplish from the get-go. "We'd work with them on specifics and titles, but they were pretty open. I really give them credit for understanding the pureness of the genre. Like the fact that it was an all-male group; today it wouldn't be PC, but they knew that to change that would crack the purity of it."

In the filming, Thomas further reveals, "the editor will tell you his job was to get out of the way since we had two different cameras recording at any given time. There was no announcer, no cutting away from the shot, and the client was going someplace you don't usually see."

When asked about the results, Becky relays, "We're thrilled with the public reception of the campaign. People really connected with the style and made the connection between the approachable glee club and Amazon. We give the agency a lot of credit," she continues. "The clarity of their creative vision, carried through to the finest detail made the difference between a good campaign and a truly outstanding campaign."

Thomas is similarly content with the creative and basks in the spot's showcasing on *Good Morning America* and several Web sites. "People continue to talk about it. By 2000, there was much less of a dot-com attack and a lot of sites had gone dark, but that spot ran for two years and Amazon can say, 'We're still here, and still stable.'"

Whether talking about the spot itself or its successful reception, Thomas muses, "Oh yeah, it's kind of like a Christmas I remember when I only spent two minutes buying gifts—but with a twist." It's surprising what too many Christmas carolers in Mr. Rogers garb on your doorstep can do to a kid.

Levi's (U.K.) Leave it to Levi's to produce creative work starring none other than a pair of customized blow-up dolls. And to do it in a fresh, tactful way, to boot.

Adam Chiappe, creative director at Bartle Bogle Hegarty in London, recalls the initial direction behind the assignment. "The brief was to generate awareness of a new product, position Levi's Engineered Jeans as the next blueprint for denim, and confirm Levi's position as cool and sexy. The target market was fifteen- to twenty-four-year-olds, however, the campaign was aimed specifically at a more creative consumer."

Not that they're mutually exclusive, but the insight to target personality paid off. The team presented three of many concepts that were immediately approved by the client, an easy sell facilitated by BBH's longstanding relationship with Levi's that dates back to 1984. The spots were researched across three key European markets and both client and agency knew they had a winner, in part because the story line hit on the product's benefits in a story that was simultaneously perverse, amusing, and strangely sweet.

"The jeans are twisted to follow the contours of the body to allow more freedom of moment. So to communicate the twisted nature of the product, we twisted the classic Levi's boy-meets-girl scenario. We took the Romeo and Juliet love story and gave it a twist," Adam says.

The spot opens with boy and girl blow-up dolls outfitted in Levi's Engineered Jeans floating toward each other down a busy city sidewalk. It's love at first sight for our doll-heroes, who float toward each other amidst bustling people oblivious to the plastic lovebirds. Corny, romantic music wafts them along and they finally reach each other and experience a moment of first-love magic—that is, until a huge city bus passes by and blows the boy doll into the barbed wire on a chain-link fence. To the horror of his paramour, he deflates slowly on the fence, and she sticks herself with the thorns of the rose he gave her and goes to deflate at his feet.

It should be noted that these were no ordinary blow-up dolls. "They were designed to our specifications and were controlled by professional puppeteers; the strings were then painted out in post-production," says Adam. Of course there's no denying the activities associated with the dolls, as Adam found while shooting the scene. "They caused quite a stir with bystanders, to the point where we had to prevent a few people from getting too personal with them!"

As for the music, Adam expounds on the search for just the right track. "We wanted something that fit well with the story line. The one that we chose was by a group called Archive, and it went perfectly with both the romantic and tragic elements of the story."

Asked how the campaign fits in to Levi's long-term global advertising strategy, Adam states that it was right on target. "The launch of the Engineered Jeans was to maintain Levi's position as the leader of denim innovation and the definitive source for jeanswear. It's been a success, reversing the decline of the entire denim sector. The ads were very well received in Europe and later ran in North and South America."

He further ensures that "BBH continues to advertise the Engineered Jeans line, and 'Twist' won a Gold Lion at Cannes and is one of the most talked-about ads of 2001."

We can only hope they keep any other blow-up buddies away from that Gold Lion figurine.

Previous spread and opposite: "The jeans are twisted to follow the contours of the body to allow more freedom of movement," creative director Adam Chiappe explains. "So to communicate the twisted nature of the product, we twisted the classic Levi's boy-meets-girl scenario. We took the Romeo and Juliet love story and gave it a twist."

ESPN No one ever accused Bristol, Connecticut, of being the epicenter of sports in America. It did, however, provide the manger for a couple of fanatics to launch a network that brings out the couch athlete in all of us.

"The key insight into the ESPN brand is the way that ESPN staff think of themselves as the world's biggest sports fan," says Ty Montague, creative director.

A father and son, Bill and Scott Rasmussen, bought a satellite transponder and soon realized they could broadcast to the whole nation. The one problem they encountered—and couldn't seem to resolve—was exactly what to broadcast. As the story goes, tempers were running high as the debate waged on, and son Scott finally blurted out, "I've had it! It's your transponder, go ahead and show football all weekend; see if I care!" Father Bill's eyes lit up. And ESPN was born.

By 1995, ESPN was a multimillion-dollar organization, and the SportsCenter part of the programming had developed a style all its own that was refreshingly irreverent. Looking to grow their audience, they awarded the account to Wieden+Kennedy, New York, with a creative brief that was enviably simple: Do a great campaign for the SportsCenter part of ESPN. Given the previously established tongue-in-cheek approach of the programming, the creatives hit the ground running; the advertising would be designed to add to the entertainment of a client that was already all about fun, sweat, and beer nuts.

First up: creative team Hank Perlman and Rick McQustin. In mock documentary style, they shot a series of behind the scenes scenarios at SportsCenter—behind-the-scenes, but with a twist. Hoping to emulate what fans imagine the reality of life at a sports news center to be, the spots portrayed a sort of sports star mecca, where athletes casually strolled about and mascots roamed the halls. As Hank recollects the birth of the idea, "We thought, what if you really thought you could walk into SportsCenter and actually see Grant Hill in the lobby playing the piano?"

As fate would have it, he recalls a moment farther down the road at one TV commercial shoot when life truly imitated art. "One time we were staying at the Bristol Radisson," he tells. "The fire alarm went off, so we all went down to the lobby. And milling around was George Muerasan and puppeteers for Little Penny, a whole lot of college mascots, and Mary Lou Retton. It was as surreal as the spots—just a weird convergence of people in the lobby."

Freak incidents aside, the team quickly found that shooting the commercials in SportsCenter would prove to be strangely more challenging than they'd expected. The show went on around the production crew while they were shooting, so the set was full of tons of people there who were just trying to get their everyday jobs done. "It was pretty funny the time we had to lay down live grass inside the office," chuckles Ty Montague, creative director.

Do Not Stare Directly at the Sun

WINTER X GAMES ✚ Safety First
February 2–6 Mount Snow, Vermont ESPN ESPN2 ABC
PLAY THE WINTER X GAME ON EXPN.COM

"We do ten campaigns per year. They
include TV, print, out of home, mugs,
T-shirts, stickers—everything and any-
thing we can dream up," says Ty.
(Art Director: Kim Schoen; Designer/
Illustrator: Geoff McFetridge)

Do Not Drink Gasoline

WINTER X GAMES ✚ Safety First
February 2–6 Mount Snow, Vermont ESPN ESPN2 ABC

SCRIPT
"Game Ball"

(Open on Dan Patrick in his cubicle. Mark McGwire enters holding a baseball.)

Mark: Dan?

Dan: Hey Mark.

Mark: We go back a long ways, right?

Dan: Yeah.

Mark: Well, you're my best friend and I have something for you. It's number 62.

Dan: No, I can't.

Mark: Please, take it.

(Dan takes the ball.)

Dan: Number 62?

Mark: Number 62.

Dan: I'm gonna cherish this for life.

Mark: Thanks.

Dan: No, thank you.

(They hug. Cut to the next day. Dan Patrick pulls up to the ESPN studio in his new Lamborghini. The license plate reads: "Sweet 62." He is wearing mirror shades and leather driving gloves.)

SUPER: This is SportsCenter.

With direction, scripts, and location under their belts, the team was left with one burning question: Can sports celebrities act? "When you walk in the door you write a script and you say 'I want to have Evander Holyfield' and you never know if he can act or not," exclaims Amy Nicholson, a current creative director on the account. "There are different talent levels. Some of the athletes are real natural in front of the camera and some are not. You really never know what you're going to get."

As for how they feel about working with ESPN, Amy and Ty agree, "They're the world's greatest client. They allow us to do what we do best—take real insight into fans and turn it into something entertaining." They've been working with ESPN for the better part of a year now and are still taking cues from viewers.

"This is work that always assumes ESPN is the sports center of the universe," explains Hank, who was originally a writer for the network and is now a commercial director. After all is said and done, ESPN and SportsCenter boast numerous awards, but more importantly they have established a dedicated following among sports fans all over the world.

Although Wieden+Kennedy now shares creative duties with Ground Zero, they remain ESPN's agency of record in charge of brand tone. "We do the lion's share," Amy notes. "It's a grand challenge. The advantage is, it's sports—and sports is a never-ending story. The NBA changes. Sports keep changing. And that continues to provide fresh material, which is always helpful."

Snickers

Rightfully so, Vice Chairman, Senior Executive **Creative** Director Charlie Miesmer of BBDO has **good reason** to shake his head at the **love-'em-and-leave-'em** relationship many **clients** have with their **agency.**

"Accounts move around now more then they used to; clients now leave at the drop of a hat. You can do two or three great campaigns for clients over the course of years, but do one bad ad and the account's up for review."

He also, however, has good reason to thank his lucky stars—or planet in this case—for the longstanding success he's had with one of the bigger accounts around. "Mars is a shining exception to the rule," he explains. "They've been incredibly loyal to the agency, even by the old standards, but incredibly loyal by the new standards. They treat us as partners—with respect. They even admire what we do."

(Did he just say *admire*?)

"Six years ago, Mars came to the agency," Charlie tells of how it all began. "It was noteworthy in the ad world and we were absolutely delighted to get the business, but disappointed with the reel of their old work. I looked at their old reels for a while and said, 'What have they done? Oh, Christ. It's all traditional packaged goods. Dull work. Oh well, it's business.'"

And business is business. But little did they know of the creative opportunity that was hiding under the couch. "Mars had promoted and realigned their staff so the people there were all relatively new," he continues. "Unbeknownst to me, they felt the same way about the old spots. So after a few meetings with them, it was like a breath of very fresh, oxygen-rich air. I realized, 'These guys *want* good stuff.'"

With this epiphany in their back pockets, the creative team started analyzing exactly why the current advertising wasn't getting anywhere. "We took the core virtue of the [Snickers] brand—it fills you up. It's satisfying," Charlie relays. "You can put three in your pocket and you won't have to eat lunch. If you're a kid playing basketball in the middle of the afternoon and you're a few hours away from food, grab a Snickers. They had been advertising this, but in a very dull way—using adults, and dull adults at that, and talking about the proposition in a very serious way."

Knowing this simply wasn't working, the team turned to the most failproof insight about their audience available: good old demographics. "We came to the conclusion that it's really about kids, ten to twenty-five, the young male: That's the person who eats Snickers. And these people, they don't respond to serious. They only respond to girls and humor, and since Mars is a family company and we're a family agency, we knew we couldn't use sex to sell the candy."

Process of elimination established their direction. With a sex sell out of the question, they went with comedy, figuring there had to be a funny way to show that a Snickers will hold you over. "So I wrote a spot," Charlie shares. "It showed the Buffalo Bills after not winning four Super Bowls, and the coach says, 'We're going to win this,' and the line comes up: 'Not going anywhere for a while?' The client loved it, but it cost two billion dollars to produce. So they ran it everywhere, but they couldn't afford to keep doing more of them."

That wasn't the first time advertising has seen this problem, and Charlie knew the routine. "I went to the creative team and said, 'Can you do spots like this, but cheap? Make them simple, comedic set pieces around the same idea.' They did exactly what I wanted. We brought it to the client; they got it immediately and produced them all. It had great results—it was named campaign of the year.

"But what happened then," he reveals, "was that after five or six years running, it started to become expected. It started wearing out. Kids started to see it coming—the setup and then the joke. So we tried to be funnier, but when you try harder to be funny, you never get funnier."

With a new tack on the horizon, Charlie recognizes the nuggets of inspiration that led the team in a new direction. "Although we needed fresh creative, we did go out with a bang; even the last spots of that campaign were pretty funny. They took the same core premise of satisfying hunger, but focused more on the state of hunger itself."

In the "Crunch" spot, recipients get to crush toy dolls however they please. "I personally hate clichés," creative director Charlie Miesmer admits. "That's why I had the dolls crunched. After the spot ran, people e-mailed suggestions for things they wanted crunched."

They also came to the conclusion that the previous campaign was more about eating Snickers out of boredom. Charlie says, "After some time the 'Not going anywhere for a while?' campaign translated to some people as 'Snickers is the candy bar to eat when you're bored'—which is simply not true.

"The universal truth is that no one ever eats a Snickers bar full," he continues. "You only eat it when you're hungry. So we decided to do a campaign about what happens when people are hungry. Now, there have been a multitude of spots that talk about being hungry; it's a well-trod and dull ground. But we really did have something that helps when you're hungry."

Pushing the creative envelope, Charlie recalls, "We started getting into the realm of 'Weird things happen when you're hungry.' Like, for instance, you have poor judgment."

Soon afterwards, the Snickers "Crunch" campaign evolved. "By this time, we assumed people knew what Snickers are. Also, we knew that 'crunch' had been done to death. People know what crunchy is. But actually wanting to physically crunch something hadn't been done to death."

Going with the unique angle, Charlie wrote the spot where small toys are distributed to passersby by a man at a foldout table on the sidewalk. Each toy represents some upsetting or insulting situation or emotion that the recipient gets to crush however they please.

"I personally hate clichés," he admits. "That's why I had the dolls crunched. After the spot ran, people e-mailed suggestions for things they wanted crunched."

As to the spot's mass appeal, Charlie's thankful that "There are people like myself who are writers, who have weird thoughts that pay off because they're channeled into humor that other people find delightful."

Get down with your weird self, Charlie. And eat your Snickers.

Script
"Voting Booth"

Elephant: "Psst...vote for me. My dad was president. I even look like my dad."

Donkey: "Big deal, my dad was a senator."

Elephant: "Yeah, we have the same shoe size."

Donkey: "Yeah, well, I invented the Internet. Lots of other stuff too."

Elephant: "Once my mom thought I was my dad."

Donkey: "Space shuttle, that was mine."

Elephant: "On the phone, people think I'm my dad."

Donkey: "That's me. I'm on TV"

Elephant: "We have the same name, my dad and I that is."

Announcer: "Not going anywhere for a while? Grab a Snickers. With peanuts, caramel, and chocolate, it will be sure to hold you."

"The universal truth is that no one ever eats a Snickers bar full," Charlie reasons. "You only eat it when you're hungry. So we started getting into the realm of 'Weird things happen when you're hungry.'"

The Economist With a **world-renowned** campaign that's **been** running in **Great Britain** for the past **fourteen** years, the **big wigs** at *The Economist* are seeing **anything** but **red.**

$$E = iq^2$$

The Economist

⊘ Creative director David Dye reveals the executional mandatories. "The rules are: red and the typeface. Other than that, it couldn't be more flexible. That's why it's lasted so long. It's not rigid and people don't get bored because of that freedom and flexibility."

Creative director David Dye at AMV/BBDO cites, "In the '80s, there was a whole bunch of cigarette advertising in Great Britain that was so creative, almost wacky. The time was right for a simple campaign like this to come along."

He gives credit to David Abbott and Ron Braun for the original concept and remembers, "For the time it was *very* odd-looking. Breakthrough. It was very simple and it was unusual to do something so sparse at the time. It was very strange-looking and that gave it fantastic impact.

"The creative was very focused," he continues. "The original media were forty-eight sheets and banners—that's where it started. It was initially created to talk to media people to generate sales and increase awareness. It worked, but the intelligence of the ads and its very targeted business success eventually spilled over to consumers and increased subscriptions as well."

With a winning formula in their back pocket, David details what goes into every assignment. "Every time we get a brief for an *Economist* ad," he reveals, "it's always very clearly defined. That helps to narrow down the parameters. It seems like a straitjacket initially, but in the end it's not."

He goes on to reveal the executional mandatories. "The rules are: red and the typeface. Other than that, it couldn't be more flexible. That's why it's lasted so long. It's not rigid and people don't get bored thanks to that freedom and flexibility."

In fact, David expounds on how some design elements have evolved over the years. "In the beginning, it was all red," he relays, "but then some photos, etc., were incorporated using other colors." Small tweaking aside, however, he's also quick to point out that what makes the campaign so effective is its brilliant visual branding. "Even if you're a hundred feet away and can't read it, you still know it's for *The Economist.*"

He tells how, given the campaign's adaptable nature, many creatives have worked on it over the years. "The work had strong legs because of its strong foundation," he reasons, "but was flexible enough for others to put in their own personality. Everyone wants to work on it, largely because of the nature of who you're talking to—the intelligent group."

David also gives due credit to the client for the high standards the work has been able to maintain. "The client is fantastic and intelligent. Ideas are what's talked about and they know exactly who they're talking to, so the work is highbrow."

Ever go blank at the crucial... thingy?

The Economist

Lose the ability to slip out of meetings unnoticed.

The Economist

"Take me to an Economist reader."

Some of the campaign's design elements have evolved over the years. "In the beginning, it was all red," David relays, "but then some photos, etc. were incorporated using other colors. But even if you're a hundred feet away and can't read it, you still know it's for *The Economist*."

As to more pedestrian factors, David adds, "The client, naturally, loves the low cost. The special red is not printed four-color; for *The Economist* they print one color for impact, so colors pop off the page. For the ad with the circle colors, it's clean and clear and very powerful."

Powerful messaging for consumers and judges alike, it seems. "It was the most awarded poster campaign in Great Britain," David is proud to report, "winning best poster of the year and best campaign of the year, fifteen years later."

As readers have warmed to color in newsprint over the last ten years, *The Economist* finds itself with a major redesign on the horizon, only the fifth since its inception in 1843. Incorporating full-color editorial pages, a streamlined typeface, and the addition of a weekly political cartoon, one can only hope this makeover enjoys as much success as *Economist* circulation numbers have for decades.

Nature v Nurture. Away win.

The Economist

Above and opposite: "The work had strong legs because of its strong foundation," David reasons, "but was flexible enough for others to put in their own personality. Everyone wants to work on it, largely because of the nature of who you're talking to: the intelligent group."

A poster should contain no more than eight words, which is the maximum the average reader can take in at a single glance. This, however, is a poster for Economist readers.

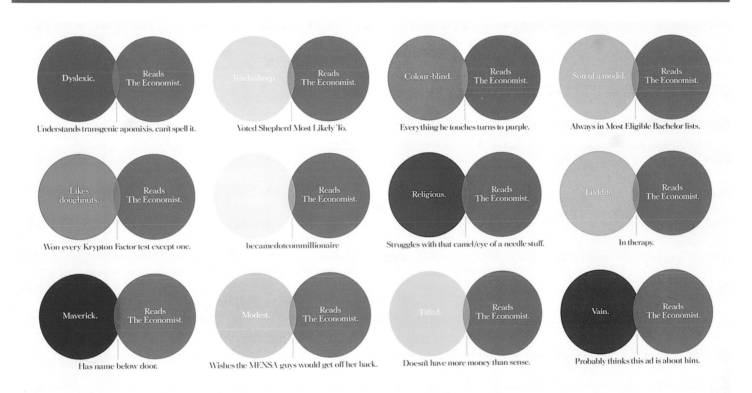

Dyslexic. / Reads The Economist.	**Tends sheep.** / Reads The Economist.
Understands transgenic apomixis, can't spell it.	Voted Shepherd Most Likely To.

Colour-blind. / Reads The Economist.	**Son of a model.** / Reads The Economist.
Everything he touches turns to purple.	Always in Most Eligible Bachelor lists.

Likes doughnuts. / Reads The Economist.	Reads The Economist.
Won every Krypton Factor test except one.	becamedotcommillionaire

Religious. / Reads The Economist.	**Luddite.** / Reads The Economist.
Struggles with that camel/eye of a needle stuff.	In therapy.

Maverick. / Reads The Economist.	**Modest.** / Reads The Economist.
Has name below door.	Wishes the MENSA guys would get off her back.

Titled. / Reads The Economist.	**Vain.** / Reads The Economist.
Doesn't have more money than sense.	Probably thinks this ad is about him.

Fox Sports Network
A few **years** ago, a **little** **network** named **Fox** sprang up and introduced a **refreshing** brand of **cheeky humor** to **TV programming**.

But how to translate that fresh, sassy approach to their growing sports audience was the challenge on the table for creative director Eric Silver's team at Cliff Freeman & Partners in New York.

"Fox Sports is very much an extension of the Fox network itself," Eric reflects. "It's brash, edgy, and always engaging. So the advertising really needs to make sure the entertainment has an easily identifiable sell, so viewers know why they're watching one of our spots. We don't want to do anything gratuitously."

Of course working for someone who's willing to meet you on the fifty never hurts either. "Neal Tiles is a fantastic client," Eric shares. "We've worked together for four years now on Fox through Cliff Freeman, and prior to that we worked briefly together on ESPN at Weiden+Kennedy."

How the two networks compare in the sports arena has contributed to the different branding styles the creative team was willing to explore. "One area we never touch is a documentary style," he explains. "ESPN owns that with SportsCenter—so it would be taboo to venture into that world." Eric adds that whereas "ESPN is the polite uncle standing in the corner," the Fox Sports approach is considerably more in your face.

To this point, Eric also acknowledges that having a more aggressive personality doesn't necessarily benefit from too brassy a look and feel. "We've tried to stay away from glitzy-looking commercials with real shiny film, etc. That seems to be the norm of commercials and we desperately want to stand out."

No doubt the client is a big fan of the mission at hand. Regarding how selling the creative goes, Eric tells, "We typically present one campaign. If Neal doesn't like it, we go back to the drawing board. I'd say it's fifty-fifty that we sell the initial campaign we present."

Whether the first round or not, the odds were definitely in the team's favor when it came to producing recent regional and NBA spots. "The regional campaign was a pretty straightforward assignment," he relays. "You only care about sports in your region—that is to say, as a sports fan living in New York, I only care about the Mets and Yankees. I really don't care what the Braves are doing, and vice versa. So we carried this premise to its most logical, yet absurd conclusion. If I live in Atlanta, watching Yankees highlights is about as exciting and relevant as watching a high-dive contest somewhere in the Middle East."

SPORTS NEWS FROM THE ONLY
REGION YOU CARE ABOUT.

"The regional campaign was a pretty
straightforward assignment," Eric Silver,
creative director relays. "You only care
about sports in your region, so we car-
ried this premise to its most logical—
yet absurd—conclusion. If I live in
Atlanta, watching Yankees highlights
is about as exciting and relevant as
watching a high-dive contest somewhere
in the Middle East."

SPORTS NEWS FROM THE ONLY
REGION YOU CARE ABOUT.

YOURS.

11 PM REGIONAL SPORTS REPORT

FOX SPORTS NET NEW YORK

Above and opposite: "Fox Sports is
brash, edgy, and always engaging,"
Eric tells. "So the advertising really
needs to make sure the entertainment
has an easily identifiable sell, so viewers
know why they're watching one of our
spots. We don't want to do anything
gratuitously."

Mastering the special effects of replacing players
on the court with actors for the script was, as Eric
describes, "a very labor-intensive process. First
Kevin Diller, the producer, and the editor, Gavin
Cutler, searched though hundreds of hours of NBA
footage to find moments where we thought we
could sub in our actors."

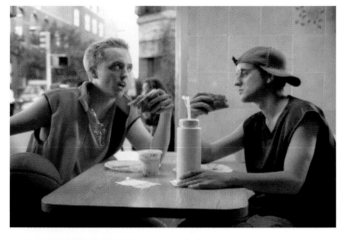

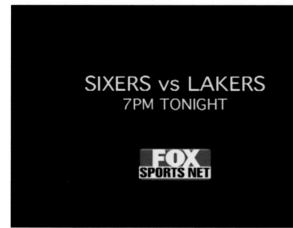

SIXERS vs LAKERS
7PM TONIGHT

FOX
SPORTS NET

Script
"Los Angeles"

(Open on two guys eating in a fast-food restaurant.)

Alan: Yo, I swear J, if I hear the word "Shaq" one more time....

Jerome: Or, Shaq Attack.

Alan: Yo, what did I just say?

Jerome: My bad.

(Cut to game footage of the Los Angeles Lakers...playing against Alan and Jerome. It is two against five.)

Alan (VO): I would really show up my mad dribbling skills on this much-over-hyped team.

(Cut to Alan juking several Lakers with his dribbling skills)

Jerome (VO): Yo. They OK.

Alan (VO): Yeah, they OK, but they ain't got the Alan Iverson grace. You know if I was playin' them, I would be punishin' them.

(Cut to Alan driving to the basket and scoring over Shaquille O'Neal.)

Alan (VO): Punishin' them for thinkin' they could stop this. You can't stop this!

(Cut to Alan doing his very own celebration dance.)

Alan (VO): I'm fresh like a can of Picante. And I'm deeper than Dante in the circles of hell.

Super: Live the game.

Super: Sixers vs. Lakers, 7PM tonight, Fox Sports Net.

What resulted was a series of spots with mock foreign sports newscasts. Although the average person who doesn't speak Chinese, Hindi, or Turkish won't understand the actual commentary, the accompanying footage tells it all: a round of blindfolded club-swinging that takes out a bystander, a tree-felling event that pummels a participant flat, a cliff high-dive straight into the ground below.

But it was an NBA assignment the team produced that maybe hit closer to home for a majority of fans. "The NBA was a fun assignment," Eric remembers. "The tag line was 'Live the game.' Simplicity rules the day. So we decided to use two *extremely* white kids sitting on a stoop fantasizing about taking down the big boys. We watch their trash talk come to life—and that's basically it."

"Basic," however, is not a word usually associated with how the spots came to life after four months of intensive work. Producer Kevin Diller expounds on the casting process alone: "We looked at a couple hundred people and ended up casting Chris Wilde, the blond guy who later got his own Comedy Central show, off the first tape we saw. We had a lot of trouble finding a second guy. We thought we hadn't gotten it exactly right with Eric, the brown-haired guy, but he turned out to be great."

Mastering the special effects of replacing players on the court with actors for the script was, as Eric describes, "a very labor-intensive process. First Kevin and the editor, Gavin Cutler, searched though hundreds of hours of NBA footage to find moments where we thought we could sub in our actors."

Kevin and Eric reveal how it took weeks to pre-build the NBA game sequences before shooting, pre-cutting the footage to time, and building a basketball court–size green-screen studio. They then shot the characters against the green screen, having them match the NBA players' actions. Quiet Man, the effects company, then digitally removed players on the opposing teams and composited actors into the scenes frame by frame, matting the two together.

"Gavin did an astounding job of solving a hugely complex conceptual problem in pre-cutting the footage and making everything work," Kevin expounds. "The whole time we were shooting, we weren't 100 percent sure the effects were even possible, but somehow Johnny at Quiet Man worked his magic and actually pulled it off."

In addition to the effects, there's no doubt the scripts were equally crucial to the comedy of the spots. "I did my best to write funny dialogue of white guys trying to sound black," Eric says modestly, "but true credit must go to the actors, whose improv made the spots great." Kevin, however, gives Eric due credit, lauding his scripts as "genius—the funniest I've ever read, and maybe even better than the final product."

He further reflects on how the end product "may look simple when viewed, but it was the most complex production and post-process I've seen in ten years of producing."

Obviously, all the hard work has paid off. "My goal is to get as many consumers as I can to try my client's product, or gain viewership," Eric explains. "If it sucks, it'll be a bust. But if the client has a good product or TV show or whatever, that's when the marketing can truly make a difference."

And when it does make a difference, he maintains his own yardstick of success: "We win a ton of awards but, moreover, everything we've tested shows that doing commercials that are unconventional yet smart yield the best results. We pride ourselves on forcing consumers to take notice of what we're selling."

Notice taken. Thanks.

Script
"Utah"

(Open on two guys sitting on a stoop.)

Alan: Yo, you know who led the league in assists last year?

Jerome: It shoulda been you, Yo.

Alan: No doubt, Boo. No doubt….Yo I gotta show these suckas how to play dis game!

Jerome: Let 'em know….

(Cut to game footage of the Utah Jazz playing against Alan and Jerome. It is two against five.)

Alan (VO): I got the flava that ya savor….Watch my Kobe Bryant "No-Look Confusion Maker."

(Cut to Alan passing the ball over Karl Malone's head to Jerome.)

Jerome (VO): Hey, Utah. Here's a little something called style.

(Cut to Jerome shooting a three-pointer over John Stockton, all net. Cut to Alan and Jerome taunting the bench with a little dance.)

Super: Live the game.

Super: Lakers vs. Jazz, 7PM tonight, Fox Sports Net

"Gavin Cutler, the editor, did an astounding job of solving a hugely complex conceptual problem in pre-cutting the footage and making everything work," notes Kevin. "The whole time we were shooting, we weren't 100 percent sure the effects were even possible."

LAKERS vs JAZZ
7PM TONIGHT

FOX
SPORTS NET

directory of agencies

ABC
TBWA\Chiat\Day, LA
5353 Grosvenor Blvd.
Los Angeles, CA 90066
310-305-5000
www.tbwa.com

ABSOLUT
TBWA\Chiat\Day, NY
488 Madison Ave.
New York, NY 10022
212-804-1000
www.tbwa.com

ADIDAS
Leagas Delaney
840 Battery St.
2nd Floor
San Francisco, CA 94111
415-439-5800
www.leagasdelaney.com

ALTOIDS
Leo Burnett, Chicago
35 West Wacker
Chicago, IL 60601
312-220-5959
www.leoburnett.com

AMAZON.COM
Foote Cone & Belding, San Francisco
733 Front St.
San Francisco, CA 94111
415-820-8000
www.fcb.com

BMW
Fallon, Minneapolis
50 South Sixth St.
Minneapolis, MN 55402
612-758-2345
www.fallon.com

BUDWEISER
DDB Needham, Chicago
200 E. Randolph
Chicago, IL 60601
312-552-6000
www.ddb.com

CARRIER
Ogilvy & Mather, Singapore
1 Maritime Square #11-01
World Trade Center
Singapore 099253
65-278-7777
Beth.barnack@carrier.utc.com

CORONA
The Richards Group4
8750 N. Central Expressway
Suite 1200
Dallas, TX 75231
214-891-5700
www.richards.com

DE BEERS
J. Walter Thompson, NY
466 Lexington Ave.
New York, NY 10017
212-210-1000
www.jwthompson.com

DEXTER
Mullen
36 Essex St.
Wenham, MA 01984
978-468-1155
www.mullen.com

DISCOVERY.COM
Publicis & Hal, San Francisco
2001 Embarcadero St.
San Francisco, CA 94133
415-293-2601
www.hrp.com

DOCKERS
BBH, London
60 Kingly
W1B 5DS
44-207-453-4610
www.bartleboglehegarty.com

DORADA
Vitruvio Leo Burnett, Madrid
Duque de Sevilla 3
28002 Madrid
Spain
011-34-91-590-5000
www.leoburnett.com

DUNKIN' DONUTS
Hill Holliday, Boston
200 Clarendon St.
Boston, MA 02116
617-437-1600
www.hhcc.com

EBAY
Goodby Silverstein, San Francisco
720 California St.
San Francisco, CA 94108
415-392-0669
www.goodbysilverstein.com

THE ECONOMIST
AMV/BBDO, London
151 Marylebone Rd.
London NW1 5QE
011-44-207-616-3500
www.amvbbdo.co.uk

EDS
Fallon, Minneapolis
50 South Sixth St.
Minneapolis, MN 55402
612-758-2345
www.fallon.com

ESPN
Wieden & Kennedy, NYC
150 Varick St.
7th Floor
New York, NY 10013
917-661-5269
www.wk.com

E*TRADE
Goodby Silverstein, San Francisco
720 California St.
San Francisco, CA 94108
415-392-0669
www.goodbysilverstein.com

FOX SPORTS
Cliff Freeman, NY
375 Hudson St.
8th Floor
New York, NY 10014
212-463-3200
www.clifffreeman.com

FREEAGENT.COM
Kirshenbaum Bond & Partners
160 Varrick St.
4th Floor
New York, NY 10013
212-627-5139
www.kb.com

GIRO
Crispin Porter & Bogusky
2699 S. Bayshore Dr.
Miami, FL 33133
305-859-2070
www.cpbmiami.com

GT BICYCLES
Crispin Porter & Bogusky
2699 S. Bayshore Dr.
Miami, FL 33133
305-859-2070
www.cpbmiami.com

GUINNESS
Weiss Stagliano Partners
96 Morton St.
9th Floor
New York, NY
212-255-3900
www.brandarch.com

H&R BLOCK
Y&R, Chicago
233 N. Michigan Ave.
Chicago, Il 60601
312-596-3000
www.yandr.com

HAMBURGER ABENDBLATT
McCann-Erickson, Hamburg
Neuer Wall 43
Hamburg, Germany 60598
011-49-40-360-090
www.mccan.com

JOHN HANCOCK
Hill Holliday, Boston
200 Clarendon St.
Boston, MA 02116
617-437-1600
www.hhcc.com

LEVI'S (U.K.)
BBH, London
60 Kingly
W1B 5DS
44-207-453-4610
www.bartleboglehegarty.com

LEVI'S (U.S.)
TBWA\Chiat\Day, San Francisco
55 Union St.
San Francisco, CA 94111
415-315-4100
www.tbwa.com

L.L.BEAN
Mullen
36 Essex St.
Wenham, MA 01984
978-468-1155
www.mullen.com

MASTERCARD
McCann Erickson, NY
750 3rd Ave.
New York, NY 10017
212-984-3004
susan.lrwin@mccann.com
www.mccan.com

MOLSON CANADIAN
Bensimon Byrne D'Arcy
2 Bloor St. West, 14th Floor
Toronto, Ontario M4W3RA3 Canada
416-922-2211
www.darcyww.com

MONSTER.COM
Mullen
36 Essex St.
Wenham, MA 01984
978-468-1155
www.mullen.com

NIKE
Wieden & Kennedy, Portland
224 NW 13th Ave.
Portland, OR 97209
503-937-7000
www.wk.com

OUTPOST.COM
Cliff Freeman, NY
375 Hudson St.
8th Floor
New York, NY 10014
212-463-3200
www.clifffreeman.com

PBS
Fallon, Minneapolis
50 South Sixth St.
Minneapolis, MN 55402
612-758-2345
www.fallon.com

PRICELINE.COM
Hill Holliday, NYC
345 Hudson St.
New York, NY 10014
212-830-7500
www.hhcc.com

REEBOK
Berlin Cameron, NYC
1370 Broadway
New York, NY 10018
212-824-2000
www.bc-p.com

SAAB
The Martin Agency
One Shockoe Plaza
Richmond, VA 23219
804-698-8000
www.martinagency.com

SAN FRANCISCO JAZZ FESTIVAL
Butler, Shine & Stern
10 Liberty Ship Way #300
Sausalito, CA 94965
415-331-6049
www.bsands.com

SKITTLES
D'Arcy Masius, St. Louis
One Memorial Drive
St. Louis, MO 63102
314-342-8600
www.darcyww.com

ŠKODA
Fallon, London
67-69 Beak St.
London W1F 9SW
011-44-0207-494-9120
www.fallon.com

SNICKERS
BBDO, NY
1285 Avenue of the Americas
New York, NY 10019
212-459-5000
www.bbdo.com

SONY PLAYSTATION
TBWA\Chiat\Day, London
TBWA Simon Palmers 76-80
Whitfield St. London
W1PSRQ
011-44-171-573-6666
www.tbwa.com

SPCA
Leo Burnett, Singapore
Pte. Ltd.
33 Pekin St. 03-01
Far East Square
Singapore 048763
011-65-382-4162
www.leoburnett.com

SWISS ARMY
Mullen
36 Essex St.
Wenham, MA 01984
978-468-1155
www.mullen.com

TRUTH/THE AMERICAN LEGACY FOUNDATION
Arnold Worldwide, Boston
101 Huntingon
Boston, MA 02199
617-587-8000
www.arnoldworldwide.com

TRUTH/THE AMERICAN LEGACY FOUNDATION
Crispin Porter & Bogusky
2699 S. Bayshore Drive
Miami, FL 33133
305-859-2070
www.cpbmiami.com

VOLKSWAGEN
Arnold Worldwide, Boston
101 Huntingon
Boston, MA 02199
617-587-8000
www.arnoldworldwide.com

About the Author

Lisa Hickey is founder and CEO of Velocity Inc., advertising and brand engineering. She has been creating innovative, memorable, and brand-defining advertising for the past fifteen years. Her work has been recognized with the industry's highest honors, including Clio, Cannes, Hatch, NEBA, The London Show, and Communication Arts awards. She's been included in *Marquis Who's Who in the World*, frequently teaches at Massachusetts College of Art, and currently resides in Waltham, Massachusetts, with her husband and four children.

Acknowledgments

I'd like to thank my producer, Kelly Driscoll, without her this book would not have been completed. I'm also grateful for the help and perseverance of Alison Waldron and Jennifer Tisdale. Thanks as well to Don Carlin, at Finish Editorial for his help with the images. Finally, I'd like to thank the people who were responsible for creating the wonderful campaigns that this book is about, as well as all the people at the agencies all around the world who helped pull the materials together.